Matisse

Matisse

LAWRENCE GOWING

NEW YORK AND TORONTO
OXFORD UNIVERSITY PRESS
1979

ISBN 0–19–520157–4 Cloth
ISBN 0–19–520158–2 Paperback

Library of Congress Catalog card number 79–87876

Printed and bound in Great Britain by Jarrold and Sons Ltd, Norwich

Contents

Preface

My first debt is to the institutions that have involved me in great exhibitions of Matisse and enabled me to know well a wide range of his work, the Museum of Modern Art in New York, where Monroe Wheeler first suggested that I should work on the artist, and the Arts Council of Great Britain. In collaboration with Robin Campbell at the Arts Council and in his company, I looked at more of the paintings more closely than is often possible; this book is dedicated to him. Many museums, in particular the State Hermitage Museum in Leningrad, where I owed a particular debt to the late A.N. Izergina, and the Baltimore Museum of Art, have helped me to study their collections at length, and the establishments in which I then worked, the Tate Gallery and the University of Leeds, gave me the freedom to do so. I am grateful to the Museum of Modern Art for permission to base some pages of this book on the essay that I wrote for the museum in 1966. My cousin-in-law, the late Jane Simone Bussy, let me read the artist's correspondence with her father, extending over more than fifty years, and Mme Georges Duthuit generously provided new biographical information, particularly about the artist's training. Lately I have had the stimulating opportunity to discuss the artist in a series of lectures at the University of Pennsylvania, where my audience will recognize many pages of this book, and I have profited from discussion with my colleague John Elderfield in New York. Successive helpers have supported me in the preparation of the manuscript and in the work on exhibitions and catalogues; the final draft has been in the care of Ilona Guinsberg. I thank them all most earnestly and record a special gratitude to the patient publisher.

1869–1899 Beginnings

The great artists who made the transition from the nineteenth century to the twentieth travelled a huge imaginative distance. The journey was unparalleled; no one since Giovanni Bellini in the Renaissance had covered so much ground in one lifetime. None had ever seen the whole terrain of art shift and split as these men did. The journey towards modern art and the sense of direction that guided it have something mysterious about them still. The destination remains in some respects enigmatic, a continually receding frontier in territory that is colonized almost before it is explored – surrounded, it sometimes seems, by hostile country and beleaguered as the historic styles never were, but held with a heroism beyond compare in any other time.

None of these men covered a greater distance than Henri Matisse. From the modest realism of his first pictures to the grandeur of the last *gouaches découpées*, the journey took sixty years. Matisse's courage was sometimes marked with caution and his eventual audacity was laboriously studied, because it was part of his talent to possess a sense of aesthetic peril that was no more than realistic.

Matisse was born on the last day of 1869, the son of a grain merchant in the little northern town of Bohain. At twenty he was a lawyer's clerk at St Quentin. He came to art quite late, a refugee from provincial business life. He went to early morning classes in drawing from casts at the art school of the town, then during a long convalescence he obtained a paintbox. He always remembered the miracle of the discovery: 'When I started to paint I felt transported into a kind of paradise. . . . In everyday life I was usually bored and vexed by the things that people were always telling me I must do. Starting to paint I felt gloriously free, quiet and alone.' His need was not for adventure or experiment but simply for the occupation of painting at its steadiest and most secure. In 1890 an *avant garde* was establishing and institutionalizing itself in the modern fashion for the first time, but innovation and disturbance held in themselves no attraction for Matisse. For him painting was an escape from disturbance.

9

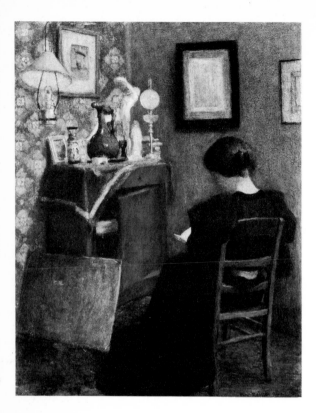

1 *La liseuse* 1894

2 *Nature morte à l'auto-portrait*
 1896

At a time when his contemporaries were inheriting the aesthetic
momentum and the figurative sophistication of a century which had seen the
most intensive development of painting since the Renaissance, he possessed
little of either. His skill was rudimentary and his idea of painting was derived
from the bourgeois naturalism that the French school had adopted from the
Dutch, a manner neither disreputable nor exciting and the only one that was
quite untouched, unless by the dust, in the battle of the styles. Matisse took it
up in a peculiarly elementary form. The simplicity and the mild, patient
1 touch give his first success, *La liseuse*, which he painted in 1894, at the age of
twenty-five, a naïve charm. The picture avoided every extreme; it was
entirely acceptable to middle-of-the-road taste. Exhibited in the next year, it
was bought by the State and sent to decorate the presidential residence at the
Château de Rambouillet; it is now in the Musée National d'Art Moderne. A
detail from it and the same stuffy brown and green scheme were developed

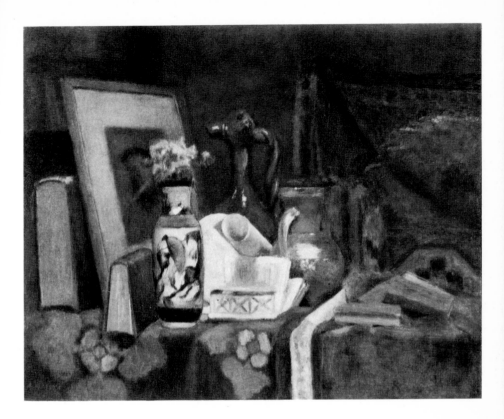

in *Nature morte à l'auto-portrait*, now in New York, in the collection of Sam 2
Salz. There is an interesting change; a flower pattern, typical of its time,
which in the first picture formed a wallpaper appeared in the second as a
cloth laid across the chest that supports the group. The pattern was evidently
inserted for its own sake, betraying an attitude more deliberately aesthetic
than anything else in the pictures – an attitude originating in Cézanne's still-
lifes of two decades earlier, which in the 1890s preoccupied the Nabis.
Matisse had none of their sophistication; there is only the barest sign of the
outlook that was to produce some of the boldest patterning in art.

The battle of the styles was reaching a climax; Matisse was content with
the *status quo*. He had good fortune. Seeking a teacher and drawing
assiduously in the covered court of the École des Beaux-Arts he attracted the
attention of Gustave Moreau. In March 1895 Moreau obtained permission
for Matisse to join his class without passing the entrance examination – a class

in which tradition was not only sheltered but understood. Moreau was the most sensitive of masters, with a devotion to the mystery of talent. Far from hidebound, he commended the far from traditional Lautrec; his own poetic and perverse imagery had contributed to the abandoned mysticism of some advanced painting of the time. But in the crisis of the 1890s Moreau's influence was on the side of gradualness. Ground was to be gained patiently, step by step; there was a time to sow and a time to harvest; the young rebels would hate liberty before they were fifty; classicism would soon be in fashion again; and so on. When Rouault, his favourite pupil, recorded all this in the 1920s, it looked to many as though Moreau's forecasts had been right.

In particular Moreau spoke often of Chardin, and of Corot and the injustice of his neglect. In Rome at the end of the 1850s, in the company of Puvis de Chavannes and Degas, Moreau had sketched the city and its light with a directness that came straight from Corot. Yet there was something incongruous in the painter of Moreau's jewelled and epicene fantasies allying himself with this tradition. The alliance was defensive. It sprang from an intelligent appreciation of the peril that tradition stood in from the schematic formulations of symbolism, the *avant garde* of the 1890s. Discussing his master's devotion to Rembrandt and the Renaissance as well, Rouault explained that it reflected Moreau's belief that the riches and the austerity of great art both stood on the same elevated plane, in contradistinction to another level, the current one, which was obliquely indicated in his dictum: 'There is no such thing as decorative art.'

Symbolism was explicitly and proudly decorative. In Moreau's studio its claims were dismissed out of hand. Against them, Moreau formulated the opposite principle, which was to effect the ideology of twentieth-century art more deeply still. For him the highest aim of art was expression; the true function of the artist was, he taught, *to express yourself*. The contrast between the two principles took on a special significance to Matisse; it underlay the alternating standpoints of his early work. To reconcile it was still the aim of the dialogue with himself, which he published as *Notes of a Painter* in 1908, ten years after Moreau's death. Eventually, after years of struggle, Matisse convinced himself that for him there was no contradiction; 'expression', he later told his son-in-law, 'is one and the same thing as decoration.' But the opposing principles were still reflected in the alternating aspects of his work. For the student Moreau's precepts and the standard that he set in the traditional skills were both exacting. It was due to them that the element in Matisse's art which was quite simply and sublimely decorative emerged with so little facility and with so much traditional meaning intact. Moreau's teaching forbade any self-indulgent way to the paradise of painting.

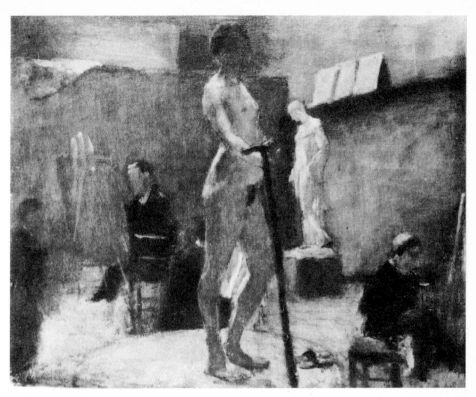

3 *L'atelier de Gustave Moreau* 1895

For the time being enlightened conservatism suited Matisse perfectly. The copying that Moreau advised was congenial to him. He made beautiful versions of Raphael and Philippe de Champagne. But for preference he studied the domestic and tonal realism of the north, copying such nourishing pictures as de Heem's great breakfast piece, a challenge to the artistic digestion which twenty years later he triumphantly surmounted. Most of all he copied Chardin, who remained his favourite painter. His devotion to Chardin was plainly reflected in two cool grey pictures – both of which bear the date 1896 – one of them, *Nature morte aux pêches*, is now in Russia, the other, *Nature morte aux raisins*, is in New York. In pictures like these the congested amber tonality of his earliest work was refined gradually to a state of silvery purity.

Moreau sent Matisse to sketch outdoors for the first time and the view along the Seine towards the Louvre, *Le pont*, which he painted in 1895,

13

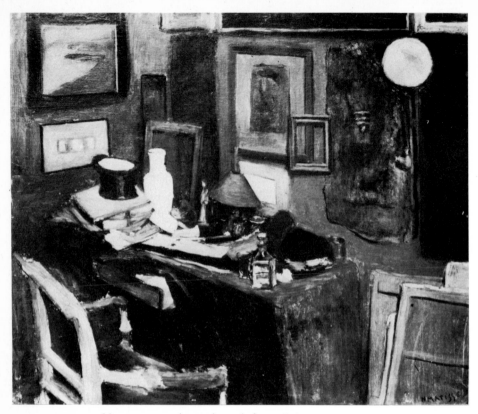

4 *Nature morte au chapeau haute-de-forme* 1896

followed the classic Roman pattern of the Ponte S. Angelo and St Peter's, the
3 pattern of Corot. By the time he painted *L'atelier de Gustave Moreau* his
method had gained a sophisticated selectiveness. The style that Matisse and
Moreau's other serious pupils adopted was in fact a tonal impressionism
much older than the chromatic Impressionism of the last two decades; it was
an invention of the seventeenth century. It was a style for imposing a refined
order on the humdrum chaos of everyday things.

Matisse's still-life interiors of the mid-nineties were pictures of untidiness,
4 images of domestic clutter clarified by the light. In *Nature morte au chapeau*
(dated 1896), showing a top hat thrown down on a littered desk, and painted
with an offhand *brio* that was quite new, the theme is plain; Matisse was
reflecting, as if involuntarily, on the disorder of a world in which people
were always telling one what to do. The arrangement of these pictures was

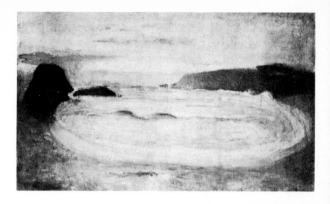

5 *Grande marine grise* 1896

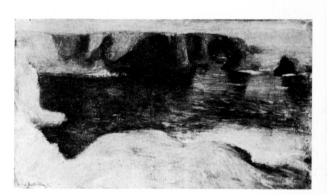

6 *Marine à Goulphar* 1896

usually oblique and receding, making diagonal slices of life, corners of nature of the kind that Zola had in mind; the temperament through which they were seen was a reticent one, in preference to the contrived styles of the advanced painting of the time. Matisse's pictures at this time avoided anything frontal or impenetrable; they sought what was transparent and opalescent; they assembled forms that were wide and shallow, hollowed like a bowl or scooped like a dish.

During the years 1895–97 Matisse went each summer to work in Brittany. On the second visit, in 1896, he painted *Grande marine grise*, which was the antithesis of still-life litter. It was the very image of what it meant to be free and alone. There is hardly a parallel in French painting; the symmetry and emptiness of the *Grande marine grise* were nearer to the spirit that Caspar 5 David Friedrich had brought to landscape, the spirit in which a few years later

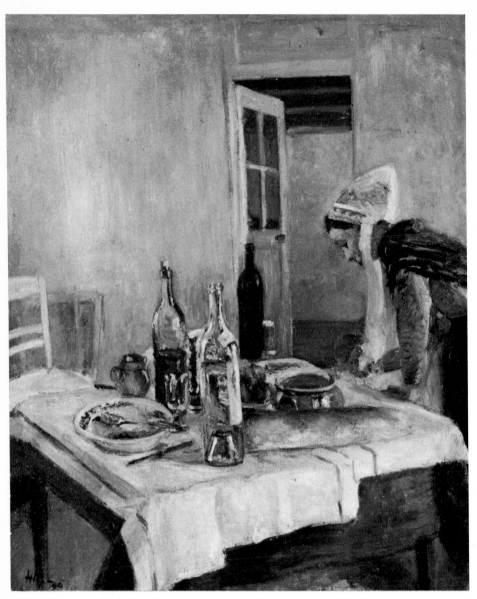

7 *La serveuse bretonne* 1896

8 *La desserte* 1897

Mondrian was to design his symmetrical images of beaches in Holland. There were still stranger images among the grey Breton landscapes of 1896. The space of *Marine à Goulphar* is denied by the shape that the dark sea makes against the rocks, lying across the canvas like an ink-blue, hammer-headed monster. But Matisse was led in another direction. His art never evolved in isolation; it was rooted in the resources of his time and his school.

In Brittany Matisse is said to have stayed at the Pension Gloanec in Pont-Aven; the decoration that Gauguin had left there meant nothing to him. But his first companion in Brittany, Émile Wéry, a neighbour in the Quai St Michel to whom he gave his sketch of the Seine, was painting in the Impressionist manner and before they parted the influence had an effect. In 1897 a *Serveuse bretonne* of the year before suggested the theme of *La desserte*, the ambitious canvas which Matisse painted for exhibition at Moreau's

6

7, 8

17

suggestion. The silvery tone deepened and the shapes of his favourite subject, a well-furnished table with an attentive servant, were made to blossom into incandescent globules collecting and scattering the light. Moreau praised the crystal decanters, which he said 'you could hang your hat on': they were in fact the centrepiece of a demonstration which combined the solid substance of tonal realism with a garnishing of bright but by no means prismatic colour. The style of Moreau's pupils, with all its delicacy of tone, seems always to have been oddly literal, and in the context of advanced painting in the nineties this vision of a corner of nature was basically conventional. The generalized figure of the maidservant, together with its sensual connotation (the model became the mother of the painter's daughter), took its place in an illustrative tradition that Zola would have recognized.

The originality of *La desserte* is elusive. It resides in the shapes that paint makes, the vaguely modelled figure among them, shapes with a rounded efflorescence of their own, and in an unexpected richness at the heart of the tonal scheme, where the dark islands which displace the turquoise light secrete their own deep colour, wine-red and orange. Matisse discovered both an amplitude that was natural to him and a possibility in the conventional *contre-jour* that had a private value, the possibility of a penumbra shot with reflections that transmit more brilliant colours than the light. Pursuing these two discoveries in the next few years, he left tonal realism behind.

In the embattled atmosphere of 1897 *La desserte* was taken for an Impressionist picture; Mattise's academic supporters were disappointed in him and hung it badly. But it was in the pictures that he painted during that summer in Brittany that his conversion became clear. To choose as a painting place Belle-Île, an island off the peninsula of Quiberon, was in itself a tribute to Monet who had produced a famous series of pictures there. His companion, the Australian John Russell, whom he had met in Brittany the year before, was painting Monet's subjects in a serviceable imitation of his style; Russell gave Matisse two drawings by Van Gogh. Matisse's *Marine, Belle-Île* was evidently suggested by Monet's stormy vision of the same scene, which was among the pictures from the Caillebotte Bequest lately and grudgingly admitted to the Luxembourg. Matisse's version was restrained and tightly knit; the only storm in all his work is watched from behind a closed window by a lady in a comfortable apartment. In *Côte sauvage, Belle-Île en Mer* (which he later, perhaps mistakenly, inscribed with the date of the previous year) he aligned the cliff-tops with the horizon, adopting a device of Monet's, to leave a straight band of cerulean sky against sea-green. Nothing else in the picture is so positive. As in most of the sea-pieces of 1897 the general effect is tentative and incomplete; probably the dappling, which is in essence atonal and chaotic, in itself prevents completion. But however

18

9 *Marine, Belle-Île* 1897

10 CLAUDE MONET: *Tempête à Belle-Île* 1886 (detail)

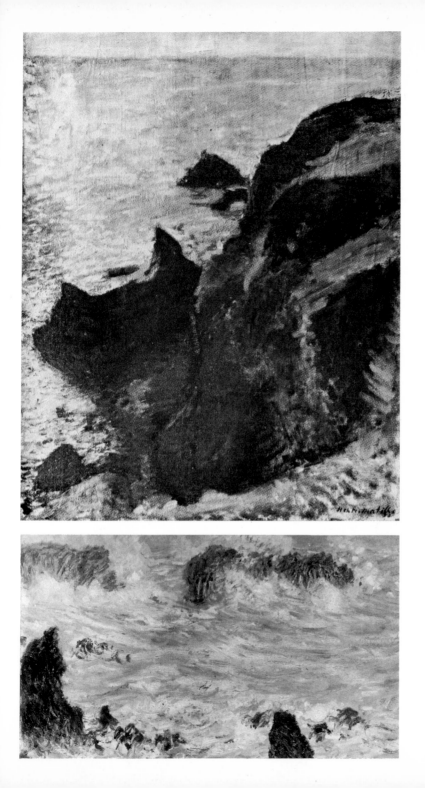

fragmentary the results, Matisse's new-found Impressionism introduced him to pure colour and the separate touch, to the intrinsic quality of the painter's means, the element of modern painting that was to occupy him continuously in the years to come.

The Caillebotte pictures were a crucial experience for Matisse. But there is no doubt that his approach to Impressionism and his whole view of modern art was due to two painters in particular. In 1897 he met the aged Camille Pissarro, who treated the young man with his invariable kindness, and at the Salon des Indépendants he saw the work of Signac. Pissarro himself had abandoned the strict Neo-Impressionist doctrine; Signac and his friends for their part had no enthusiasm for the neutral and rather melancholy townscapes which the old man painted from hotel windows in his last years. But they had still in common, as well as mutual respect, an approach to painting that was systematic rather than subjective. Signac's system involved a belief, as articles of faith, in the necessity for primary colours and in the reality of their reactions on one another.

Matisse married early in 1898 and set out on the travels which took him for a year to the south and introduced him to the light which was to have almost as profound an effect on him as any influence from art. But before he left Pissarro performed two services; he recommended him to go to London to look at Turner and he introduced him to the art of Cézanne. The romantic, indeed fanciful tributes that Matisse paid to Turner in old age leave no doubt that the pictures in the National Gallery impressed him deeply. He imagined Turner living in a cellar, throwing open the shutters only at dawn and sunset, as the paragon of a painter's ideal of self-abandonment to colour and light. He did not see the unexhibited later works in the Turner Bequest; none was shown until seven years later. But Signac's comments on a visit which he made probably by coincidence, in the next few weeks, show how strong an impression could be gained from the pictures then hanging. The ideal of the liberated colourist, which Signac recognized in Turner, was surely sympathetic to Matisse at that moment.

8 Years later Matisse described the change in his direction. After *La desserte*, 'I decided to allow myself a year's respite. I wanted to reject all restraint and paint as seemed best to me. Before long there came to me, like a revelation, a love of the materials of painting for their own sake. Growing within me I felt the passion of colour.' The great part of Matisse's work in the years that followed, as he approached his thirtieth birthday, was impetuous and free. Most of the pictures were quite small, many of them sketches made while travelling; some were simply and directly handled while others were heavily pigmented and chaotic. For the first time Matisse's work was uncontrolled, unashamedly personal and reckless. The experience of Impressionism, as he

wrote later, in a statement that has a good deal of autobiography in it, 'proved to the next generation that these colours . . . contain within them, independently of the objects that they serve to represent, the power to affect the feelings.'

The reaction that the brightness of Impressionist colour touched off in the work of the industrious apprentice was a surprising one. Joined to the bright light of Ajaccio, where the wonder of the south struck Matisse, as he said, for the first time, it resulted in the distracted vividness of sketches that were far from the objectivity of Impressionism. The feelings which colour had the power to affect were tumultuous feelings about the possibilities of painting. There is an occasional sign in the crimson streaking of bands of shadow across Corsican paths of the example of Renoir, which otherwise left him unaffected. The strongest effect of light among these sketches, in *Coucher de* 11 *soleil en Corse*, was surely due to the influence of Turner, the modern master of landscape *contre-jour*. The yellow sun, shining straight out of a green sky

11 *Coucher de soleil en Corse* 1898

streaked with cyclamen pink and set against a shadowed foreground of deep red earth, an effect unparalleled in recent painting except in pictures by Van Gogh, which Matisse did not then know, was a clear echo of the Turners that he saw in London.

Already in 1897 the essential point of some of the smaller sketches that he had made in Brittany was the precipitate scumbling of blue and turquoise against crimson pink. Painting olive groves in Corsica the next year or a canal near Toulouse, the archetypal designs of Impressionist landscape were adopted in a strangely rudimentary, childlike way; the dappling of rose-pink became the real object in itself. This impulsive and unrealistic colourism converted the Impressionist landscape method to a purpose quite foreign to it. In the event, Matisse was able to preserve far more from the nineteenth century than the other inventors of modern art. With him the mood which deprived the familiar style of its sense did not arise from alienation; he was infatuated.

In Matisse's still-lifes of the next four years colour took on a positive reality that seems to precede and transcend the separate existence of specific things. The way that objects materialize out of colour is nearer to Turner than to anything in French painting. A bowl and coffee cup in a *Nature morte au compotier* form themselves out of patches of moss-green; in the triumphant
13 *Nature morte à contre-jour* a patch of scarlet takes belated shape as a plate and knife. Sometimes in the later 1890s the failures of Matisse's art were Turneresque; such pictures became congested fantasies of a chromatic richness beyond belief. The moss-green in *Nature morte au compotier* was moulded with violet and the conjunction was further confused by the addition of cold blue and coppery orange; the scarlet plate was shaped by a fat stroke of grass-green. The intensity became feverish and oppressive; the tranquillity and freedom that were essential to painting were in danger.

This series of sketches with their random richness was interrupted by a fully worked out picture, which turned abruptly to an approach that was in
12 origin analytical and controlled. The motif of *Buffet et table*, painted at Toulouse, Mme Matisse's home where the couple settled for a time,
8 descended from *La desserte*, but the style that he brought to it derived from Signac. Matisse was reading Signac's *D'Eugène Delacroix au néo-impressionisme* which was serialized in *La Revue Blanche*; any discussion of the reactions between complementary hues, the reactions that echo problematically through the previous pictures, must have interested him at that moment. There is no practical instruction in the essay and Matisse, as he said later, did not paint by theory. But the assumption that the common object of painting from Delacroix onward was the greatest possible *éclat* of colour was congenial and no doubt it brought to mind the pictures by Signac and

22

his circle that he had seen in Paris. The major works of Seurat were out of sight in private collections and it is unlikely that Matisse had seen the memorial exhibitions seven years before. His own instinctive response to colour was stronger than any of Seurat's followers, and although he accepted the need for control and restraint, he could never have followed in practice Signac's teaching that Impressionism, based on instinct and inspiration, should give place to a technique that was not only methodical but scientific.

In *Buffet et table*, at the complex centre of the subject the separate, uniform brush marks that the doctrine of Neo-Impressionism required were lost in a delicate and luminous confusion. The virtue of the method to Matisse was rather that it encouraged a quality of detachment and restraint that he needed. The deliberation and artifice of the style separated him a little from the material of life and pigment; they allowed a certain artificiality. The primary colours slide into enchanting lilac and turquoise for which the theoretical prescription had no place. There is evidence of the idea that the greatest charm of colour resided in a capricious stippling of pink. The way that pink colours the stem of the *compotier* is indeed unaccountable; henceforward a certain arbitrariness was part of the essence of Matisse's art. Here and there a spot of paint landed fortunately in the middle of the spot before, gaining from it an elegant nimbus that surrounded yellow with a ring of green, or mauve with scarlet. Signac, with his concern for integrity of touch, would never have approved of such a practice and Matisse did not pursue it. His style repeatedly threw up potentialities of decorative artifice which he left less serious painters to develop.

12 Sketch for *Buffet et table* 1899

1900–1905 The way to Fauvism

Matisse adopted at each stage only as much of Neo-Impressionism as suited his empirical outlook. But the example of precision and detachment had a special value for him. When he returned to Paris and took up again the series of still-lifes outlined in rich congested colour against the light, it was *Buffet et table* that suggested a new direction. The same motif was used in little canvases which developed the alternative method of classification and control, tentatively, yet with a deeper originality than anything that he had painted so far. One of them, *Nature morte*, in the Cone Collection at Baltimore, is in the stippled, probing style in which Matisse also painted a self-portrait, very likely in 1900. Another, *Le compotier et la cruche de verre*, is both more fragmentary and more significant. Both pictures seem to have been derived from *Buffet et table* rather than directly from the still-life group; these are perhaps the first works of Matisse that we have which were not painted entirely from the subject. The receding perspective of the setting was squared up (though without disturbing the group of objects that it held) until the planes were almost frontally disposed. The untidy corner of nature was converted in *Le compotier et la cruche de verre* into an ordered structure. It is built out of clearly defined areas of colour. The picture is a system of deliberately designed correspondences, modulations and transitions, spanning tonal differences and neutralizing them. The local colour of the fruit is equated both with the colour of light – the yellow light filtering across the *compotier* and the creamy light transmitted by the translucent curtains – and equally with the golden colour of reflection that flattens the forms, a colour as bright and high in tone as the colour of light. Indeed we hardly notice which source of colour is which in the radiant pattern that forms round the residual core of shadow.

The completeness of the picture has little to do with descriptive consistency. It depends rather on correspondences between colours whose descriptive reference is barely indicated. The fruits are no more than orange discs or flat yellow crescents, extraordinarily elementary and direct by the standards of the conventional styles that Matisse had been using up to this point. Looking closely one can follow the whole story, as one often can in Matisse's pictures afterwards. A golden yellow makes both the crescent of

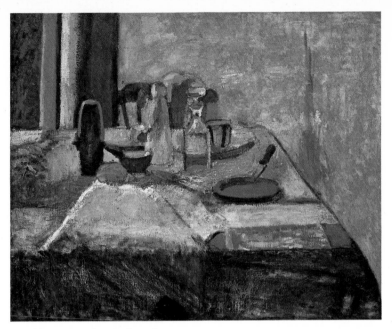

13 *Nature morte à contre-jour* 1899

14 *Le compotier et la cruche de verre* 1899

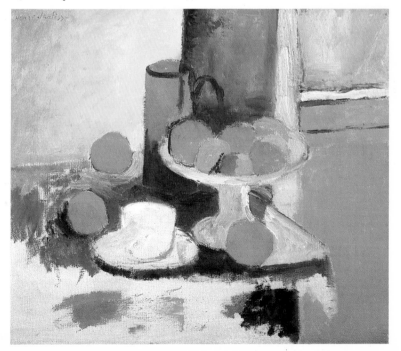

direct light on the fruit and the reflected light on the panel under the window behind. This colour has a family relationship with the yellowish white of the curtain that falls between them. We can see that the magically clear pale colour, which stands for translucent linen, was arrived at almost by chance in the preliminary scumble on the patch that shows below the bowl of the *compotier*. The tapering strip of curtain above was originally a blue-grey, which related it to the shadow on the *compotier*. It was reworked in thick jabs of yellowish white to match the transparent paint below, and so discovered a subtler agreement with the patch of reflected light inside the bowl, which has hardly any colour; the priming is barely washed over by the paint. (Among the characteristic qualities that appear for the first time is Matisse's tender respect for the surface, its flatness and grain.) Further, the yellows are linked with the source of light, the pale greenish yellow of the garden outside, seen to the right at the top of the picture. At the other end of the scale the yellows deepen into the enigmatic yet unarguable discs of orange, which are both the local colour of the fruit and the reflected light upon them, and on the opposite side of the picture the orange is reinforced by the complementary tints of blue that are made to surround it, a blue which itself develops into the colour of the pitcher. The final correspondence, embracing light and material, links the deep colour of the pitcher with the green outside.

The upper strip of curtain never quite agreed with the patch of curtain below (opaque paint never does match transparent) but the attempt conveys the meaning. This pattern of correspondences was new and urgent; as usual with Matisse there is a hint of impatience. The radiance that appeared in *Le compotier et la cruche de verre* is now familiar and recognizably characteristic of its painter; it is hard to realize how strange it must have appeared in 1899. Matisse himself could not pursue for some ten years the possibility that opened before him; indeed he did not realize it fully until the last years of his life. The audacity of transpositions like that which made a table-cloth pink at one point and blue at another was not by the standards of the time extreme; what was unparalleled was that it took place not at the behest of a transcendental pattern but in the normal course of unstylized representation. The picture was in fact a little more ingenious than it appears. Not only was the setting simplified to the point of invention, it seems that in reality the table-cloth never existed. In the original group the objects stood on a polished wood buffet with diagonally cut corners of a common *dix-huitième* shape; it was the line of the corner that suggested the slanting fold of a table-cloth in the paraphrase. A cloth gave more plausibility to the transpositions of hue that Matisse's purpose called for.

The plan, so far as he had one, was to liberate the constituent colours from the analytical function of Impressionism and make them into the constituent

areas of a scheme that expressed light more broadly and freely. Eventually he realized that for him the function of colour was not to imitate light but to create it. In this respect too, Matisse's understanding of his own innovation was gradual. He reverted repeatedly during the next ten years to a spotty, impressionistic touch, and for long after he seems to have meditated on the relationship and the opposition between this *vibrato*, as he called it, and the plain simplicity of colour – indeed, between the impulsive directness of pictorial method and the flat serenity that was needed in the result. In *Le compotier et la cruche de verre* the solution was tentative and it was not uniformly successful. The attempt, for example, to identify a correspondence between the crimson pinkness of light on the table corner and the analogous colour in shadow and reflected light behind missed its mark, and not only because the difference of tone was too great to support the equation. The fact is that orange is a special kind of colour. It evokes light and reflected light with a unique directness. Matisse made it his special property, just as Turner took possession of yellow; oranges, which had been rare in painting before, became his chosen subject.

Matisse's art around the turn of the century was in general less resolved. The possibilities of strong colour presented themselves with a desperate, contradictory force. The figurative structure was sometimes near to collapse under the weight of contrasting complementary hues, which the loaded brush heaped upon it. The confrontation of green with pink, which preoccupied Matisse, was superimposed on the delicate tonality of *La Malade* at Toulouse. Back in Paris, the sunlit patterns of little street scenes were outlined in violet. Looking westward from the window of his studio to paint *Pont St Michel* he abandoned the grey tone and the precise touch with which he had painted the view before. The version now in the Buhrle Collection had derived its stippled descriptive style from Pissarro. It was perhaps in the autumn of 1900 that Matisse returned to the motif with the new fullness of colour. A version of the subject that later belonged to Michael and Sarah Stein set orange trees against an emerald sky; the result was busy and congested. In another canvas (incomplete and still in the family collection) the scene was treated with the same inspired combination of tentativeness and freedom as the *Le compotier et la cruche de verre*. Patches of yellow and orange-pink were separated from violet and turquoise by scarlet contour and by the deep blue of river and sky. The touch remained Impressionistic and descriptive, rendering above all the evening light. Matisse had not yet finished with the prosaic incidents of the scene and in the version in the Burden Collection the detail was gathered into the fat bunches of a pattern that had affinities with Bonnard. The actual light and shadow of a certain time of day, with the sun a little higher, was still recorded.

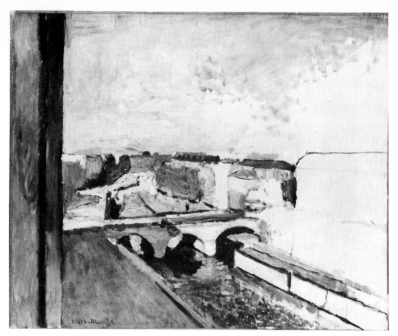

15 *Pont St Michel* 1900

16 *La Seine* 1900–01

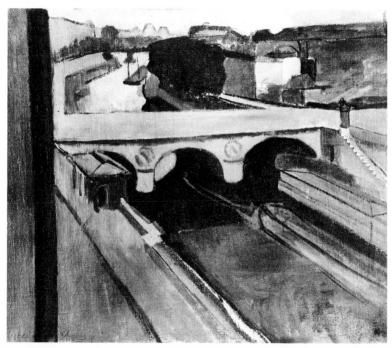

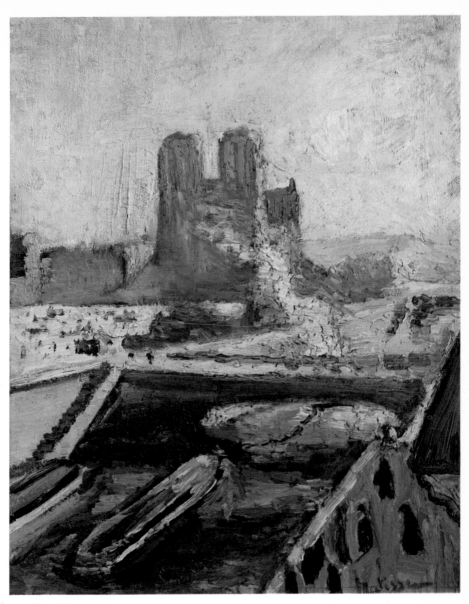

17 *Notre-Dame* 1900

It was *Pont St Michel* now in the Ludington Collection, perhaps the last of the series, that took the decisive step. The brilliance and the detail were resolved into a schematic design of violet and jade-green; the only light was the inherent light generated by the colour. The element of disorder and chance which is inseparable from Impressionism had almost vanished; Matisse was confirming the insight of Gustave Moreau, who had told him that he was destined to simplify painting. In a whole series of more or less summary and impulsive sketches he made impatient cascades of pink and green brush strokes metaphorically evoke the light on the towers of Notre-Dame. His palette and his touch at the turn of the century had something in common with painters like Bonnard and Vuillard who had taken their starting-point from Gauguin and the Café Volpini exhibition ten years earlier. Gauguin himself was reflected in the primitive-looking *cloisonnism* of some of the still-lifes of the next few years – it was the barbaric aspect of Matisse that appealed to Russian collectors. Another still-life, of sunflowers, can hardly have been independent of Van Gogh.

The sources for Fauvism were in fact already complete in 1900. Bonnard and Vuillard, neither of them much older than Matisse, had more assurance and far more solid achievement to show. Gustave Moreau was dead and the antipathies that his students had shared were evaporating. The old divisions were closing; in 1899 Signac planned an exhibition that was to include with the Neo-Impressionist group, the Symbolists and 'a few of Moreau's pupils', Matisse surely among them. Marquet, Matisse's oldest friend and his close companion in these years, was evidently impressed by Vuillard's lithographs; in Matisse's art the dappling of colour had a suggestion of Bonnard and there appeared behind him, in the self-portrait painted in 1900, which epitomized his worried, dogged mood, a chequered floor that introduced a type of pattern new to his art. Sometimes in later years, in a chessboard or a patch of shimmering foliage, the reminiscence recurs and at a crucial moment a suggestion from Vuillard was helpful. The essential innovations both of Vuillard and of Bonnard were already virtually complete while that of Matisse had hardly begun. In style his pictures were various and discrepant; they had in common only their odd recklessness, a quality that seemed at odds with the refined conventions on which they were founded. This was the first glimpse of an element in Matisse's artistic constitution that reappeared at the turning-points in his development. These pictures had already more of the boldness of modern painting, more of its compulsive and unplanned response to requirements inherent in the picture than almost anything that his contemporaries had painted.

Late in his life he described the frame of mind in which the impetus had come to him. 'Although I knew that I had found my true path . . . there was

30

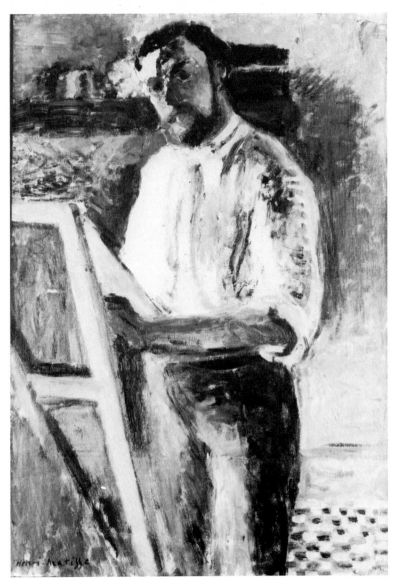

18 *Portrait de l'artiste* 1900

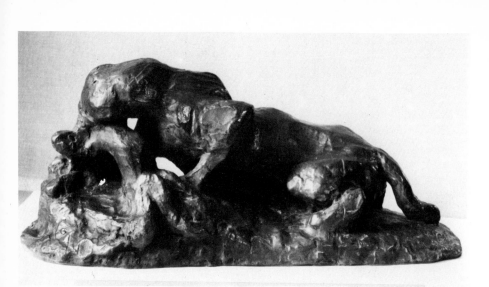

19 *Jaguar dévorant un lièvre – d'après Barye; Le tigre* 1899–1901

something frightening in feeling so certain and knowing that there was no turning back. I just had to charge forward head down. People had always been badgering me to hurry. Now I heard them as if for the first time, urged on by I do not know what – some force that I see today is quite alien to me in my everyday life.'

Matisse's beginnings left him with a sense that the colour and the substance of nineteenth-century painting were real and credible, a sense that the painters who were born a year or two later than he did not share. His adaptation of Impressionism, though strangely impulsive and crude, showed none of the ironic estrangement of Picasso's essays in the style of the *fin de siècle*. For Matisse there was a simple, natural value in pure colour. Looking back many years later, he described how he learned it from outside the European tradition. 'What a pleasure it was to discover Japanese prints! Colour has its own existence; it possesses a beauty of its own. It was the Japanese prints that revealed this to us. Then I understood that one can work with expressive colours that are not necessarily descriptive colours.'

The virtue of the discovery owed nothing to novelty. Japanese prints had influenced successive developments in French painting for more than forty years, since Manet painted Zola's portrait. They had been a chief source of

the rhythms of the *fin de siècle* and the dappled patterning of Matisse's older contemporaries contained an obvious element of *japonisme*. Matisse came to Japanese prints, as he came to everything, late but seriously. There is no sign of the decorative orientalism that was common in the nineties; one could hardly guess that the transition from descriptive to expressive colour in a picture like *Le compotier et la cruche de verre* owed anything to the Japanese example. 14

In 1900 Matisse seemed to be debarred from the facility that was in the air. The eclectic brilliance of Derain, which was often near to outright pastiche of one or another of the Post-Impressionist styles, and the violence of Vlaminck, his colleagues in the next few years, were both as foreign to him as was the airy lightness with which Braque reflected their influence later. Matisse and Derain had studied together in 1899; two years later Derain introduced Matisse to Vlaminck, with whom he was working, but Matisse was never much in sympathy with the young man whom his son-in-law described as 'the jealous, independent flash in the pan from Chatou'. While the younger men continued from the point that Matisse had reached, Matisse himself hesitated. For him progress was always laborious. Lack of support and hardship deterred him; he was a prey to obsessional anxiety and there was reason for it now. He had three children; in 1900 he was painting exhibition decorations by the metre for a living and during the following years he was often unable to keep his family together.

Moreover, he regarded his apprenticeship as still unfinished. He would hurry from his hack work to night school to model a jaguar after a 19 bronze by Barye. The study was obsessionally rigorous; the months that he devoted to it turned into years and before he could finish it he had to borrow a dissected cat from a medical student to examine the articulation of the spine and the tail. He explained that his object was 'to identify himself with the passion of the beast, expressed in the rhythm of the volumes'. He was evidently confident that the passion could be studied as objectively and by the same methods as other constituents of art had traditionally been studied. The idea seems incongruous but it was typical of him.

Matisse was still looking for a way out of conventions that had long ago ceased to govern the *avant garde*. The assumption that guided him was itself oddly conventional; he regarded art as composed of separable ingredients on which he could concentrate in turn. 'I studied the ingredients of painting separately – drawing, colour, tone, composition – to explore how they could be combined without diminishing the eloquence of any of them. . . .' Matisse studied everything and he worked from morning to night all his life to ensure that the apparent spontaneity of the result should be thoroughly rehearsed. His application was exemplary; as his son-in-law wrote, the only

33

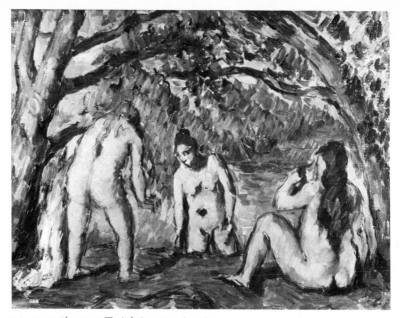

20 PAUL CÉZANNE: *Trois baigneuses* 1879–82

flaw was 'his inability to relax, his killing labour, his absolute incapacity, if
only for the space of a tear or a smile, to sit down with his neighbour.' In
1900 Matisse was rehearsing self-identification with the expression of
animal-like passion. The animal quality, the natural force of impulse, had a
special value to him and he cultivated it. The nickname *Les Fauves*, the wild
beasts, which his circle was given five years later when the full force of his
originality burst on the public, though a little puzzling was not at all
unwelcome to him.

The clarity and freedom that appeared in *Le compotier et la cruche de verre* in
fact demanded a sacrifice for which Matisse was by no means ready. They
required him to abandon the realistic substance of nineteenth-century art and
allow the traditional grasp on nature to slip. Only Cézanne had achieved
clarity and force without loosening this grasp and in his dilemma Matisse
turned to him; Pissarro's final service to Matisse was to introduce him to
Cézanne's heroic example. Whenever in Matisse's later work the body takes
on a monumental grandeur, one can deduce the presence of Cézanne's *Trois
baigneuses* which he bought in 1899 and kept for more than thirty-five years
until he gave it to the City of Paris for the Petit-Palais (apparently to spite the
State). The simplified mass of the backs in the Cézanne, emphasized by

20

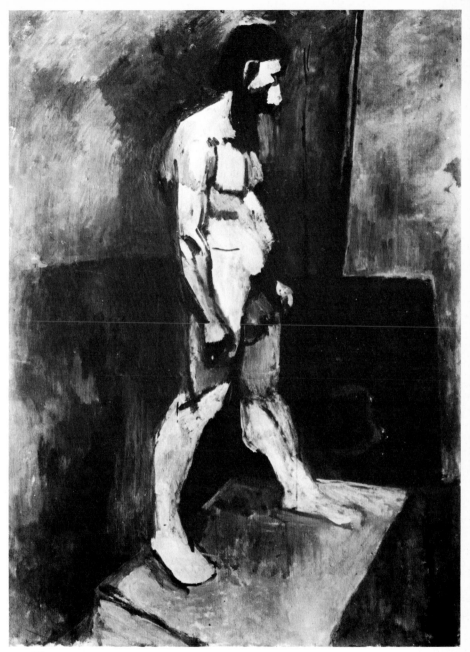

21 *L'homme nu* 1900

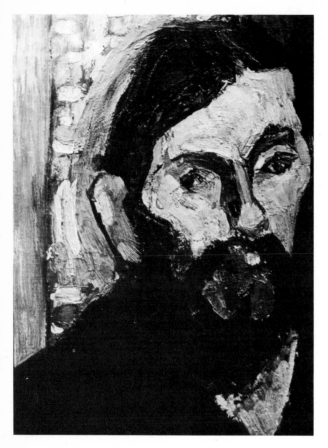

22 *Portrait de Bevilaqua c.*
1900–02

64, 66–9 hanging hair, recurred in his own reliefs of *Le dos* (1909–29) as well as in his decorations. The customary equilibrium of his designs held suspended a ponderous physical imbalance, as Cézanne's did. But the structural and dynamic purpose was only one element in Matisse's artistic constitution. The Cézanne that he bought was one of the slighter and more diffuse compositions and Matisse's paintings of a male model in 1900, which were directly modelled on Cézanne, are quite isolated in his work. There is an 21 unaccustomed energy in *Homme nu* which affects both the aggressive masculinity of the figure and the assertive pictorial statement. The model had been a favourite with Rodin, to whom Matisse applied for lessons. The

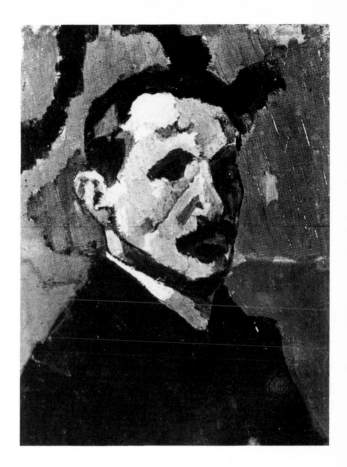

23　*Portrait de Marquet c.*
1900–02

pose that he painted and modelled, again over a period of years, owes something to Rodin's striding figures, but in his hands they lose their springy step. The tribute to the substantial and energetic qualities of nineteenth-century art is plain but the forceful handling does not quite achieve its aim. Looking at the head, for example, one remains unsure whether the boldly stated wedge of paint constitutes a big nose or a small chin; at root the statement is primarily concerned with its own positiveness.

Matisse's interest in portraiture seems at this time to have rested on an absorption in the bodily image. It is odd that one painter should have experimented within a short time, as Matisse did in the first year or two of

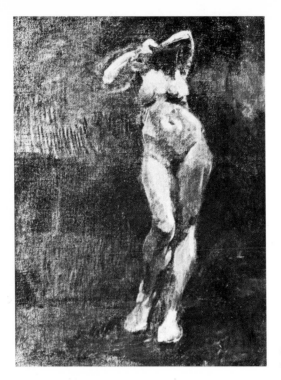

24 *Nu debout, académie bleue* 1901

22, 23 the century, with styles as different as those of the portraits of Bevilaqua and Marquet. The uncouth Bevilaqua, whose expression seemed to carry the instinctual force associated with, and eventually repellent in Rodin, was seen with a quite Dostoevskian intensity. The conception of Marquet by contrast showed the Cézannian style at its most finished and compact. It was with Marquet in 1901 that Matisse painted in the Luxembourg Gardens shadowed pictures that reflect the mood of oppressive anxiety in these years. The anxiety concerned not only material difficulties but the problematic prospects for traditional painting.

 The female nude presented an analogous problem. The dazzlingly

24 forceful chromatic modelling of the *Nu debout, académie bleue*, which Matisse dated in 1901, agrees with the exaggerated sexuality of the body and the ecstatic pose, with hands clasped to the head like Rodin's *Eve*, but it disagrees with the delicate domestic and tonal consistency with which the painter was

25 at ease. The alternative solution, in the *Académie bleue* in the Tate Gallery, replaces the sensual challenge with a coyly mannered grace. The

38

25 *Académie bleue c.* 1900

accentuation of the rhythm at the expense of specific definition in the modelled version, *Madeleine I*, suggests that Matisse may have had an actual Mannerist prototype, perhaps a bronze by Giovanni da Bologna, as well as his model, at the back of his mind. It was always in doubt whether the freedom that Matisse required to make life exquisite was to be an attenuation, even an extinction, of its human nature.

Sculpture enabled Matisse to deal directly, though never easily, with this issue. Form and the physical substance of art were both of them precious to him. Modelling, he was able to test how much of them could be retained and in what shape. The fulfilment that he sought in painting eventually required him to relinquish not only the figurative virility that had culminated in Cézanne but the traditional naturalness of the subject. He did not let them go willingly; he more than once reverted to a descriptive manner that was like the decorative husk of Cézanne's style. The transmutation that Matisse achieved was a real sublimation, but the change in the physical status of imagery amounted to a kind of mutilation. When the sculpture of Bevilaqua

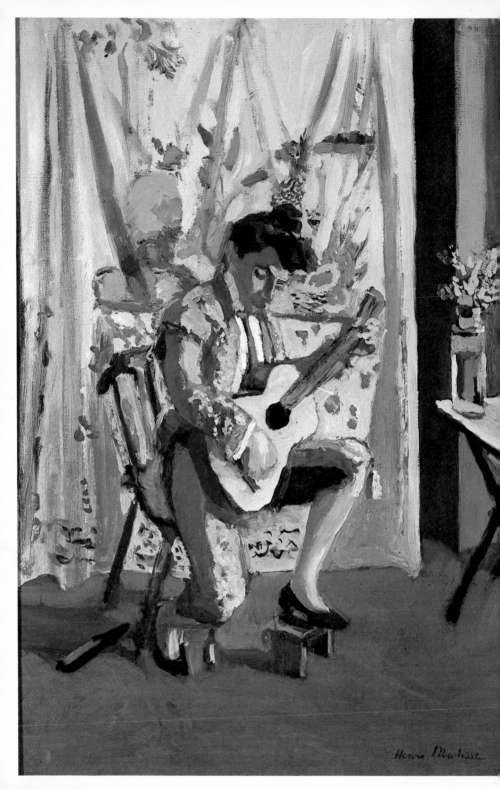

Henri Matisse

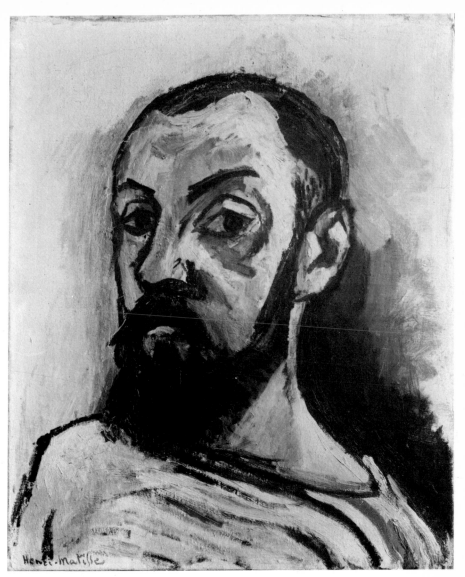

27 *Portrait de l'artiste* 1906

26 *La guitariste* 1903

28 was cast it was deprived of its arms and labelled *Le serf*. There was indeed an element like heroic servitude in Matisse's dedication to an ideal of the
27 progressive disembodiment of an image. A self-portrait that he painted in 1906 during the triumph of Fauvism showed a powerful head, descended from Cézanne's vision of the artist, but mounted on shoulders that were by contrast dwarfish and misshapen; the artist's body was bound like a captive by the decorative stripes of his shirt. Representation in the *rubéniste* tradition was both an expression and a portrayal of bodily power, and both were
21 excluded by Matisse's aim. The physicality of *Homme nu*, marked by the gross extremities, prehensile hands and pendulous organ, was in the context of Matisse's art grotesque. It was exchanged by stages for the ethereal Moroccan subjects of ten years later, in which one hardly notices that the limp golden-brown strips in an expanse of emerald green stand for the limbs
91 of a real man. The innocent piper in *La musique* (1910) with his rudimentary member (which was painted out by Shchukin, the Moscow collector) personified what was at the time felt to be an outlandish infantilism in Matisse's conjunctions of primitive colour. The criticism hurt; he gave one hostile interviewer a message: 'Oh, do tell the American people

28 *Le serf* 1900–03

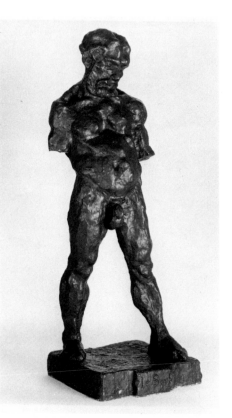

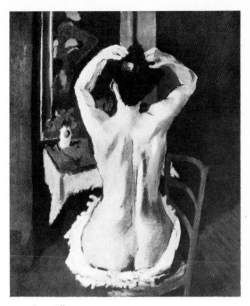

29 *Carmelina* 1903 30 *La coiffure* 1901

that I am a normal man, that I am a devoted husband and father, that I have three fine children . . .'.

Unlike Vlaminck, who thought visiting the Louvre sapped one's strength, Matisse was well aware of what the tradition of tonal structure and the substantial modelling that went with it had to offer. Nudes like *Carmelina* 29 and *La coiffure* were rigorously studied from life and robustly modelled in 30 deep tone. Their force was wholly traditional. Technically Matisse was consolidating his ground and he was pondering the discoveries of a decade.

In effect, for two or three years after 1900, Matisse's aim was limited to giving the utmost surface richness to the traditional Post-Impressionist conception of painting. Madame Matisse was dressed up in bull-fighter's costume for *La guitariste* in 1903, but under the glittering, apparently 26 spontaneous embroidery of golden colour (which was in fact characteristically laborious), the picture took its place in a familiar Impressionist tradition; it was indeed posed rather similarly to a picture that Pissarro had painted of his wife sewing a few years before. The Spanish disguise itself had more than once fostered the development of colour in French painting. So had oriental patterning like that in which Matisse embedded a similar figure

31 *Luxe, calme et
volupté* 1904–05

32 *Femme à l'ombrelle*
1905

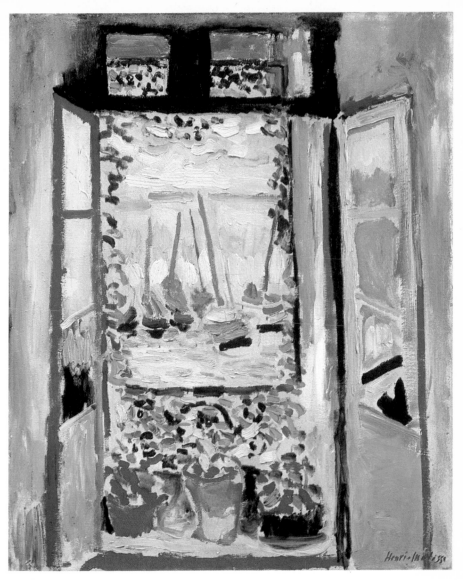

33 *La fenêtre ouverte* 1905

34　*La terrasse* 1904

35　*Vue de St Tropez*
1904

34　　when he painted *La terrasse* at St Tropez in the next year. The new pattern
owed something to his experience of Islamic art at an exhibition in the
Pavillon de Marsan.

Islamic art completed the artistic resources that sustained Matisse for the
next ten years and essentially for the rest of his life. All the material that he
needed, the whole repertoire of suggestions and possibilities, was now in his
hands. But Matisse possessed, as the counterpart of his recurrent boldness, an
almost equally persistent streak of caution. It was a part of his strength; he
never moved until the way ahead was clear. All his life his development
proceeded by alternate forward steps and pauses. When the time came for
each step he was entirely convinced of its rightness and beauty, and ready to
hold forth on the subject – almost too ready for some of his friends.

When Matisse went to the South in 1904 he still had Cézanne in mind. The
influence which prompted his next step was not a new one; he had already
been affected by Neo-Impressionism once. But this time the influence was
supplied by the dominating proximity of Signac himself, his neighbour at St
Tropez, and it went deeper. A deliberate, methodical system had a special
virtue to 'the anxious, madly anxious Matisse', as Cross, who lived a little

46

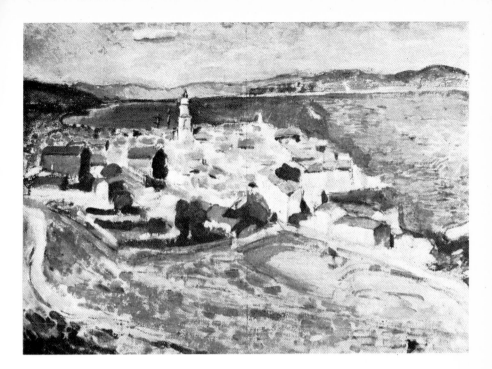

distance away and watched the process of conversion, described him. Moreover the deliberately placed lozenges of paint isolated two elemental ingredients of painting – the effect of one pure colour on another·and the energy inherent in a brush stroke.

Matisse absorbed the influence slowly. The full effect of Signac's example did not appear until after he had left St Tropez. The landscapes that he painted there, among them a jewel-like view of the town (*Vue de St Tropez*) 35 which is now in the museum at Bagnols, show a delicate clarity but only the very beginnings of his adoption of the Neo-Impressionist analysis. But while he was there he painted a study, still by no means consistent in method, for a figure composition, *Luxe, calme et volupté*, to be executed according to 31 divisionist doctrine – the first of his pictures that could not of its nature be studied from life.

Back in Paris he made Neo-Impressionism his own by using the style to paint from life; life-painting was his invariable recourse when anything challenged his power to assimilate it. Painting with Marquet, each artist seems to have portrayed not only the model but the other painter across the room. But if Matisse's version is compared with Marquet's, his departure

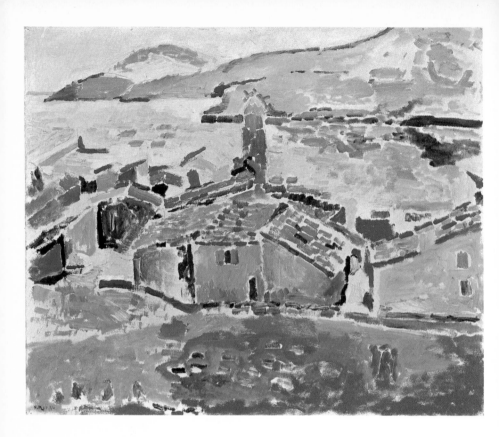

36 *Les toits de Collioure* 1906

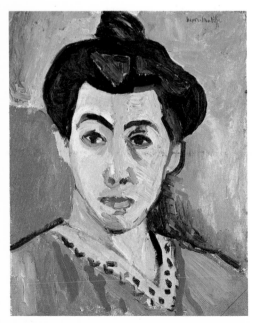

37 *Portrait de Madame Matisse* 1905

from the visual canon of representation which Impressionism inherited from the Renaissance tradition, is seen to be considerable. Christopher Rawlence has pointed out that the receding planes are tilted as if seen from a higher viewpoint to make a pattern on the picture surface; the perspective diminution and convergence are flattened to form areas in which colour can tell for its own sake. Marquet's record of the event makes it clear that Matisse's pattern was not seen, so much as imagined, or reconstructed on Japanese lines. He made versions of his St Tropez pictures that were completely in the new style. In style *Luxe, calme et volupté*, with its 31 complementary haloes, followed Signac and Cross; in design it had affinities with Symbolism and reminiscences of the earlier bathers of Cézanne. But it also contained something of Matisse's own that was independent of all of them. The couplet from Baudelaire's 'L'Invitation au voyage', from which he took his title, was like a motto:

> *Là tout n'est qu'ordre et beauté*
> *Luxe, calme et volupté.*

Matisse had discovered within the Post-Impressionist apparatus, which had been devised to deal directly with the world, the possibility of quite a different and opposite purpose. The pictorial means themselves held qualities of tranquil profusion and delight. They offered an escape.

Signac was delighted with *Luxe, calme et volupté* and bought it. Despite a certain awkwardness, indeed perhaps partly because of it, the style evidently suited Matisse for the moment. When he went to Collioure in 1905 he was still using it in its most elementary and artificial form. The sophisticated manner was followed, as if naïvely, for its own sake, so that the Impressionist illusion dissolved and only the visual elements were left. His Neo-Impressionist studies, despite the complex notation, had already a suggestion of his later simplifications. They even foreshadowed a quality in his observation akin to wit. Life around the port of Abail or Madame Matisse 38 with her sunshade (*Femme à l'ombrelle*) took on a doll-like unreality. 32

But the Indian summer of Neo-Impressionism was over. It had served its purpose; the intrinsic qualities of painting which it laid bare meant far more to Matisse than the system. In the works that followed, the orderliness and the restraint of Neo-Impressionism both vanished.

The stimulus of pure colour provoked another headlong rush, apparently as impetuous as the first. The pictures exhibited at the Salon d'Automne in 1905, including *La femme au chapeau* and *La fenêtre*, which earned Matisse and 33 his friends the name of 'wild beasts', had the appearance of recklessness both in colour and in the brush that applied it. Objects regained specific, positive colours, of which Neo-Impressionism had deprived them, but the colours

38 *Port d'Abail, Collioure* 1905

were now remote from any conventional code for the colours of nature. Taking the primary hues of Signac, adding a brick-red from Gauguin and a cyclamen-pink like nothing else in painting, Matisse proceeded not to imitate natural colour or analyse it, but rather to transpose it. His transposition, if not in truth very savage, must have seemed gratuitously capricious, directed only by a dissatisfaction like Baudelaire's that nature had no imagination. At Collioure in 1905 the meadows were indeed dyed red, as Baudelaire had wished, and the transformation remains one of the imaginative leaps of modern art. But it was by no means arbitrary; it was directed by a very positive purpose.

The odd and unusual colour scheme that had recurred from time to time in earlier works now came to dominate his palette; the new pictures revolved around the poles of red and green. The polarity set them apart from the characteristic schemes of painting under the sign of Impressionism, schemes that were aligned with the poles of yellow and violet or orange and blue, the oppositions that carry the illusion of light and shadow and the implication of atmosphere and space. The combination of red and green offers precisely the reverse. It denies depth; it insists on the painted surface. The pictures painted in the summer of 1905 were above all pictures of red and green, and pictures of the elation of escape from the naturalistic spectrum. The light in these pictures is of another kind. Where red and green meet something happens; there is a continuous, fluorescent palpitation as between no other colours. It may be that the eye detects along the margin the possibility of the additive mixture that forms yellow, an effect more real and more surprising than anything in Neo-Impressionist theory. At all events, the extremity of the contrast in hue between equivalent tones sets up a dazzling vibration.

It is such vibrations that give light to pictures like *La fenêtre*. Matisse was now dealing with colour in itself. The contrasts of tone that had given light to his earlier pictures were abandoned. Impressionist tonality was defied; the indoor colour was now no darker than the view outside and the window motif took on the paradoxical magic that occupied him at intervals for the rest of his life. The navy-blue transom over *La fenêtre* was both the end of tonal realism and the first of the abrupt, arbitrary-seeming dark accents, later most often a vibrant black, which give the other colours in a picture by contrast a common radiance like reflected light.

Painting outdoors at Collioure, Matisse transposed colour with just the same delicate boldness. (Derain, working by his side, had boldness alone.) Matisse arranged around the red-green axis a whole series of new oppositions, jade against violet, turquoise against lilac. The views over Collioure all revolve around the church tower. In one of them, comparatively straight, which Matisse gave to Edward Steichen, the yellow-orange tower is haloed with turquoise in an ultramarine-blue sky. The redness of the tower makes the sky greener by contrast – the reaction appears to be calculated on Neo-Impressionist principles. In the Leningrad picture, *Les toits de Collioure,* the distinction becomes apparent. The interaction no <!--36--> longer refers to any sensations but those of paint and the picture.

Fauvism ended a whole epoch of subtle confusion, at root, perhaps, a semantic confusion, springing from ideas like Mallarmé's – to paint not the object but the effect it produces. If the effect of nature had been the aim, why not have painted the object and let it produce its own? If indeed that was ever the aim, it was so no longer. Painting did not depend on the dwindling effects of effects; it could generate its own lively brightness. The whole of Matisse's later practice was, in a sense, an extension of the discovery of 1905. When he came to teach, he distinguished two opposite methods – 'one considering colour as warm and cool' in the Impressionist manner, 'the other seeking light through the opposition of colours'. The latter was his way, and he pursued it almost without interruption for the rest of his life, placing colour against colour and revealing an inherent light in the interval and the interplay between them.

Fauvism was the best prepared of all the twentieth-century revolutions. The possibility had been in the air for years; the whole of modern painting pointed towards an art made solely out of colour. The example of Gauguin in particular encouraged the abandonment of what Matisse called 'imitative colour' and showed what could be done with red and green. Gauguin's ideas had pervaded the thought of a whole generation. It was hardly possible to take the intensification of perceived colour as a principle of art without sharing in some degree an attitude that was due ultimately to him. Later

Matisse taught his own principles, rather than his practice, to his students: '. . . Just look at an object. "But this brass is yellow." Frankly put a yellow ochre . . . and start out from there. . . .' His words were an involuntary echo of Gauguin's famous lesson to Sérusier: 'How do you see these trees? They are yellow. Very well, put some yellow. This bluish shadow? Do not be afraid of painting it as blue as possible with pure ultramarine.'

The presence of Derain, ten years younger and painting with a fire reminiscent of Van Gogh, stimulated Matisse and unsettled him; Neo-Impressionism was the style of the middle aged. That was part of its virtue; it agreed with the strain of persistence and perseverance in Matisse's nature. The disintegration of linear continuity had in itself a certain value. The alternative way with pure colour, the curling strips of paint echoing and reiterating contours with which Derain imitated the restless exaltation of Van Gogh, had no place in the idyllic economy that Matisse sought in painting. He experimented with this kind of line only once, in a large woodcut that is exceptional in his work, when he was evolving his own relaxed style of arabesque in 1906. In 1905 he confined himself to tracing the curling patterns of Madame Matisse's kimono in snaking emerald and cyclamen-pink in *La Japonaise au bord de l'eau*. Brush strokes that render the potted plants are not descriptive as Derain's brush is – they wriggle with a vitality that is inherent in the meeting of colours.

Matisse's eventual adaptation of the pointillist lozenges of paint to his own descriptive purpose owed something to Vuillard, who had passed through the same phase. 'At Collioure', he told Pierre Courthion long afterwards, 'I started from an idea that I had heard expressed by Vuillard, who used the phrase "the defining touch" . . . this helped me.' One can imagine that the words were of more use than anything in Vuillard's practice. Matisse needed a principle that allowed him, as orthodox divisionism did not, to exchange on impulse the systematic spot which described nothing but a conjunction of hues for brush work that made offhand approximations to actual things. Sometimes the brush strokes, now squarer and looser, themselves made the detail. Elongated into dashes they made the tiles at Collioure and forming a multicoloured row of parallelograms they constituted distant roofs against the sea. To the left of the tower in *Les toits de Collioure* a roof appears to be identifiable as pale yellow, making the sea pale blue around it. At another glance it is seen to be part of a series comprising (in clockwise order) lime-green, jade-green, scarlet and an orange-brown strip, all revolving round a cyclamen-pink patch in a quite independent kind of dance.

At other times the description took on a makeshift literalness that was rather childlike than savage. 'I saw', he wrote in retrospect, 'that the creating mind should preserve a kind of virgin innocence toward the material of its

36

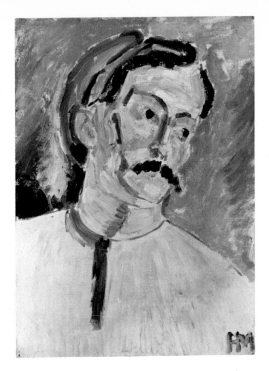

39 *André Derain* 1905

choice and reject anything dictated by reasoning.' Often the rejection of structure had a purpose with an intelligible urgency behind it. No time was lost in constructing the sandy-red panels of a *porte-fenêtre* when the object was the precise jade-green reflected in its panes; why study an ochre chairback if its only function was to frame bright clear patches of blue? By the standards that all French painters, and Matisse among them, had observed before, this extemporization was extraordinarily primitive and free. Nevertheless it achieved a definition that was consistent and complete. It defined an extravagant interplay of colours with a naturalness that made any other content or purpose in painting seem, for the moment, irrelevant.

The precedent that Matisse studied most closely and the one that fortified him best was undoubtedly his own. 'I found myself or my artistic personality', he told Apollinaire, 'by considering my early works. I discovered in them something constant which I took at first for monotonous repetition. It was the sign of my personality, which came out the same no matter what different moods I had passed through.' The self-regarding habit, indeed the engrossment in himself that the words betray was characteristic; it was a vital part of his equipment. It led him to a frank acceptance of the painter as the single significant source of his painting, and the recognition

53

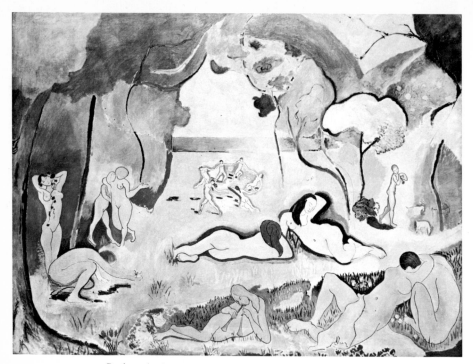

40 *Bonheur de vivre* 1905–06

that his pictures record more about him than he knows. Matisse, who was almost oblivious of how he appeared to others, was nonetheless an earnest student of himself. He gave some of the first and clearest descriptions of the reflexive realism of modern art. It was the pictures of five and more years earlier that gave the clue to the way ahead in 1905. They taught him not only boldness but a confidence that the kind of painting that was natural to him was based on oppositions of pure colour. The same inveterate study of himself showed him what had gone wrong the time before. Painting that was marked by agitated brilliance belied the *calme* that was essential to him. The self-abandonment was dangerous. Moreover, a style that was based on oppositions of colour required that the oppositions should be planned and clearly mapped out on the picture surface.

The freedom of the Fauve style, in which accents of red and green were scattered rapturously across the canvas, was never lost. Two famous portraits of his wife showed the way Matisse was moving. In the first, *Mme Matisse avec chapeau*, green passed elusively around and between the patches of

54

scarlet, orange and violet that denoted the model. In the second (now in Copenhagen), *Mme Matisse à la raie verte*, the green was fixed and identified as a stripe of shadow between the pinkness of light and an ochre reflection. The conclusiveness of the formulation was influential. When he turned again to the Arcadian mood of *Luxe, calme et volupté*, which epitomized what he most needed from art, the impulsive spontaneity of his reaction to painting from nature was married to a deliberation of design that was new to him. The force of the reaction now outdid Derain. *Bonheur de vivre*, which he showed at the Salon des Indépendants in 1906, was the turning-point in a struggle, which continued nearly all his life, swaying first one way then the other, the struggle (as he wrote long after) with the viewpoint 'current at the time I first began to paint, when it was permissible only to render observations made from nature'. It was a struggle with a part of himself. The shortcomings of Impressionism had been the subject of advance guard discussion for twenty years, but with Matisse the criticism took a special personal turn. The properties of light and colour were more precious to him than to any other painter, yet he had a peculiar awareness of the dangers that beset them. There was an ever-present threat that the effect would prove transitory. The attempt 'to register fleeting impressions' was obviously vulnerable, but Matisse's training had left him with a conviction that the process of conception had to pass through this analytical phase. The opposite method, the invented synthesis, was equally in danger. 'When the synthesis is immediate, it is premature, without substance, and the impoverished expression comes to an insignificant conclusion, ephemeral and momentary.'

1906–1908 An ideal world

Matisse's whole development was a search for the kind of light that could be depended on to last. This was the preoccupation that had given Cézanne a special significance to him. He understood Cézanne earlier and better than any of his contemporaries, but his own standpoint was different and he had a talent for distinguishing between an example and a pattern. His attention was concentrated not only on achieving something durable like the art of the museums, but even more on the attainment of a continuous, undisturbed condition – as if the primary object were an inward bliss which almost anything outside himself might interrupt. There was an obsessive concern with continuity in itself. 'One can judge the vitality and power of an artist', he wrote, 'when . . . he is able to organize his sensations to return in the same mood on different days.' Light changes, and with it one's impressions; obviously art could not depend on them. Yet for Matisse, in one sense or another, it always did depend on them. He needed light to see the picture and one kind of impression was indispensable, his impressions of his own painting. In old age, when a radio interviewer asked why the Midi held him, he answered: 'Because in order to paint my pictures I need to stay for a number of days under the same impressions. . . .' Divisionism and Fauvism both inherited the empirical outlook of the nineteenth century and both depended on transitory sensations and the evanescent brush mark. The very immediacy of the effect was disturbing: 'I want', he wrote 'to reach that condensation of sensations which constitutes a picture.' For him painting existed apart, in a region of ideal detachment.

40 He had tried to paint this region before in *Luxe, calme et volupté*. He portrayed it again with complete success in *Bonheur de vivre*. The title forms another of Matisse's mottoes and an appropriate one; he looked to art for the undisturbed, ideal bliss of living. All the materials of the picture – the conventional Arcadia, the juxtapositions of colour, which were developed from his sketches, and the accented contour – came in one way or another out of earlier art. The rhythmic drawing was a new development; Matisse once remarked that he preferred Ingres's *Odalisque* to Manet's *Olympia* because 'the sensual and deliberately determined line of Ingres seemed to

conform better to the needs of the painting'. Ingres's *Bain turc*, painted fifty years earlier, had been shown at the Salon d'Automne in 1905, but the influence, like everything else in *Bonheur de vivre*, was transformed. The consistency of the picture was indeed deliberately determined; it reflected a new idea of the needs of painting.

In front rose-pink lovers lie against deep blue-grey and purple grass. Beyond them the same combination of pink and blue outlines the reclining women in a long arabesque. In the distance, dusky pink melts out of the sky across the blue-grey sea. The radiance is concentrated in the centre of the lemon-yellow ground. Under the trees it turns into scarlet and orange; emerald-green curls through them, making the stem of a tree on one side, foliage on the other. Each colour is sinuously outlined not against its complementary, but rather against an amicable counterpart in a refined and consistent colour system of Matisse's own. There is an air of resplendent artifice and a delicate yet extravagant disproportion. 'Observations made from nature' are forgotten. The new condition of painting was quiet and detached; it was *cool*, in a way that empirical and impulsive painting could never be. It was devised deliberately with much labour. Discussing the picture Matisse explained why: 'I painted it in plain flat colours because I wanted to base the quality of the picture on a harmony of all the colours in their plainness. I tried to replace the vibrato with a more responsive, more direct harmony, simple and frank enough to provide me with a restful surface.'

All his earlier work had in fact been found wanting; it lacked the quality that Matisse most needed from art. 'There was a time', he wrote later, and he may have been thinking of the turn of the century, 'when I never left my paintings hanging on the wall, because they reminded me of moments of nervous excitement and I did not care to see them again when I was quiet.' The need for harmonious quietness preoccupied him continually. Matisse once explained his tendency to simplify: 'It is only that I tend towards what I feel; towards a kind of ecstasy . . . and then I find tranquillity.' It may be that all painting is intended, among other things, to present some ideal state. But the quietness that Matisse sought – the plain colour and the 'restful surface' – had evidently a special significance to him. His ideal not only excluded what was momentary or potentially transitory; it avoided equally anything that was energetic. The ideal of art as expression, which had guided him since his days with Moreau, had to be redefined. Eventually expression was found to be 'one and the same thing as decoration'.

Anything disquieting was unwelcome. Behind the attitude to art there was an acute intolerance of whatever was in any way disturbing or oppressive, and not in art only. He sought in art, and in life as well, hermetic

conditions of private self-preservation. When he tried, with his usual candour, to describe them, he arrived at a definition which seems at first sight extraordinarily inert and self-protective: 'What I dream of is an art of balance, of purity and serenity devoid of troubling or disturbing subject-matter . . . like a comforting influence, a mental balm – something like a good armchair in which one rests from physical fatigue.'

It was not unusual to require from art a solace and a refuge. Matisse was unique in the realism with which he recognized the need; the resourcefulness with which he pursued it amounted to genius. He demanded of art the expression of an ideal state of being. He did not merely require a representation of a perfect world, although he sought that as well in several different forms. His object was not even directly sensuous. The senses were continuously engaged, but Matisse half-mistrusted them: sensual gratification was itself precarious. Looking at Titian and Veronese, 'those wrongly-termed Renaissance masters . . . I found in them superb fabrics created for the rich . . . of more physical than spiritual value.' In 1929, after ten years at Nice spent in making pictures as sensuously delightful as he could, he concluded that 'one may demand from painting a more profound emotion, and one which touches the spirit as well as the senses.' Looking to the end of the story we can see that at root he was demanding nothing less than the independent, abstract re-creation of ideal conditions of existence – states of visible perfection from which the least possibility of frustration was eliminated.

At first sight the things that Matisse was excluding from painting – the 'moments of nervous excitement', the troubling subjects and the forced expression – seem more real than what remains. At some points in his development the meaning he drew from the world and the meaning he gave to it were wilfully, almost artificially restricted. The satisfaction that he demanded was so extreme that it amounted to changing the role of painting. He made painting fulfil requirements so exigent that when the demands were at last fulfilled to the letter at the behest of the imperious old man in bed, the effect was to alter the place that painting takes in life – to alter our use for it, as Cubism, for example, never altered it. It is the overweening self-absorption of Matisse's dream that achieves this change in painting, and offers it, with all its luminous substance, a new place in the physical world.

Matisse's direction led him to a difficult issue. 'A work of art', he wrote, 'must carry in itself its complete significance and impose it on the beholder even before he can identify the subject-matter.' Yet the luminous substance of nineteenth-century painting, which depended on identifiable sensations, had a special and indispensable meaning to him. The older generation had faced the crisis of Impressionism twenty years earlier; the painters of 1900 confronted the crisis of representation. But Matisse met them both together.

His standpoint was more complex and apparently less decisive than those of his younger contemporaries. The formula that he arrived at had an element of equivocation. 'The painter', he wrote, 'must sincerely believe that he has painted only what he has seen.' He sometimes faltered when the belief was patently at variance with the facts. His basic attitude was as purposeful and as single-minded as anybody's. But he was travelling in the opposite direction to virtually all the other painters of his time. In the end, when the developments of the first half of the twentieth century were complete, it was apparent that while for the other survivors from his generation representation of one kind or another and the basic reference to form had outlasted the luminous substance of painting, with Matisse the reverse had happened. Light had outlasted representation. In considering the apparent inconsistencies of Matisse's development, we have to bear in mind this solitary, epoch-making destination. No one else was travelling the same way. The attitude that Matisse developed was conservative, because it was self-protective. He had something very personal to protect – a quality that for decades together remained inseparable from conventions of figuration that the rest of the *avant garde* had finished with.

After *Bonheur de vivre* the tendency to clarify and simplify received a new impetus. The sympathetic vibrato, which the first Fauve pictures had shared with all the styles that came out of Impressionism, was now superfluous. In the second version of *Marin*, the dappled mutations of green and blue were replaced by flat masses of positive colour flowering out of a plain pink 41, 42

41 *Le jeune marin I* 1907–08 42 *Le jeune marin II* 1907–08

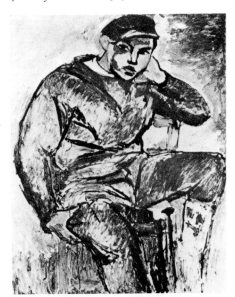

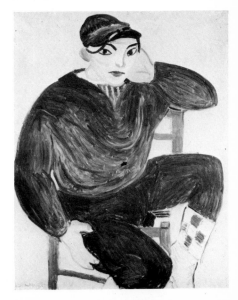

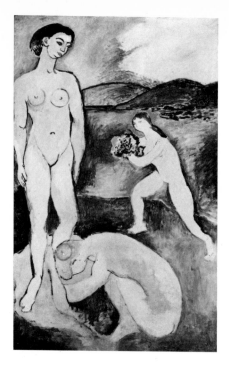

43, 86 background. *Le luxe*, begun in the next year, passed in two versions through similar stages. The year 1906 was the time of the triumph of pink. Picasso was painting pink pictures at Gosol; even Signac was working in pink. It was hardly possible to combine the empirical method with the kind of imaginative synthesis that Matisse was now in search of. While Picasso set about his last pink picture, *Les demoiselles d'Avignon*, which was to change everything, Matisse's problem led him in another direction.

The simplicity that he was in search of was not merely a matter of choice. As he explained to Apollinaire, he felt it the only way open to him: 'When difficulties held up my work, I said to myself: "I have colours and a canvas, and I must express myself with purity even if I do it in the briefest manner by putting down four or five spots of colour or by drawing four or five lines that give plastic expression".' Underneath his discrimination there was something compulsive. *Notes of a Painter*, which he published in 1908, revealed this: 'If I put a black dot on a sheet of white paper the dot will be visible no matter how far I stand away from it – it is a clear notation; but beside this dot I place another one, and then a third. Already there is confusion . . .'. He had an acute sensitivity to the slightest hint of the

disquieting confusion that was felt to threaten a picture; with every additional brush mark the threat grew closer. The only escape from it was through boldness. '. . . In order that the first dot may maintain its value I must enlarge it as I continue putting other marks on the paper. If upon a white canvas I jot down sensations of blue, of green, of red – every new brush stroke diminishes the importance of the preceding ones. Suppose I set out to paint an interior: I have before me a cupboard; it gives me a sensation of bright red – and I put down a red which satisfies me; immediately a relation is established between this red and the white of the canvas. If I put a green near the red, if I paint in a yellow floor, there must still be between this green, this yellow and the white of the canvas a relation that will be satisfactory to me. . . . The relation between tones must be so established that they will sustain one another.'

The purity of painting was evidently in continual danger of disturbance. It required safeguards that were arbitrary and drastic: 'I am forced to transpose until eventually my picture may seem completely changed when, after successive modifications, the red has succeeded the green as the dominant colour.' No more extreme reversal could be imagined. Yet Matisse made such changes freely. They were an earnest of the independence and freedom of painting. '. . . As each element is only one of the combined forces (as in an orchestration), the whole can be changed in appearance and the feeling sought remain the same. A black could very well replace a blue, since the expression really derives from the relationship between colours. One is not tied to a blue, green or red if their tones can be interchanged or replaced as the feeling demands. You can also change the relationship by modifying the quantity of the elements without changing their nature. That is to say, the painting will still be based on a blue, a yellow and a green but in different proportions.'

There was something incongruous in Matisse's explanations of the liberties he took with representation. The younger artists were claiming much greater freedom and the leadership of the *avant garde* was passing to them. His own associates had none of Matisse's integrity. Derain's figure compositions produced an eclectic parade of styles; his picture *La danse* showed a hint of the Romanesque. Braque was already being affected by the example of Picasso, and Vlaminck developed his own version of Cézanne-type Cubism. Yet Matisse's almost hypochondriac sensitivity to any disorder in painting was perhaps the most progressive insight of its time. In his analysis of precisely the confusion that ensues when a second and a third dot are added to the first he was in fact setting a new standard of intrinsic purity. His analysis and his example affected the whole subsequent climate of painting. The dependence of Kandinsky and his circle on the visual richness

44 *Intérieur à Collioure* 1905

of Fauvism is clear enough, but Matisse's compulsive purism was of even greater significance in the years that followed.

The standard of purity he set was a high one. It demanded: 'Order, above all in colour. Put three or four touches of colour, which you have understood, on the canvas; add another if you can – if you can't, set this canvas aside and begin again.'

From the time of *Le compotier et la cruche de verre* onwards, Matisse's ability to put a canvas aside was a kind of talent, and one which a multitude of ephemeral unrealized pictures by other people has shown to be inimitable. All the possibilities were stored up to be recovered and pursued in turn. His studious, piecemeal approach to the ingredients of art was a part of his originality. He had, as well as industry, an incomparable sense of direction. He was instinctively reserving for painting an element more specifically and purely visual than anyone else could detect. But he was evidently far from willing that the remainder should be lost. Earlier pictures like *Carmelina* valued not tonal modelling only but the basic commitment of art to its physical subject. In 1905 he had jettisoned both; nothing could be less substantial than the ragged patches of emerald and scarlet that served for

29

human figures in *Intérieur à Collioure*. The quality of bodily life lay elsewhere; the subject of a siesta in a bedroom flooded with reflected light (a subject that southerners never paint) was in itself luxuriously physical. The green figure sprawling on pink seemed to abandon herself to the colour.

The apparent dissolution of physical substance was only one aspect of the change in Matisse's art. The solidity of forms like the back of *La coiffure* was by no means lost. It was transferred into its own appropriate medium and modelled as sculpture. Eventually the subject became the theme of the series of large bas-reliefs of *Le dos* to which Matisse returned repeatedly during the 67-9 next twenty-five years. Painting was left free to deal with the strictly visual residue. There was a streak of economy in Matisse; however lavish his purpose, nothing was wasted. In later years each day's work on a picture was photographed, not only out of well-founded self-esteem but from native prudence, in case it was lost and irretrievable. In sculpture the successive stages between the laborious life-modelling of 1900 and the serene resolution of 1930 were, barring a few accidents, preserved because they served a continuing purpose.

From first to last Matisse's vocation was painting. But he came to it at a time when the idea of an artist's *métier* had lately changed. By the end of the nineteenth century the basic vocation was no longer the production of pictures in themselves so much as the pursuit of a personal artistic direction, wherever it led. The change was reflected in the reappearance of the painter-sculptor. Both Degas and Moreau, his friend, who left a cupboard full of statuettes, realized in modelling purposes that were in origin pictorial, and realized them in some respects more fully. Moreau even said that his statuettes, cast in bronze, would give the measure of his qualities of rhythm and arabesque better than his pictures. Matisse was attracted by the magnetism of Rodin's achievement and perhaps by the battle that was fought over it. Probably it was as much his awareness that all the resources of the arts were again the artist's province as his invariable thoroughness that led him to seek, as Degas and Moreau had not, training in a sculptor's studio.

Matisse's application to the craft of sculpture under Bourdelle in the Académie Rodin was only partially successful. His command of modelling technique remained, from the conventional standpoint, uncertain, and initially some of the character of his sculpture was due to the intractability of the medium in his hands. It did not matter; when he took up modelling again after 1905 it was a means to an end. The account of the part it played, which he gave to Pierre Courthion, was characteristically revealing. 'I did sculpture because what really interested me in painting was setting my mind in order. I changed my medium and took to clay to give myself a rest from painting, in which for the moment I had done absolutely all I could. That is to say, it

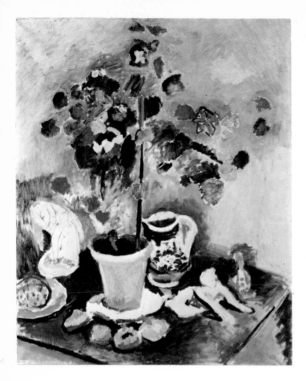

45 *Nature morte aux géraniums*
1906

46 *Nature morte en rouge de Venise*
1908

was always so as to organize; it was to put order into my sensations and seek a method that really suited me. When I had found it in sculpture, it served me in painting too . . .'.

The explanation is unexpected. With his style exhausted and his mind unsettled he sought a solution in a medium which of its nature excluded the qualities of his recent pictures. Painting and modelling had one thing in common, the human subject. The clarification that Matisse sought evidently concerned the representation of the figure. He seems to have felt the disembodied colour that made figures in the *Intérieur à Collioure* to be as unsatisfactory from another standpoint as the obtrusive virility of the *Homme nu*. The alternatives were characteristic of the dilemma that painting faced in the first years of the twentieth century. Matisse's two opposing styles were based on the same Post-Impressionist assumption, the common assumption that style consisted in the treatment to which the forms of nature were subjected, forms that were in themselves indubitable.

The limitations of the Post-Impressionist viewpoint had already become
31 apparent in *Luxe, calme et volupté*, which followed the Symbolist practice of renovating the nineteenth-century subject-matter on ideal classic lines. A nymph, reclining on her elbow according to the classical pattern, was

64

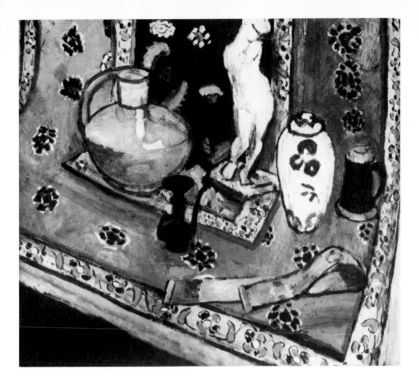

adapted to the modern context by the provision of a cup of coffee. Except as a peg to hang the modern style on, the combination was incongruous. The possibility of assimilating such a figure to current life was explored in a statuette; clothed in a shift and with hair arranged in the current manner, the tiny figure turns to support itself on both hands in a pose that is by contrast grossly natural. In this form it appeared in *Nature morte aux géraniums* (1906) 45 which grafted Cézannian modulations of colour on an inconsequent Fauvist scheme. Another little plaster in the same picture is more difficult to recognize as a *Tireur d'épines* conceived in the spirit of Degas. The sculptures supplied living presences, of the kind that sculpture had provided for Cézanne, but the result was the reverse of Cézanne's full-bodied effect. Pictures like the *géraniums* gave the first sign of a mood that often returned in the years that followed, a wish to assimilate Fauvism to Post-Impressionist naturalness and to a physical norm that was established through sculpture. In this mood Matisse modelled piquant little standing nudes that were embodied in a series of relatively conventional still-lifes, from the *Nature morte et statuette* at Yale onwards, culminating two years later in the richness of *Nature morte en rouge de Venise*. The need for a physical canon that was less 46 conventional, more outlandish was forced on him as if against his will.

65

47 *Nu, le bois clair* 1906

48 *Nu* 1906

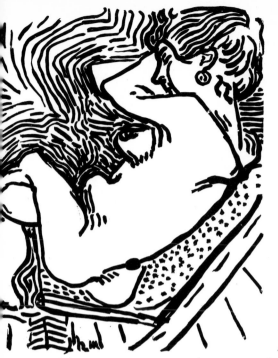

Nu, le grand bois 1906

There was no attempt to rationalize the theme of *Bonheur de vivre*. The reclining figure from *Luxe, calme et volupté* reappeared several times in her pure Arcadian role, made luxurious by the wilful arabesque and extravagant colour. The relaxed mood, which was epitomized by the pose itself, began to approach the ideal that Matisse envisaged for painting. But something conventional in the residue of illustration must still have irked him. At all events he took a similar reclining position, supported against the back of a canvas chair, as the subject of three prints, *Nu, le grand bois; Nu, le bois clair* 47–9 and *Nu,* all of 1906, which examined closely from different standpoints the connection between style and physique. The largest of the three (*Nu, le grand bois*), a woodcut, is Matisse's solitary essay in the convulsive rhythms of Van Gogh. Another woodcut, reacting to the opposite extreme from the linear expression of strain, assimilated the figure to the offhand patterning of Fauvism, with a suggestion of wayward voluptuousness. The surprise came in a lithograph, *Nu.* Specific shapes and features vanished; instead the body was modelled with the ovoid simplicity of a lay figure – a jointed studio doll. A good deal of the pictorial effort of the time had been directed towards simplification of one kind or another and Picasso, whom Matisse met in the

autumn of 1906, was transposing the nude into a primitive state that was only a little less elemental. But in 1906 the formulation of Matisse's lithograph was essentially unprecedented and unparalleled. His originality lay in an extraordinary emptiness. Peeling the detail away disclosed no core of structure or function. The simplification uncovered no system except the sequence of shapes. In retrospect the sequence is seen to possess in itself a quality that is recognized as significant. The Fauvist woodcut had already indulged an awareness that an arm and a leg, with their similar angles, make a primitive kind of herringbone pattern, a pattern which leaves their natural connotation intact, indeed amusingly enhanced. In the lithograph the analogy between the shapes of elbow and knee develops irrespective of the human connotation; it runs counter to anatomy itself. By traditional standpoints it is a denial of meaning. It is no wonder that Matisse was not ready to pursue this experiment in 1906. He returned to it eventually, as he did to everything. The formulation of the body as a lay figure reappeared at an equally crucial moment ten or eleven years later, and twenty-five years later it was exactly this vein of simplification that allowed him to make his way through images of the body towards the disembodied meaning of his last works.

By contrast with the *staccato* touch of Fauvism the style of the lithograph is *legato*. It is not only the smooth shading that binds the shape together. The whole figure is formed and, by naturalistic standards, deformed by a search for imaginative continuity. Buttock, thigh and leg, indeed both legs, are contrived out of the bending of a continuous imaginary tube. The line of the back continues upwards from the shoulder to include the egg-shaped head, linking them together in a way that became the subject of repeated experiments. In the next few years girls were often shown stooping or hunched and bowed so that the head became an integral part of the body, continuing its thrust, yet also became, however intent, in a natural respect irrelevant and dumb. At the same time an opposite solution was possible. A process of attenuation gives other figures a long-necked, vapid look and isolates the physical rhythm from any remaining human expressiveness in the token termination which is the head. Both forms were brought together 43, 86 in 1908 in the two versions of *Le luxe*. Matisse was meditating on the fate of the sensate, functioning aspect of the body in art.

68

1908–1909 Painting and sculpture

In *Notes of a Painter* there is a tribute to Cézanne that is at first sight curious. In his pictures 'all is so arranged that no matter how many figures are represented or where you stand you will always be able to distinguish each figure clearly and know which limbs belong to each body. . . . Limbs may cross and mingle but still in the eyes of the beholder they will remain attached to the right body. All confusion will have disappeared.' In the Fauvist style nothing had been attached to anything but now disruption and particularly the disruption of a body was seen to constitute a threat. The younger painters who succeeded to the leadership of the *avant garde* welcomed fragmentation and cultivated it. For them it was the saving grace of the Post-Impressionist styles, the only element that they could accept without irony or equivocation. For Matisse it was a source of disturbance, an evident cause of the very anxiety that art was intended to keep at bay. To fragmentation he opposed an ideal of physical integrity and completeness. The wholeness of the body was precious in itself. Cézanne eventually became his talisman against Rodin, who in 1908 was evidently the sculptor in his *Notes* for whom 'composition is nothing but a grouping of fragments'. This alertness to the possibility of physical disjunction was typically hypersensitive, as if it involved some real danger of dismemberment. So in a sense it did; Matisse's concern for the body as a unit sprang from a devotion to something that was of personal value to him, a quality of completeness in the image as much as in its subject, in fact a quality of art itself. As he worked his way towards the great decorations his purpose was explicit: 'Our only object is wholeness.'

Among the interwoven, indeed tangled trains of thought to which the *Notes* are witness, there are threads both of jealous loyalty and of compulsive analysis. Matisse's considerable intelligence and formidable perseverance were both directed in these years to separating his private use for art from the elements in his tradition that he required to disown. It is significant that they were thought of as qualities of illustration and expression. 'When we go into the seventeenth and eighteenth century sculpture rooms in the Louvre and look for instance at a Puget we find that the expression is forced and exaggerated in a manner that is very disquieting.' The issue had occupied

69

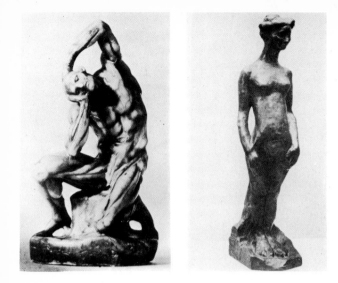

50 *Écorché de Michelange,*
sixteenth-century
sculpture, Florentine

51 *Nu debout* 1906

Matisse before. He had once copied, and often included in still-lifes a
Florentine sixteenth-century statuette, a common studio property which
was then known as the *Écorché de Michelange*. It had provided Cézanne with a
motif; it appears in the background of the Courtauld *Amour en plâtre*. The
baroque rhythm of Cézanne's developed compositions explains Matisse's
preference for one of the earlier and less articulated designs.

Nevertheless, from the Barye copy onwards Matisse's earliest use for
sculpture was to ponder a kind of force that was now beyond the reach of
painting. (Barye had served a similar purpose to Cézanne. One of his
lithographs was the source for a gentle, block-like sketch of a tiger painted
for Victor Chocquet, an admirer of the qualities that Cézanne shared with
Delacroix.) Matisse's early figurines often sprouted wing-like forms, raised
arms or little faun-like horns, like emanations of natural energy. The hands
that are clasped to the head of the flayed and twisted *Écorché* speak of a
Michelangelesque realization of that which is agonizing in the bodily
condition. The little figure is like a personification of an anxiety that haunted
Matisse. 'Then again', the *Notes* continued, 'if we go to the Luxembourg, the
attitudes in which the painters seize their models is always the one in which
the muscular development will be shown to the greatest advantage. But
movement thus interpreted corresponds to nothing in nature . . .'. Matisse's
criticisms of academic idealization seem themselves oddly academic in the
context of 1908. The fact that he discussed an issue which had ceased to
matter to anyone else reflected a need that was still unfulfilled. His concern

70

for the integrity of the physical subject combined rather oddly with his equal concern for intrinsic elements, his isolation of colour and touch in themselves. The apparent contradiction weakened his polemical position; the artists who learned most from the latter article of his faith were those who most strenuously rejected the former. Kandinsky detected that Impressionism was in Matisse's blood, but in equating it with conventional beauty he missed the point of which Matisse was painfully aware. Matisse was conscious of the dire implications of the shift away from illustrative and human references towards the intrinsic meanings of modern art.

In 1907 the significance of Cézanne's bathers was that they were the single demonstration of the possibility of a radical redefinition in the new terms, the possibility of figures that conceded nothing to convention but grew with a consistent strangeness out of intrinsic relationships between marks on a surface to fill the grandest roles. To Picasso they suggested the possibility of an ecstatic disjunction between the marks. For Matisse on the other hand they were examples of wholeness and continuity. But they indicated to him, too, the obsolescence of the convention and the imminence of a new canon.

The decisive discoveries in sculpture, which were to help Matisse in painting, began in the summer of 1907 at Collioure. He was still working on the reclining pose that had developed out of *Luxe, calme et volupté*. It was to 31

52 *Nu couché* 1907

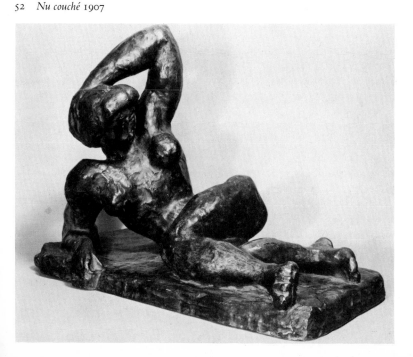

53 *La coiffure* 1907

occupy him at intervals for thirty years, revealing its significance gradually. Perhaps the choice owed something to the related position of Maillol's *La Méditerranée*, a version of which Matisse helped to cast in 1905. There was no closer connection. 'Maillol', he said, 'worked with volume like the ancients; I am concerned with arabesque like the Renaissance artists . . .'. In 1907 he returned to the figure in the form that had appeared in the middle of *Bonheur de vivre*, languorously twisted at the hips with one arm raised, and began to model it again. Matisse had no model at Collioure; he worked from memory and from dubious photographs of nudes. The bronze still shows the signs of the struggle. Trying to realize the natural forms which had been wilfully summarized and flattened in pattern, he still lacked an alternative to the convention of 'muscular development shown to the greatest advantage'. The raised arm had been left indefinite in the painting. Evidently it was clasped to the head, but why and how? It is likely that the difficulty sent him back to the source of such conventions, the conventions of the Luxembourg and of Cézanne alike. The arm clasped to the head in the form that he adopted was invented by Michelangelo for the figure of *Night*. The *Écorché* itself is like a nude from the Medici Chapel stood on end. The gesture is an expression of the anxiety that lay in wait for modern art. The figure wakes not to any exaltation of the body but to a brooding awareness of its mortification.

40
52

72

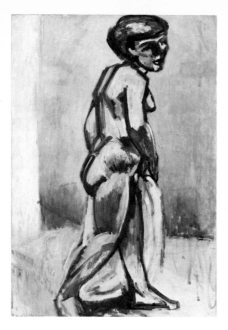

54 *Nu debout* 1907

The example of Michelangelo remained of value. Ten years afterwards, in 1918, Matisse went to the École des Arts Décoratifs at Nice to draw the figure of *Night* and to model it as well; he hoped, he wrote, to instil into himself 'Michelangelo's clear and complex idea of construction'. Ten years later still, around 1928, a photograph of a famous drawing of *Night* in the Louvre was still pinned to his studio door, together with Delacroix's *Barque de Dante*, in which the figure is echoed. Matisse had been to Italy earlier in the summer of 1907 and the Renaissance ideal was in his mind, to judge by the advantage to which physical rhythms were displayed in the picture *La coiffure*. The relation between the figures in *La coiffure*, and the disjunction of an enormous hanging arm have an incongruous suggestion of the much admired Palestrina *Pietà*, an imitation of which had lately been published as a Michelangelo in the *Gazette des Beaux-Arts*; the picture is like a sophisticated rejoinder to the primitive classicism of Picasso's *La toilette* of the previous year. The need for a forceful redefinition of the nude was felt in 1907 by several painters who knew of the enormity on which Picasso was at work. Braque painted a standing figure which reflected it and it probably accounts for the coarsely realized energy of Matisse's striding *Nu debout*, now in the Tate Gallery. The standing figure with a towel was assimilated into a little *Baignade*, designed with a triangular symmetry like a famous Cézanne *Baigneuses* of the eighties. At the same time and on the same scale Matisse

53

54

55

73

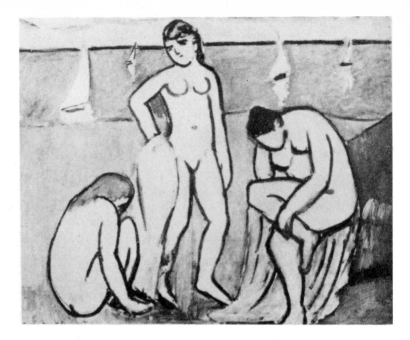

56 painted the spontaneous *Musique (esquisse)*, an odd assembly of self-absorbed, nude children, among them a standing boy violinist, set against deep-toned grass and sky, which was nearer to Picasso's sketches of idyllic adolescence a few years earlier.

 None of these resourceful formulations offered the solution that was needed. It was the laborious modelling of the *Nu couché* at Collioure that produced the answer, through the kind of conventional defeat that often supplies a victory for modern art. Not for the first time Matisse's technique as a modeller failed him. He turned the modelling stand and wetted the clay until the figure fell apart; it dropped to the ground and lost its head, the very focus of the difficulty. The spell of the conventional ideal was broken and turning exasperated from the sculpture Matisse was ready immediately to

87 paint the motif in a picture that is one of his masterpieces, *Nu bleu*. The subtitle 'Souvenir of Biskra' suggests that the bodily disjunction was thought of as exotic and barbaric in itself, and thus as in a sense decorative.

74

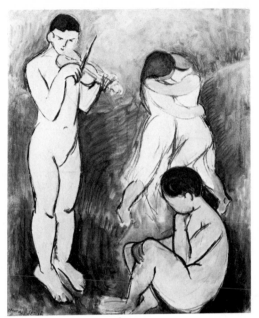

55 *Baignade* 1907

56 *Musique (esquisse)* 1907

It is not easy to understand that the *Nu bleu* can ever have seemed outrageous, yet it was ridiculed and burnt in effigy for years. We are aware only of a freshness in the look of awakening and bewilderment with which the figure discovers herself to be an integral and congruent part of the new context. The functioning structure of a body is remembered only remotely; the re-creation involves a delicate maltreatment. In place of functional construction, the sequence that links the shapes together is the thread of imaginative rediscovery. The shapes spring out of one another according to a visual necessity so consistent that it takes on a naturalness of its own which is everywhere slightly unexpected, as if the line were awkwardly alive, and its newborn creature with it.

The sculpture of the *Nu couché* was salvaged and cast. It had a lasting significance to Matisse; it was the nearest that he ever came to realistic naturalness. None of his sculptures was called on so often to supply the physical presence that a still-life was felt to need. In 1908 *Nu couché*

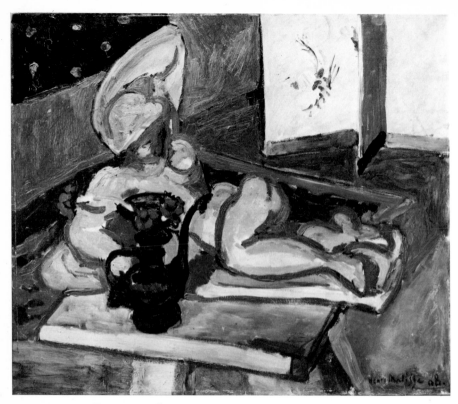

57 *Bronze aux œillets* 1908

57 participated in the deepening colour of *Bronze aux œillets*; she seemed at home in the sensuous depth of colour, as *Nature morte au torse grec* showed that the original classical form was not. At the summit of the new style in 1911, painted like flesh, the *Nu couché* basked in the radiance of *Poissons rouges*

59 *et sculpture*. Matisse came to treat the sculpture as if it were actually alive. In 1912, when he painted the goldfish motif twice more the serenity had passed. It was the stirring of the anxious life in the *Nu couché* (now characterized with

58 features) in the purple void of *Poissons rouges* at Copenhagen that heralded the tense meanings of the next few years. Fifteen years later Matisse reverted to the pose in two sculptures, *Nu couché II* and *Nu couche III*, which

76

inaugurated his own classical phase. A series of drawings and the stages of the picture show how the figure found in 1935 its final shape in Matisse's flat, idyllic art, with the wanton twist of the hips ultimately eliminated, in the completed form of the *Nu rose*. Drawings of the late twenties with their convulsive spiral movement, uncover the connotation that he extracted from the classical nymph and eventually sublimated in the 'distributed voluptuousness' of his later style. The pose of this nude is in essence that which from the time of Dürer has signified *Luxuria*, or lust.

147

58 *Poissons rouges* 1912

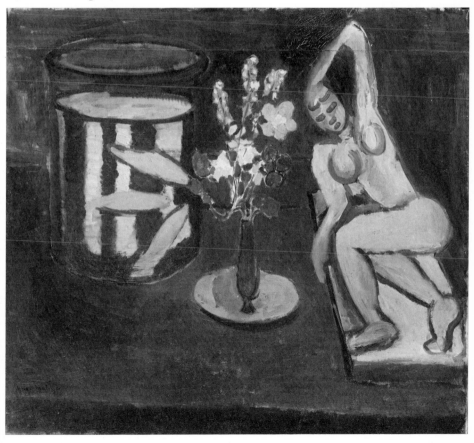

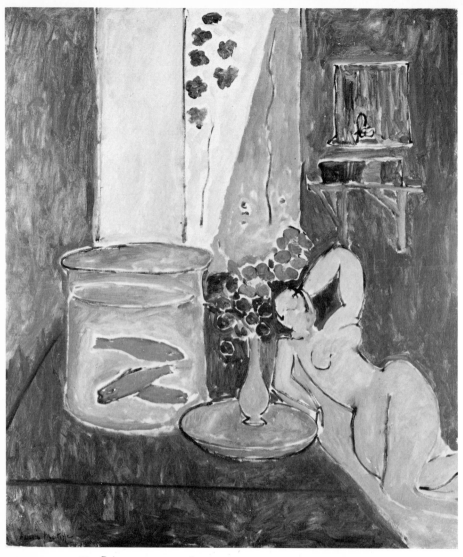

59 *Poissons rouges et sculpture* 1911

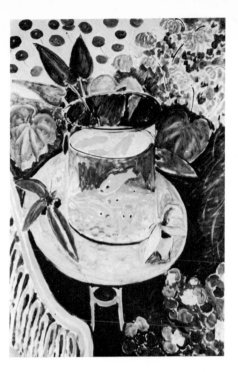

60 *Poissons rouges* 1911

Sculpture placed at the painter's disposal embodiments of sensual life which were more completely his own than the most submissive models. Nevertheless, this was not its deepest purpose. Matisse's feeling for the wholeness of a picture developed continually until the last year of his life and nothing in painting had as little reference to a third dimension as his final style. Yet this style was evidently nourished by the experience and, in particular, by the physical content of sculpture. In 1908, Matisse modelled a group from a photograph of two Negresses. The form of *Les deux négresses* is 61 simplified and abridged; it offers hardly more than tokens for figures as the terms in a visual equation. The almost symmetrical arrangement balances complementary views, so that from whichever side we look we relate front and back, like aspects of a single figure. The group has no content except the expression of a bodily wholeness, which is never more than half seen, an expression that is perhaps more physical and less pictorial than anything in five centuries of Western sculpture.

Approaching sculpture from outside the sculptural tradition, never modelling on the scale of life, Matisse had remained untouched by the convention of one-to-one equivalence that had been its basis since the

61 *Les deux négresses* 1908

Renaissance. His own purpose was simply what he called the organization of his thought, and from this standpoint a profound difference between the sculptural formulation and the visual resolution of painting must have been apparent. Sculpture in this tradition does not represent the body; it is the body. The body is the sculptor's medium. Within it his whole meaning is contained; it is his canvas and his frame. The strangely elementary originality of Matisse's sculpture reflects his understanding of this; its significance is expressed not through the figure but, as William Tucker has written, *in* the figure.

The group of *Les deux négresses* is rectangular and compact, like the figures. It is picture-shaped and we read across it as we might a canvas. It presents a bodily unity that is image-shaped, a miniature but none the less monumental slab composed of complementary views. The importance of it to Matisse is shown by its place in the most absolute, and most successful of the exotic colour-patch still-lifes of these years, *Bronze et Fruit*, now in Moscow. In the picture the modulations of blue that render the statuette emanate from an all-over blueness. The blue is not only a counter in the chromatic contrast – it has a pervasive presence of its own which peoples itself with aspects of the body. This is the first that we see of a single, spreading colour as an intense reservoir of meaning.

80

Through picture-shaped sculpture like *Les deux négresses*, Matisse developed the analogy between the wholeness of the body and the wholeness of an image which was the theme of a sculpture that was not only exceptional in Matisse's work, exceptional in size, in positiveness, in conception and in the continuity of his concern with it over a period of twenty years – but exceptional in the whole of modern art – perhaps in all art.

The body of *Le dos*, far larger than life, dominates its slab from the beginning. From the second state onwards it fairly fills the slab. Eventually, in the last two states, finishing twenty years after the first, the body comes to share the rectangular, upright shape. None of the versions of *Le dos* was exhibited in Matisse's lifetime; the second was indeed forgotten until it was rediscovered after his death and the series was not seen together until a set was installed at the Tate Gallery in 1956. The importance was to Matisse himself and it was profound. 66–9

The series of drawings that led to *Le dos* evidently began when Matisse moved to his new studio at Issy-les-Moulineaux. The first stages were by no means monumental; it would be truer to call them descriptive and illustrative, like the treatment of such poses by Rodin and by Dalou before 63–4

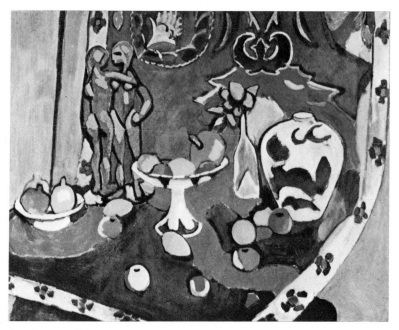

62 *Bronze et fruit* 1910

63 *Le dos (esquisse)* 1909–10 64 *Le dos II (esquisse)* c. 1913

him. Then the traditional associations of the pose, with the model's head cradled in her arm as if in fatigue or submission or realization, all dropped away, leaving it as empty of illustrative content as Cézanne's bather. But whatever the dawning simplicity and grandeur owed to Cézanne, the conception of a great square back that comes in itself to constitute the image has an undoubted affinity with Gauguin, who was certainly in Matisse's mind in 1909, and as the hanging hair becomes the axis, the design increasingly recalls pictures like the Tahitian beach scene, painted in 1892, which has passed from the Lehmann Collection to the Metropolitan
65 Museum, and the *Moon and Earth* in the Museum of Modern Art, New York. The beginning of the sculpture is recorded in the photograph of an initial state that was not only monumental but bulgy. It was never cast; Matisse evidently retained his scepticism about the kind of style that showed physical development 'to the greatest advantage'.

82

In the first state of *Le dos* that was cast the motif is not so much embodied in three dimensions as half-disembodied, with its roundness unrolled and sprawled against the plane as if by a persistent pressure. It is a vivid sculptural realization of the actual process of pictorial flattening, which creases the hollows and crushes the bosses. In the progressively resolved forms of the subsequent versions the process is never reversed. It is only the pictorial consistency, the idea of an image, that develops. As soon as *Le dos* was cast at Issy, Matisse, established for the summer at Collioure, turned back to the other possibility that sculpture offered – the open presentation of a total and perhaps drastic reconstruction of the whole body, free-standing and entire, from head to foot.

He still, after all, lacked conclusive forms to match the visual transmutation made through colour. The need was pressing; it disorganized his sensations and upset his self-possession. It was characteristic of him, indeed it was a sort of genius, to feel a figurative problem to be nothing less than a disorder of the self. The real virtue of modelling was that it could remodel the human shape.

65 PAUL GAUGUIN: *The Moon and the Earth* 1893

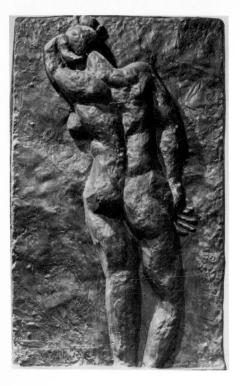

66 *Nu de dos I c.* 1909

67 *Nu de dos III c.* 1913–14?

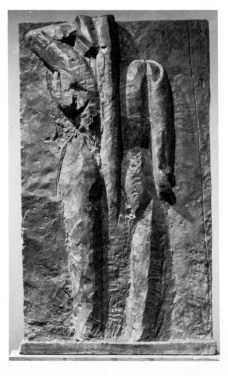

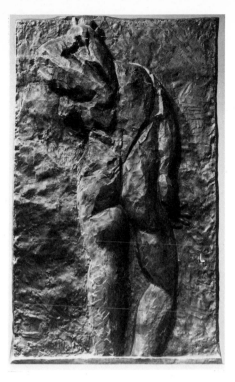

68 *Nu de dos II c.* 1914

69 *Nu de dos IV c.* 1929

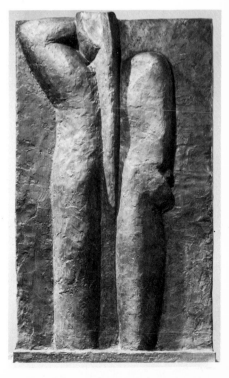

70 ANTOINE BOURDELLE: *La nudité des fruits* 1906

71 Nothing could be much more simply physical than his only model for *La serpentine*, a photograph in a pornographic album charmingly entitled *Mes Modèles*. The stylistic guide was a bronze of three years earlier by Bourdelle,
70 inscribed *La nudité des fruits*. With no other supports than these Matisse proceeded to one of the most decisive and disconcerting strokes of originality in his work. Matisse's sculpture often embarrassed his admirers. Henry McBride of Philadelphia described how, on a visit to Matisse's studio with Roger Fry, he was struck dumb by the sight of *La serpentine*, 'whose thighs were almost as thin as wires and whose lower legs were as thick as her thighs should have been. Mr Fry, who is always equal to any

71 *La serpentine* 1909

social demand, murmured something felicitous enough to get us over the situation . . .'. In fact this very discomfiture was a part of Matisse's theme. He recognized, probably as early as anybody, that the quality in Cézanne's bathers that had seemed like embarrassing incapacity was their virtue. Working from within the tradition and profoundly allied to it, he felt the fate of its central possession, the proportionate image of the body, more intimately than anyone, and wore the badge of its expropriation with more pride. *La serpentine*, with debonair unconcern, announces that another confusion is ended. The forms of life, so far from indubitable, are the perennial creation of art. They share in its metamorphoses; each style breeds an anatomy to match.

In the new art the overriding unities are the imaginative connections that join kindred sensations paradoxically together. In painting they are the unreasoning leaps made by an eye intent on colour. In *La serpentine* just such metaphoric connections dictate sequences that supplant everything else. The continuities of trunk and limbs are followed as the metamorphoses of a ductile and protean tube. The arms describe and govern their proper zone in one twisting line from hand to hand. Yet the metaphoric meaning is conveyed with an elusive visual truthfulness that was inseparable from whatever Matisse did. To the eye the sharpness of the thigh, collecting light along its edge, means as much as any fatly rounded shape. From every side each contour from head to foot draws the impeccably convincing edge of an invisible and natural form, which substantiates the token that we see. The visual sensations, set in order, produce their own species of creature, with qualities of sexuality and character. She takes up a lively linear attitude in space, even a certain coquettish, mock-reflective attitude to space. She is the consummate, graceful outcome of the arabesque with which, as Matisse said, he was concerned.

The figure pictures of the next few years depended on *La serpentine*. Often the anatomy was derived from her. Throughout, the invention of the decorations depended on the free, metaphoric standpoint that had been established in the sculpture and on its distance from both convention and the model. Portraits, too, were subject to physical reconstruction. The painting 72 of the *Jeune fille au chat* introduced a new kind of non-functional plastic fluency, which is both unconventional and humanly charming; it showed the way out of a kind of severity that had been the only alternative to wanton exotic disjunctions.

Another set of sculptures that evolved through Matisse's characteristic and original process of casting and reworking successive states had a wider 73–7 significance. The bust of *Jeannette* began as a portrait head modelled in the Impressionist manner. The third state, in which the shapes of features and

88

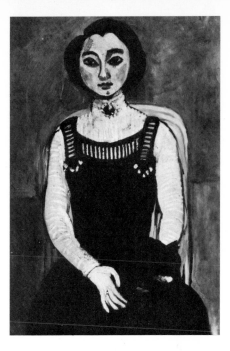

72 *Jeune fille au chat noir* 1910

hair emerged as separate, conceptual forms, was the source of two parallel conclusions which produced alternative solutions of radically new kinds. In *Jeannette IV*, finished by 1911, the projections develop independently, barely connected; they are looping, pulpy growths, not entirely benign, to which the residual nucleus of a real person is the involuntary, perhaps suffering host. In *Jeannette V* the separate vitality of the parts is incorporated in a new synthesis. The bulge above the eyes is neither forehead nor hair but both. The vigorous conceptual modelling of an eye (and one is enough – the other is sliced through to show the continuity that the eye interrupts) is no more than incidental to the symbolic, compound form. The capacity of modelling to endow physical forms with a separate life, so that they grow and gather of their own accord a rhythmic coherence that is recognized as the hermetic life of art, had appeared in *La serpentine*. The last version of *Jeannette*, which *Nature morte au buste de plâtre* showed complete in 1912, pointed in a direction that was taken up again when Picasso reached the same formulation twenty years later. It appears that Matisse's invention was a basic source for the style of biomorphic abstraction which spread in the thirties with a decisive effect on the decades that followed. One can already detect in *Jeannette V* the crawling, gastropodous movement which, dis-embodied, was to animate another kind of art.

89

73 *Jeannette I* 1910–13 74 *Jeannette II* 1910–13

The final usefulness of sculpture to Matisse's style and thought towards 1930 was of another kind. The fantasy of forms as organisms, which *Jeannette IV* anticipated, developed under the aegis of Surrealism, which afforded no shelter to Matisse. To take the human organism as the type of form was the sustaining fantasy of tradition and Matisse carried it to the extreme point of the final version of *Le dos*. His explanation of the reason that he worked in sculpture ended with one of his more significant statements: '. . . It was always done with a view to mental self-possession – with a view to a kind of hierarchy of all my sensations that would allow me to reach a definite conclusion.' For Matisse, as for Cézanne, *sensations* included sensations of art. He had needed to clarify the conflicting data as so many levels of sense and feeling – for him the possibilities of art were nothing less – and to arrange them in due order. The work of his life was repeatedly from successive standpoints to establish as the highest plane of painting (and to establish it in part through sculpture) the level that is least subject to *the torment of the three-dimensional*. It was the only plane on which he was assured of the mental self-possession that he called 'une possession de mon cerveau', recalling, and without doubt independently, the elusive mastery of oneself that was the objective of Cézanne. For Matisse the levels of art were a veritable hierarchy. There was something papal in the chair-borne authority that Matisse exercised in his concluding and conclusive works.

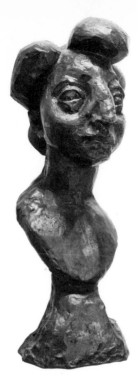

75 *Jeannette III* 1910–13

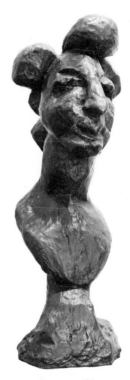

76 *Jeannette IV* 1910–13

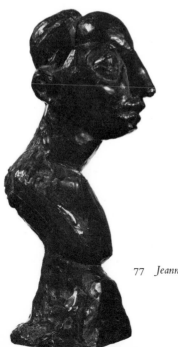

77 *Jeannette V* 1910–13

1909–1910 The great decorations

Simplification was essential to Matisse's progress on his way to the great figure compositions of 1910, yet his method involved not only purification but lavish enrichment. It may be that the great table-laying picture that Matisse dated in 1908 and repainted as *Harmonie rouge* in 1909, presented him with the problem of human definition that the first three states of *Jeannette* were devised to deal with. Red flooded across the canvas in place of blue. In other pictures blue ceased to be the attribute of a specific thing – an identifiable drapery or a connected pattern. In *Nature morte aux géraniums* of 1910 at Munich it assimilated the geranium leaves and the familiar draperies to the boarding of the studio wall at Issy (where the drawings for *Le dos* were made). In the *Conversation* of 1909 the saturation of colour carries a sense of

96

78

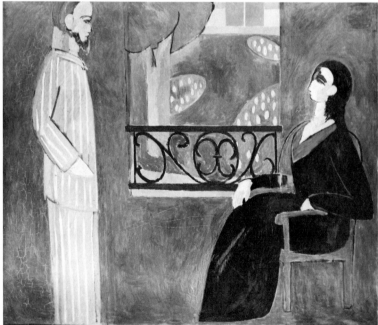

78 *La conversation* 1909–10

physical presence and gives us our first sight of the painter of the self absorbed in self-hood. Matisse is seen to be the painter of the emotional *contretemps* and the maladies of a marriage, the painter of the *mauvais quart d'heure*; the atmosphere of the *Conversation* is nearer to Strindberg than anyone else. Cross had called Matisse madly anxious but he could not have foreseen – we hardly realize even now – that he was to be the painter of anxiety. That is what his figural drama is about; that is why elimination was so essential to his method. We have a glimpse in the *Conversation* of the solution that Matisse's figure compositions were striving to enact. It was in this situation that exotic harmony came to his rescue, like a land of ideal make-believe in which the domestic and stylistic *contretemps* were held for ever in suspense. Colour washed the conflict away.

The solution was evolved in 1908 and 1909. The figure compositions of 1908 were like meditations on how Cézanne's late bathers leaned invariably towards the middle of the picture. The pretexts that Matisse supplied for the convergence looked a little incongruous. *Bagneuses à la tortue* developed the 79 symmetrical design of *Baignade* on three times the scale; it was rationalized 55 rather comically by the provision of the least animated of creatures for the

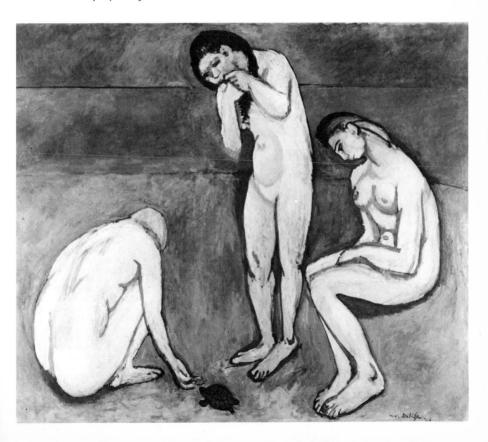

figures to converge on. The illustrative content was no longer relevant, hardly even noticeable. Intense deep colour welled up round the figures. The robust bodies were stilled and subdued by it, as if patiently awaiting transformation.

Only the impotent, spellbound look spoke of an unsolved dilemma. Matisse debated the issue at length. *Notes of a Painter* discusses whether the movement that is seized in art corresponds to anything in nature and then, supposing such a movement is caught in a photograph, whether *that* corresponds to anything we see. The argument seems pedestrian and almost irrelevant; the intention reflected in his pictures was only intermittently naturalistic. In fact it concerned the very crux of the changes that were taking place. The rendering of movement was certainly associated with academic convention and its discredited ideal physique. Yet, if the aim was expression, how could movement be dispensed with? From the time of Leonardo onwards expression had been nothing more or less than movement. The ecstatic state that Matisse proposed to express positively called out for movements. *Bonheur de vivre* would have been incomplete without the round dance in the background. Whether movement was suspended or unloosed, the contradiction was evident in 1908. The piecemeal studies of the elements of art had been a preparation for just this problem and all the results were called on to resolve it – the intrinsic value of colour, the visual economy and the remodelled physique, supplying both the subject and the pattern for art.

By 1909 the transformation had begun. The real vigour of *La nymphe et le satyre* derives from a new order of reality. It arises from an exact balance between the pinkness of flesh and the bright grass-green that surrounds it everywhere. The pink generates its own red contour and the optical fluorescence makes the line strangely graphic and mobile. The colours vibrate together as if physically. The design itself seems on the point of resolving into great springing arcs; Matisse was visibly reluctant to let the back of the nymph's head interrupt them. Behind, the rounded trees are divided by spandrels of sky. More than twenty years later Matisse was at ease with the arched space that Dr Barnes commissioned him to decorate because he had imagined it already.

Matisse was working systematically towards the most exact adjustment of colour and form that modern painting had achieved, which meant for him colour and physique – an adjustment between colour and that real, human zone in which action is excited or suspended. 'I shall get it', he wrote, 'by the simplest, by the minimum of means which are the most apt for the painter to express his inner vision.' The danger of disquieting confusion was to be banished finally; he ordained it like a monarch:

94

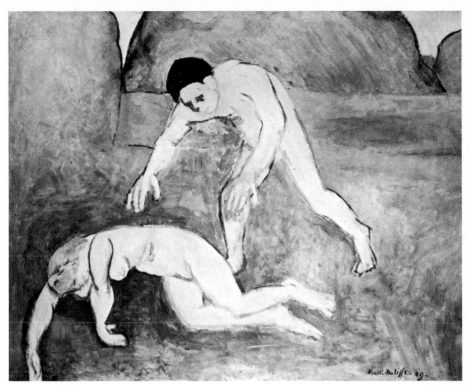

80 *La nymphe et le satyre* 1909

'We are moving towards serenity by simplification of ideas and means. Our only object is wholeness. We must learn, perhaps relearn, to express ourselves by means of line. Plastic art will inspire the most direct emotion possible by the simplest means . . . three colours for a big panel of *La danse*; blue for the sky, pink for the bodies, green for the hill.'

It was in this mood that Matisse conceived the wave-like design of *La danse* 83
for the first of the decorations commissioned by Shchukin. But in the development of the conception recorded in the full-scale sketch in New 81
York, a conception as fluid and artless as *La musique (esquisse)* of two years 56
earlier, into the finished decoration, every element in his thought played a part. The metaphoric physique of *La serpentine* provided him with beings whose movement was no longer functional; they have only the pictorial momentum of marks on a surface. The effect is none the less energetic by contrast with the limp dancers in *Bonheur de vivre*. The bodies fill the extraordinary design. Feet are pressed against the bottom of the canvas; the 40
upper edge is carried on a bent head and on powerful shoulders. The picture

95

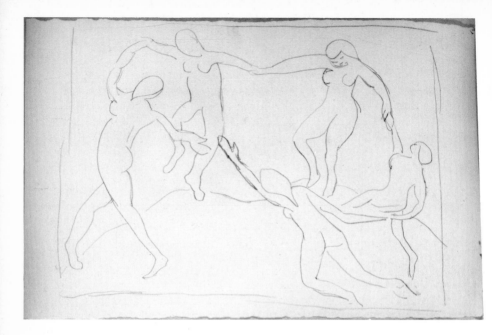

81 *La danse* (study after painting) 1909

82 *Les capucines à la danse I* 1908

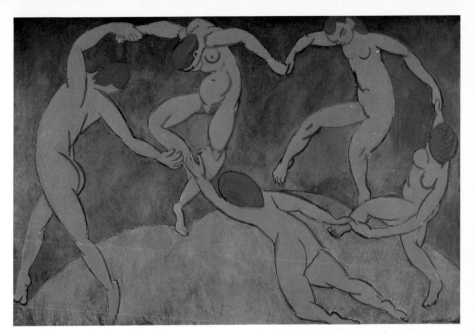

83 *La danse* 1909

itself is as physical as if it were comprised of compound multiple atlantes. Like the relief of *Le dos*, the image is in a profound respect formed by the body. Yet the pattern, so far from formalized, seems to incorporate instantaneous impressions. Matisse told Georges Duthuit that the subject originated in a *sardana* that he had watched at Collioure and photographs of the *sardana* record positions rather like the farther figures. Possibly the skipping backward step was the outcome of the debate about the value of the momentary vision. The quality of suspended animation is its advantage in *La danse*. The whole vigour of the picture is in a sense contradictory. The indications of movement counteract each other; even the cursive slant of the foreground figure is held in check. There is no sense of the circle revolving in one direction as it does in *Bonheur de vivre*. The effect is nearer to Rodin's dry-point of *La ronde*, exhibited in 1905 and possibly a source of the motif in the earlier picture. The suggestion of conflict in Rodin's illustration of the perpetual movement which was the punishment for violence against nature in the seventh circle of the *Inferno*, even the convulsed, hunched pose and the halting leap of his figures, were converted in *La danse* to a purely visual sense of arrest in pattern.

97

84 *Nu, paysage ensoleillé*
1909

Yet the recipe for *La danse*, as Matisse himself formulated it in the words that are quoted above, was still incomplete. The idea – the most direct emotion possible inspired by the simplest means – was perhaps still an intellectual one. It seems that the physique and the action were still not quite fully visualized in Matisse's own chromatic terms. He tried to naturalize it in his own imaginative realm by the means he always used: he cannibalized it and fed off the visual impression of his own achievement; he painted pictures of his own painting as it hung in 1909 in the studio at Issy. But perhaps the real trouble was that the analysis that he had stipulated had not yet produced the material for synthesis. He had not painted naked bodies out of doors. So the conception, the illustration of movement, still prevailed over the visual realization.

Matisse's real subject was not an action but a state, a state of agreement between the physique of painting and its colour. It seems that the decisive step which changed the whole direction of his art was taken when he replaced the *pink for the bodies*, specified in his plan for *La danse* and used in the sketch, with a brilliant brick-red, the colour that he described as *vibrant vermilion*. As a colour for flesh it was unparalleled. Yet it is not only an element in an invented pattern; it has the quality of visual truth that we come to expect of Matisse – a quality that is not always easy to account for. A good

deal of the summer of 1909 at Cavalière was spent painting his model (called Brouty) nude outdoors. She was posed under trees among patterns of sunlight and shadow. In one sketch, *Nu, paysage ensoleillé*, she stood in grey shadow against green foliage, making a patch of flat orange-pink hardly darker than the sandy sunlit ground (with an emerald patch between her thighs). In *Nu assis* the pose makes it clear that Matisse had Gauguin in mind; when the sketch was finished and dry the sandy ground and shaded flesh were both rubbed over with a bright mauve-pink, separating them boldly from the navy-blue shadow. In both pictures the tenuously defined figure was almost lost against the arbitrary pattern of sunlight. There is a reason for the paradox; the tone of the body in shadow happens (as so often with Matisse) to be exactly equivalent to the sunlit ground.

84

88

The shadows in flesh, like the shadows on the oranges in *Le compotier et la cruche de verre*, yielded a colour that integrated the radiance of the living world into an equal community of colours. Such an alert balance of light with the vividness of life is rarely to be found, to tell the truth, in Gauguin. It rather reminds one of the picture at Lille which Matisse said first attracted him as a youth to painting – that lovely picture by Goya called *La jeunesse* in which the tone of flesh in the penumbra cast by a parasol, outlined in black, is reconciled with the surrounding sunlight with just the boldness that is the recurrent mood in Matisse when he is at the top of his form, most original and most traditional botn a. once.

14

85

85 FRANCISCO GOYA: *La jeunesse*
c. 1812–14

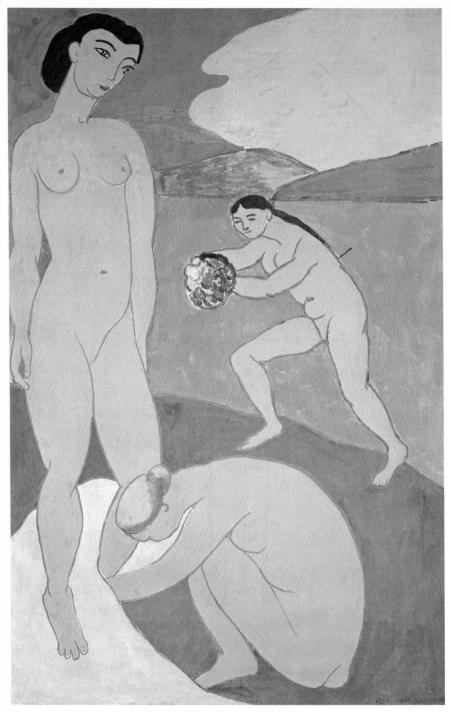

86 *Le luxe II* 1907–08

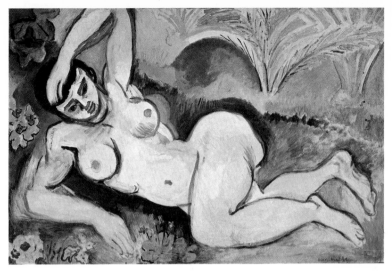

87 *Le nu bleu* 1907

88 *Nu assis* 1909

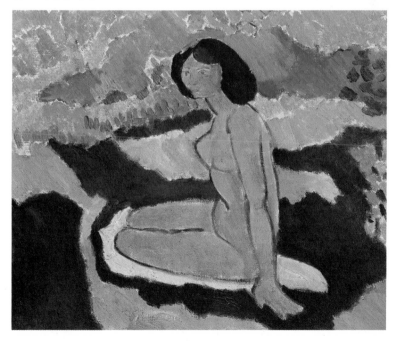

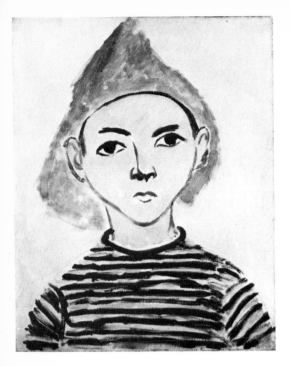

Yet Matisse was not really a painter of the Age of Reason. It is the appearance of wilful arbitrariness that is beautiful. In the decoration the apparently arbitrary brick-red evidently incorporates experiences of the luminous paradoxes of reflected light. Yet they are embodied in a radiance that is imaginary.

89 The clarification that Matisse achieved in 1909 affected his art for the rest of his life. It liberated him. When he painted his son Pierre in the summer a few offhand linear signs were enough to evoke what he needed. Colour and light were freshly caught as if by chance between the unthinking brush marks. At this crux in his development Matisse was guided by an extraordinary confidence. He imagined an ideal order of painting, in which the luminous, idyllic content was set free, held suspended in its medium, poised and weightless like his goldfish. In *Nu au bord de la mer*, one of the pictures that looked both back and forward, the conventional roundness of flesh was eliminated from the familiar subject. Instead, the image grew directly out of wedge-shaped conjunctions of flat colour, which were to
91 form the primitive-seeming figures in *La musique*.

The primitive had a special value to Matisse. He is said to have introduced Picasso to Negro sculpture but it had quite a different significance to him. He

had no use in painting for the drastic transformations that primitive art suggested to others. His transformations were evolved in his own sculpture on the rhythmic principles of his tradition, and the boldest of them were confined to sculpture. In painting Matisse looked rather for an exotic refuge. After *La musique* his pictures of the next few years showed no sign of strenuous constructive purpose. The pictorial form was so flat or so general that it amounted to an abstention from form. The energetic movement of *La danse* was never repeated; it was in a sense unresolved and in the years that followed Matisse reflected at length on the sketch for it which remained at Issy. Still-lifes which took it for background and associated it with the trailing arabesque of a nasturtium, reclaimed it for the stillness of his private world and assimilated its colour to the pervading blueness of his room. During the stages of painting *La musique*, the figures abdicated the active roles that they had taken in the sketch three years before. The curves of *La danse* were attenuated into pattern and then abandoned; in place of the fat brown contours, *La musique* is drawn in black line as sharp and direct as if chiselled. Colour fills it in a new way.

82

Later Matisse described the process: 'My picture *La musique* was composed with a fine blue for the sky, the bluest of blues. The surface was coloured to saturation, to the point where blue, the idea of absolute blue, was

90 *Baigneuse* 1909

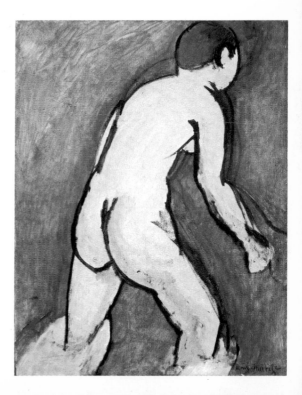

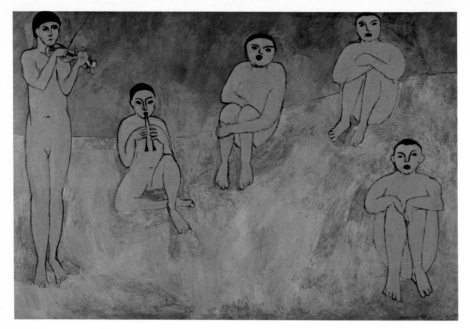

91 *La musique* 1910

conclusively present. A bright green for the earth and a vibrant vermilion for the bodies. With these three colours I had my harmony of light and also purity of tone.' The *conclusive presence* of which Matisse spoke is the real subject of the picture. In their vacancy the figures seem to know it; any character that might distract from it has dropped away. They make an odd company, destitute of anything but this elemental order of visual presence and the moaning primal melody that one can imagine goes with it. The suggestion must have come not from primitive art in itself so much as from an earlier stage in its assimilation to Matisse's own tradition. The economy of the formulation, the poses and the spirit – the ecstasy that aches like misery – are close to Gauguin's later woodcuts, like *Soyez amoureuses, vous serez heureuses*.

92

The diversion of attention from the human content has human springs and connotations of another kind. The conclusive presence of colour requires only the minimum ascription, the linked chain of the arabesque in *La danse*, and in *La musique* the intervals themselves. They are appropriate illustrations of the themes of dance and music, but they are more. Their vast yet concentrated visual meaning gives us reason to believe that the painter attended solely to it without any other thought. Painting was well rid of the

83, 91

possibilities that were realized in sculpture. The formal synthesis of the final *Jeannette* was extraordinary, yet it was less extraordinary than Matisse's concentration, abandoning everything else by the way, on the fulfilment of his ideal for painting. His description of *La musique* continued in an instructional vein: 'Notice that the colour was proportionate to the form. Form was modified according to the interaction of neighbouring colours. The expression came from the coloured surface, which struck the spectator as a whole.'

It was the laborious process of modification that gave *La musique* its spare tautness in contrast to *La danse*, which had flowed from the brush. The modifications were guided simply by the artist's reactions to what he had done. Writing about Matisse, Apollinaire concluded: 'We should observe ourselves with as much curiosity as when we study a tree.' Matisse probably suggested the idea; he certainly exemplified it. 'My reaction at each stage', he said, 'is as important as the subject . . . it is a continuous process until the moment when my work is in harmony with me. At each stage, I reach a balance, a conclusion. The next time I return to the work, if I discover a weakness in the unity, I find my way back into the picture by means of the weakness – I return through the breach – and I conceive the whole afresh. Thus the whole thing comes alive again.'

92 PAUL GAUGUIN: *Soyez amoureuses, vous serez heureuses* (detail) 1901

Matisse, in fact, grasped as clearly as anyone an essential attitude of twentieth-century painting. The same self-regarding habit that had given him confidence in his direction was applied to the actual process of painting. His point of departure remained his subject, either a visible subject descended from Impressionism or an Arcadian one imagined on the Symbolist pattern. His method was to watch his reaction, and his reaction to the reaction, and so on until the cumulative process gathered a momentum of its own that became irresistible. 'I am simply conscious', he wrote, 'of the forces I am using and I am driven on by an idea that I really only grasp as it grows with the picture.' He understood an essential irrationality: 'Truth and reality in art begin at the point where the artist ceases to understand what he is doing and capable of doing – yet feels in himself a force that becomes steadily stronger and more concentrated.' The traditional starting-point might be so modified as to be lost and replaced by a form as elemental and primitive as the colour that filled it, as it was in the final state of *La musique*. The result was thus hardly less disconcerting than the work of the Cubists, whose invention was centred directly on form from the first. The fact remains that Matisse's very radical purpose was also in one respect reactionary. He needed to retain the Impressionist starting-point, and indeed to return to it over and over again, until he had assured himself from every possible angle that he had preserved the luminous substance that he required from it.

The frankness with which the painter and his intuitive reactions were placed in the centre of the stage was none the less original. Even Analytical Cubism retained the traditional extroversion of painting; basically it was an analysis of Post-Impressionism, developing the disjunctions of form and jettisoning the colour, but it was none the less outward-looking and founded on common experience. Matisse's alternative to the extroversion was a systematic and deliberate self-engrossment. Many painters were more subjective and more inventive. He was distinguished by an odd kind of objectivity. He was realistic about himself and the way he filled the role of painter. His view was extraordinarily acute and it yielded new information about the nature of the artistic process. Matisse instituted the method that has now become the method of virtually all painting. Deliberately basing painting on reactions to painting, he was setting in motion the modern feedback – the closed circuit within which the painter's intuition operates, continually intensifying qualities that are inherent.

There is hardly a more original talent in twentieth-century painting than this sedate, almost comfortable talent for self-regard. It grew on him, and it held obvious limitations from which he did not always escape. But Matisse's standpoint, which was so close to narcissism, had none the less a real sublimity. He was aware that the painter who is everything to himself has

reason for modesty as well as pride. The reaction that he studies is not his alone; the conditioning of the reflex was not due to him. 'The arts have a development which comes not only from the individual but also from a cumulative force, the civilization which precedes us. One cannot do just anything. A talented artist cannot do whatever he pleases. If he only used his gifts, he would not exist. We are not the masters of what we produce. It is imposed on us.' Whoever feels the radiance of Matisse's last works is experiencing the intensity that came from isolating what was intrinsic not only to a personality but to a whole tradition and the communally conditioned reflex that it depends on.

The inherent light in the conjunction of colours possessed a special magic for Matisse. When he had arrived at the three colours which gave him his 'harmony of light', it seemed to him that an actual radiance was generated. As a student he would put his picture in the centre of the studio and call the attention of his companions to it: 'Look how it lights up the room!' A sour rejoinder is recorded; one of the students said that if light were the object he would rather have an oil-lamp, and the future was apparently on his side. The decades that followed had no use for the idea of painting as a source of light; Matisse alone cherished it. At a certain moment in the evening, as the daylight was fading, *La danse* 'suddenly seemed to vibrate and quiver'. He asked Edward Steichen to come and look. (When his painting puzzled him he always sent for a friend.) Steichen's explanation of the Purkinje effect, in which warm and cool colours change their relative values at twilight (though perhaps not conclusive), is said to have satisfied him. Probably it no more than confirmed Matisse's faith in the magic incandescence of his pictures. It was not only painting that was luminous; his drawings shared the virtue. 'They generate light; seen in a dim or indirect illumination they contain not only quality and sensitivity but also light and variations in tone which correspond to colour.' Matisse thought of his pictures as actually emitting a beneficent radiation; they were extensions of himself. More than once, when people who were ill looked to him to nurse them, he left a picture with them instead, and went off to paint.

Only his art and himself were entirely real to him; more and more of the rest of existence was excluded. Painting was not only a source of painting; it became a part of his subject and soon he was representing a private world in which his own pictures shone like windows, a world that was often sufficiently peopled with his sculptures. For the rest of his life the interiors that he painted were seen as settings for his pictures, which shone out as nothing else, and without the slightest incongruity. The virtue of the procedure was regarded as self-evident. What could art rely on more surely than on art? What could form a more proper study than oneself?

1911–1913 Colour in itself

Younger painters almost without exception concerned themselves with the structure of painting. For Matisse alone colour remained the ultimate substance of the art. By 1910 it was the mark of seriousness in a painter to possess a rigid and consistent style. Only Matisse continued to work freely in a variety of manners as if style were incidental, a matter of choice. Not even his achievement in 1911, the greatest year's work he ever did, was based on a stable convention of its own. The works of preceding years had sometimes looked like hybrid combinations of Cézanne's modulations and Gauguin's patterning. The richness was to the taste of his Russian patron but the originality was elusive. It resided, as much as anywhere, in the most backward of qualities, the actual arrangement of a still-life. The decorative cloth on which well-chosen properties were placed would be drawn up with shameless artifice behind them so that the pattern filled the picture. In 1909 93 the spreading pattern in *Nature morte au camaïeu bleu* became a common medium of existence in which individual objects were suspended, patches of yellow, orange and copper-brown which float in the pervading blue-green. The all-over pattern makes an enveloping symbolic reality which is 'conclusively present' just as the colour is. In the spring of 1908 the pattern of the same cloth had appeared in a new version of Matisse's old subject of *La* 96 *desserte*, painted in a harmony of blue. The colour was clarified and heightened; the pattern spread up the wall behind the table – a pattern rampant that held the whole design in its curling claws. The picture was exhibited at the Salon d'Automne as a harmony in blue and bought by Shchukin. But next year Matisse saw a way of making the presence more conclusive still; he took it back and repainted it a uniform and continuous crimson. Someone who pointed out that it was virtually a different picture annoyed Matisse: 'There is no difference. It is forces that I am concerned with and a balance of forces.' One can still trace the process of adjustment along the edge, where the original colours remain. The aim was to bring the presence of the red-blue pattern and the distance of the emerald-green view outside into a balance of a new kind, active and vibrating. The subject of laying the table, which had once been presented in steep recession with the richness of

93 *Nature morte au camaïeu bleu* 1909

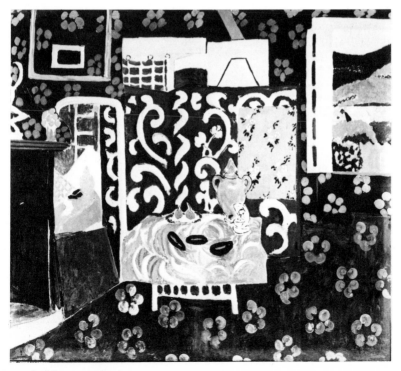

94 *Intérieur aux aubergines* 1911

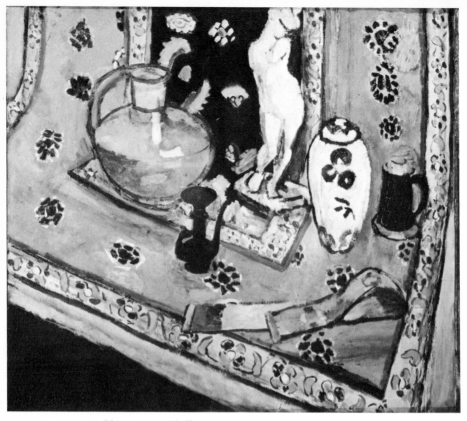

95　*Nature morte, Séville* 1911

nature, was now embedded in a single frontal plane, inlaid in the symbolic richness of a picture.

This new and active species of pictorial pattern had only one precedent; the flame-like rhythm of the wallpaper in Cézanne's *L'Ouverture de Tannhäuser*, which Vollard sold to the Russian collector Morosov in 1908; the pattern reappeared in one of Cézanne's self-portraits. The series of interiors and window pictures which *La desserte rouge* (or *Harmonie rouge*), inaugurated formed Matisse's most significant achievements in the next few years. In one of the first, *La conversation*, the vibrant visual equilibrium was identified with a strange emotional tension; the possibility was laid aside to be pursued at another time. The way toward the interiors of 1911 was quite untroubled. It is significant that the subjects were domestic, for conditions of

78

living were Matisse's deepest theme, but the everyday world was transcended in a fashion that lies quite outside the specific reference of Western painting. In 1910 his direction led him to the most delightful and productive of his sources, the experience of Islamic art, and to a great exhibition at Munich. He recorded that 'the Persian miniatures showed me the full possibility of my sensations. This art has devices to suggest a greater space, a really plastic space. It helped me to get away from intimate painting.' He was always clear that it was his own sensations that chiefly concerned him. His interest in everything else was strictly limited. Years later when he was considering visiting a great exhibition of Chinese art he confessed with a curious and almost disarming mixture of shame and pride: 'Je ne m'intéresse qu'à moi.'

Late in 1910 when he was depressed by Shchukin's initial refusal to accept the decorations, Matisse went to Seville. There in a hotel room he painted with extraordinary liquid fluency two versions of *Nature morte, Séville,* in 95, 100 which pattern finally broke loose and sprawled across the pictures, almost abolishing the identity of objects, overriding the furniture, devouring the fruit, eventually clothing everything in a vivid life which presses urgently forward against the picture plane. Patterns grew out of colour in 1911, a part of its pervading nature. They proliferated on every level; represented in the Post-Impressionist idiom or decorating the canvas itself as if naïvely, in the way pottery is decorated. One level merged into another; the spreading fabric represented an inherent quality of colour and a recognizable quotation both at once. Matisse's transcriptions of the popular decoration of the cultures that border the Mediterranean played an essential and original part in his creation of an ideal pictorial world. Their meaning lingered in his work to the end and they helped to form the art of mid-century, far more than the popular borrowings of Cubism, because they were so whole-hearted, radiant, infatuated.

As Matisse said, revelation always came to him from the East. The experience of Islamic painting at Munich suggested more calculated schemes than the riot of patterns that he painted at Seville. The *véritable espace plastique,* of which he spoke, meant in the language of the time the intrinsic space of art, in distinction to illusions of depth; it meant the spatial implications of areas on the picture surface. The devices that suggested it must have been the juxtaposed rectangular patches of different patterns – labyrinthine, reticulated or broadly spread with simple flowers – which map out the field of Islamic painting. They were echoed in *La famille du peintre,* 99 reversing Western perspective at a stroke. The areas that claim to show the veritable space of art apparently must be rectangular to make each conclusively present on the surface. Even here it is doubtful if Matisse's

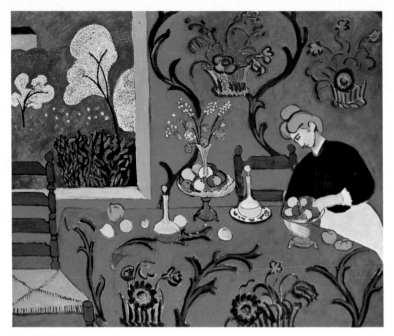

96 *La chambre rouge; La desserte – Harmonie rouge* 1908

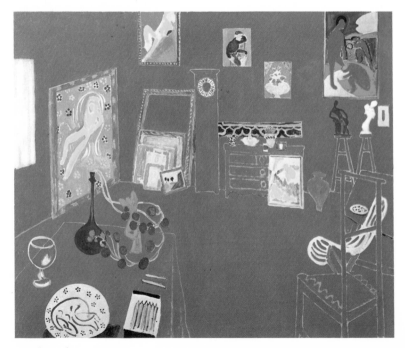

97 *Le studio rouge* 1911

98 *Fleurs et céramique* 1911

revelation came from as far outside his tradition as he supposed. The miniatures at Munich that anticipated his scheme, like *The Sultan Mustafa Enthroned*, in fact from Constantinople rather than Persia, were affected by Gentile Bellini's influence at the Sultan's court.

Matisse was in search of a childlike simplicity of definition. The systematic equivalence which he had found and taught between the colours of nature and the analogous systems of colour in painting were now too complex for him. He needed not colours but colour – a simple and single equivalent, hardly more than a single colour. Often the chosen colour was red; when he described his colour method the hue that came first was always red. His own impressive beard and hair were sandy red and it was a *Nature morte en rouge de Venise* three years before that had opened the new phase. Now the same colour was seen as a continuous medium flooding everything. In *L'atelier rouge* the space and its furniture are submerged in it. It is the substance of their existence; there are only the traces of yellow edges to show the immaterial frontiers where separate objects once existed. The identity of things is soaked out of them – all except Matisse's own pictures. They remain themselves, simple and lovely, situated at last in their own appropriate world.

Matisse had discovered for colour its deepest meaning. Colour was seen as all-embracing; it resided in the nature of existence. This is the meaning that was concentrated in the blue pictures of 1911 and 1912. The colour is now half emblematic. The bright spreading blue is the sky, the thing without limits that always attracted Cézanne; it is the general colour of space and of picture surface. The green which is allied to it is the colour of specific things, very simple, selected ones, a single plane or an isolated vessel. The cool continuum is only interrupted by the wedges of red or brown-pink, the representative of life in these pictures. In *Poissons rouges et sculpture* (a view across the studio at Issy towards a door opening under an awning on to an ivy-covered wall which we can only construe because Matisse later represented it directly) the awakening orange-pink of the figure is concentrated in the lively scarlet fish. As in the *Fleurs et céramique* the colours blossom together outwards from the centre, as if of their own accord; they make room for one another, hardly touching.

When Matisse was painting *La famille du peintre* he wrote significantly, 'This all or nothing is very exhausting.' It was indeed a matter of all and nothing, an ideal pictorial wholeness that eliminated the separateness of things. This was the historical antithesis to Cubism. As Braque said, 'Colour either absorbs or is absorbed'; with Matisse it absorbed everything. The elimination was ruthless; only the living germ of the picture was preserved. The result was at the opposite extreme to the coherent material reality of the Impressionist tradition. Only one artist among Matisse's predecessors had

99 *La famille du peintre* 1911

100 *Nature morte, Séville II* 1910–11

achieved such sacrificial concentration; Moreau's teaching had equipped Matisse to understand Redon (Matisse once chose a picture by Redon for his father) and it appears that the understanding bore fruit in 1911.

The supremacy that colour attained in these pictures was quite new and unparalleled. Colour was no longer put to any descriptive or expressive purpose. It was simply itself, the homogeneous primal substance. The development culminated in an inspired invention. Can anyone forget when

101 he first became aware of *La fenêtre bleue*? In a moment one knew one of the simplest and most radiant ideas in the whole of art, the idea that the shapes of things are immaterial except as fantastic vessels – a dish, a vase, a pot like a chalice, a tree like a bunch of balloons – to contain the airy brightness of the world. The blue fills them. They are gently inflated and rounded by the pressure. The common colour presses outward with a persistent pulse. The descriptive green that preceded it remains visible between the brush strokes, but the blue has come to stand for all colour, all but its precious antithesis, the golden ochre.

116

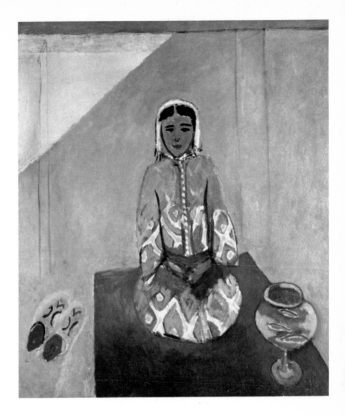

102 *Zorah sur la terrasse*
1912

The solution that Matisse sought was an extreme one; the difficulty of it tormented him. 'Painting', he wrote, 'is always very hard for me – always this struggle – is it natural? Yes, but why so much of it? It is so sweet when it comes naturally.' Some circumstances were more favourable than others and in two wonderful winters he found the conditions in which painting came most naturally and sweetly of all. Morocco bridged the gap between the reality and the dream. There was something of his imaginary ideal in the place and the light and his brush moved more freely there than ever before. His explanation is interesting: 'These visits to Morocco helped me to make a necessary transition, and to gain a closer contact with nature than would the practice of any theory such as Fauvism,' which had become lively but somewhat limited.' It seems that a place, and especially a southern place, could do for him what his system and his style had sought to do. It provided him with what he required from painting – the realization of a desirable state of being. Later his move to Nice had an analogous effect; the environment took the place of a style.

103 *Paysage vu d'une fenêtre,*
Tanger 1912

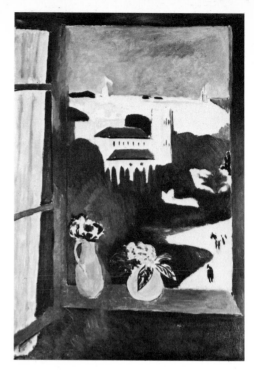

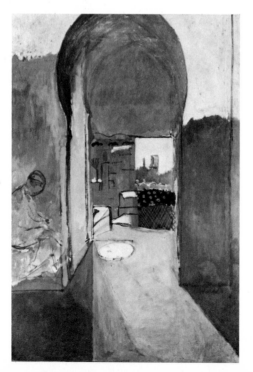

104 *La porte de la Kasbah*
1912

105 *Zorah debout* 1912

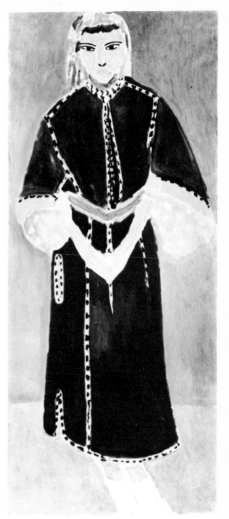

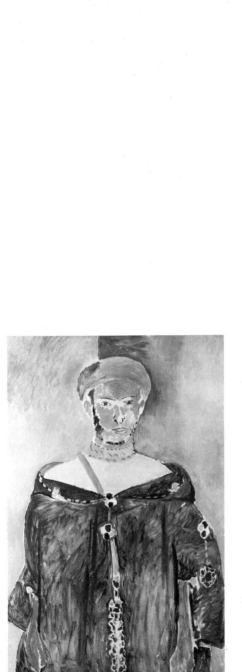

106 *Le riffain debout* 1912

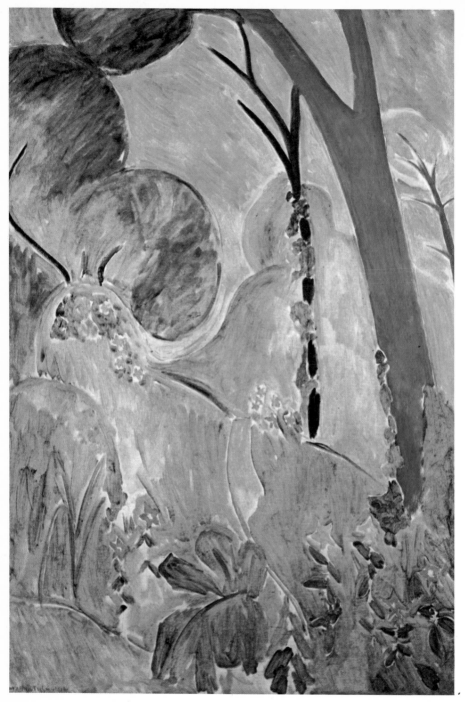

107 *Jardin marocain (Pervenches)* 1912

In Morocco his sensations guided him. The presence of *Le riffain debout* was 106
made out of nothing but emerald-green, flooding out almost to the edge of
the picture. Pink and ochre were scumbled across the head, leaving for
shadow a blue-grey that was lighter than either. In the three Tangier
pictures, which he authorized Morosov to hang as a triptych, the blue
flooded everywhere, across the casement and the landscape alike,
incorporating bright inhabited islands of ochre and softening an enchanted
fastness – in actuality the English church. In the pictures of Moroccan
gardens the relaxation was complete. The colour is languorous and dramatic 107
by turns; lustrous meetings of green with mauve-pink and violet-blue are
broken by sharp emerald explosions of light on palm leaves and aloes.
Characteristically, the final meaning of colour was only attainable through
the uttermost luxury. It made visible an unlimited state of being.

The development ended at home a few years later in one of the fullest and
emptiest of Matisse's window pictures. In *Le rideau jaune*, which Matisse 109
called *Composition*, colour is no longer identifiable as either object or non-
object, thing or space. Matisse needed the yellow, as he said, not to describe
anything but simply to express his 'excitement and pleasure at the contrast of
trees and sky . . .'. The great shapes were filled and rounded by the colour,
until the scene took on the elemental simplicity of some basic natural
situation. Matisse once wrote: 'I express the space and the things that are
there as naturally as if I had before me only the sun and the sky, that is, the
simplest thing in the world. . . . I think only of rendering my sensations.'
Pictures like *Le rideau jaune* mark the fulfilment of the self-identification that
he had sought from the beginning; we become aware of the reality of a
relationship of which he often spoke towards the end of his life. He
explained, for example, that study allowed him 'to absorb the subject of my
contemplation and to identify myself with it . . .'. He spoke of a painter's
need for whatever 'will let him become one with nature – identify himself
with her, by entering into the things . . . that arouse his feelings'.

The long process had reached a triumphant conclusion. When *Le rideau
jaune* was painted Matisse's style was already altering and soon it had
changed completely. The concern with bright colour for its own sake,
which had seemed the mainspring of his work, was laid aside, as if in reserve,
for twenty years.

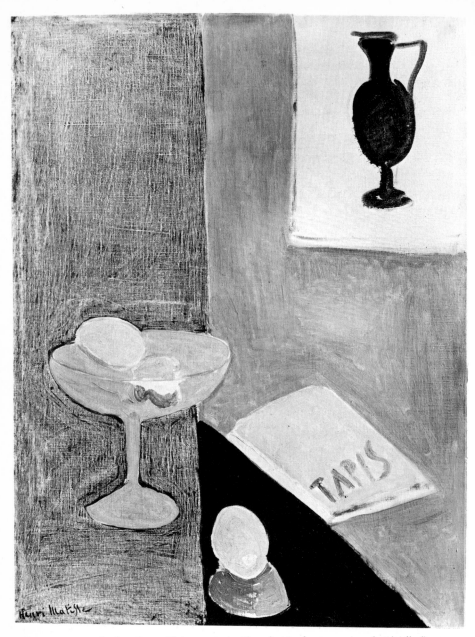

108 *Les citrons; Nature morte de citrons dont les formes correspondent à celle d'un vase noir dessiné sur le mur 1914*

109 *Le rideau jaune 1915*

1913–1918 The period of experiment

Matisse turned abruptly to the formal structure that was the general preoccupation of the time. Yet it was far from reducing the personal character of his work. The constructive strength and the depth of tone, and underlying them the sense of disciplined purpose, which all reappeared in the next few years, reflected something in his artistic personality that had hardly been seen since the beginning of the century. It is clear that his final destination could never have been reached direct from Fauvism; something systematic and deliberate in his temperament was missing from it.

133 Morocco, as Matisse said, had brought him into closer contact with nature. The *Portrait de Madame Matisse*, which he finished in 1913 after a hundred sittings, established a contact of another kind which was closer still. In place of the sensuous reverie the formulation was suddenly specific and exact. The pervasive blue, holding as much light as ever, generated a grey tonality in which the curving surfaces of the head could be modelled with a simple clarity. The smooth convex plane along the eyebrow and the nose was the kind of shape that his friend Brancusi had lately reached in sculpture. (Soon afterwards Brancusi seems to have drawn a suggestion for a sculpture entitled *The First Cry* from the sliced facet of the eye in the final state of Matisse's *Jeannette*.) The economy of style in the portrait was austere, yet it brings us as close to a specific person and to the alert balance of a particular pose as anything in twentieth-century art. It restored at a stroke to Matisse's art an older and more solid kind of structure, and used it for the authentic classical purpose. The picture was exhibited at the Salon d'Automne in 1913 and made a considerable impression in France before it went to Shchukin, who had bought it while it was still on the easel. It had, as Matisse wrote, a certain success *parmi les avancés*. Its influence was reflected in the work of Modigliani. Despite its success the picture did not satisfy Matisse. He told his friends that a long and arduous effort lay ahead. In the years that followed he painted a series of portraits on the same scale, like variations on a theme, traditional enough in itself, which was for him essentially new. The direct presentation of a figure, with its physical presence and human role intact, shifted the emphasis of painting. The sitters filled the canvases as the nude

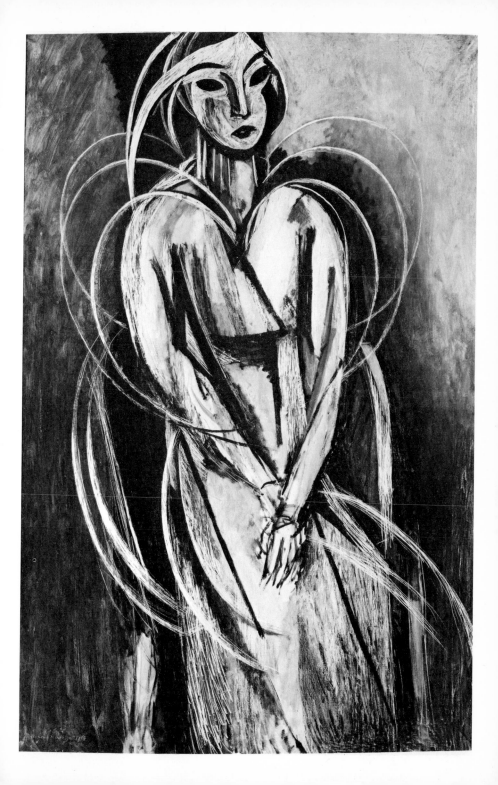

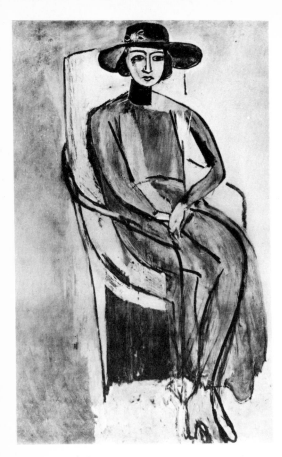

66–9 came to fill the relief of *Le dos*, which Matisse reworked at intervals in the same years. The figure constituted the form.

110 The picture of *Mlle Yvonne Landsberg*, which he painted in the next year, 1914, was in the outcome far from traditional. It began as a realistic portrayal of a slight, reserved young woman. But at the end of the last sitting Matisse suddenly incised into the paint great curves which sprang outward from the V-shaped neckline and arched across the background to converge towards the elbows and the hips, curving out again to echo the shape of the thighs. The figure spun a diaphanous cocoon of lines, and the picture was finished. There had been no sign in Matisse's work before of shapes that so plainly and deliberately transcended the forms of life. Yet the invention does not appear imposed upon the sitter. It is like a natural emanation, unfolding a delicacy of

126

her own, as a flower might unfold. Matisse had been drawing magnolia buds before his sitter arrived that day, and the device conferred on her a metaphoric efflorescence. Its dynamic character was a characteristic of the time. Boccioni's practice and theory, in sculpture particularly, made much of lines of force, and the example may have stimulated Matisse. His purpose was different. The self-contained linear web was the antithesis of the lunging directions of the Futurists; its heart-shaped pattern was a recurrent shape in his own work. Matisse's lines of force extended an image that would in itself have seemed meagre and isolated in the picture. He explained quite clearly that the intention was simply to give the figure more amplitude in the space.

The arduous effort, which in 1913 Matisse detected lay ahead, was concentrated on breaking out of limitations that had appeared to be the precious virtues of his art. In the years that followed, a basically sensuous, Post-Impressionist style was transformed in a strenuous series of experiments. The new basis of style was rectilinear design, coincidences of direction and formal correspondence – the devices that Matisse described (when he imposed them on a still-life by de Heem) as 'the methods of modern construction'. Its object was a unity of interplay and analogy, not so much sensuous as intellectual, reflecting the rigorous temper of Cubism but abstaining from its increasingly playful fancy. For a year or two after 1914 Matisse seemed to embark on as many styles as pictures. The results were not only different from anything before; they were inconsistent with one another. He was undeterred; he pressed on, keeping all the options open. The expression of his work was changing, too, to accommodate the tension and anxiety that in 1908 it had been the avowed purpose of painting to eliminate. There was an alternative to the amplitude that he conferred on Yvonne Landsberg – a mood of isolation and restraint that confined a figure in a picture as if in a prison.

The atmosphere was now restless, strenuous and tense. It has often been thought that the example of Cubism had at last penetrated the defences of Matisse's self-indulgent art. In fact in 1914 the Cubists were moving in the opposite direction, towards a fanciful self-indulgence of their own. The need for a more deliberate and calculated form was already implicit in Matisse's portraiture and the succeeding portraits in 1915 and 1916 experimented continually in the most various directions with uncertain success. The old themes, like the goldfish, were repainted in the new speculative, striving frame of mind. Not only the lines of force in *Yvonne Landsberg*, but half the image in a portrait like *Mme Greta Prozor* or the last sombre, desperate 111 *Poissons rouges* in the Schönborn-Marx Collection was carved and scraped out of paint. Matisse's mood in these years was extraordinarily ruthless and reckless. His intelligence was ferocious and intolerant of anything in his way.

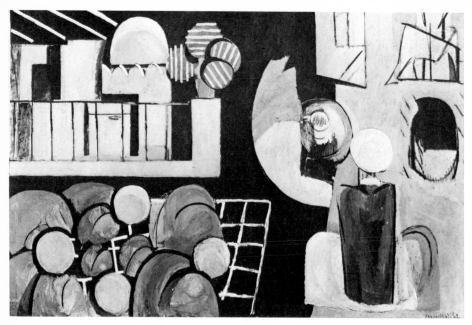

112 *Les marocains* 1916

He deleted it irritably or scratched it away, leaving untouched only his own glinting, darting emblems, the scarlet and crimson fish, until sometimes almost the whole of a picture seems to be made out of half-erased vestiges. He compelled the picture to take on a new form, a structure of analogy and interplay for which there was essentially no precedent.

112 *Les marocains*, a formulation of his memories of Tangier, was bolder and more baffling as well as more subtly inventive than any earlier picture. But it was also in a sense more objective, more definitely and conclusively shaped to represent real correspondences and echoes of the kind that had been evoked elusively before. The three zones of the picture arranged respectively impressions of the buildings, the still-life and the people of the city. Alfred Barr, in one of the acute studies that are embedded in his great book on the artist, pointed out that 'they are like three movements within a symphony – with well marked intermissions – or perhaps three choirs of instruments within the orchestra itself.' Following the chain of spherical analogies Matisse, who knew the Louvre as well as anyone, may well have had Poussin's *Eliezer and Rebecca* at the back of his mind.

128

There survives from the first autumn of the war a canvas called *La porte-fenêtre*; it is a view between parallel vertical strips of a shutter and curtain – blue, grey and green – into black night. The darkness is ominous yet the four colours rest calmly together on the picture surface. The vertical formulations of these years often held a sense of tension. It is one of Matisse's two alternative moods; sometimes in these years he painted a version of his motif in each mood in turn – the one tense and calculated, revising and reiterating the subject until it could be stated with the most austere simplicity, the other resuming the subject with an extempore fluency that might appear carefree. His old motif of Notre-Dame, situated now in a schematic linear setting was measured and weighed over and over again till it bulked exactly large enough in the diagrammatic blue-grey expanse of one canvas, while in another simultaneous variation it was painted as if impromptu with flower-like fragility and abundance in fluid liquid paint. But the pictures of this time were not often like the comfortable armchair to which Matisse had likened painting in 1908. Their symbol was rather the penitential stool on which Mme Raynal was made to pose for *Femme au tabouret* in 1913–14. As every human grace was progressively deleted from the minimal grey scheme, the picture became the most disturbing of Matisse's images. The only gloss on

113, 114

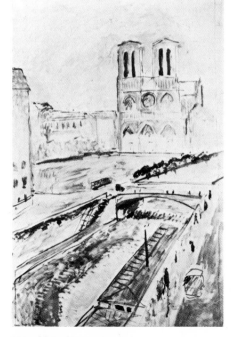

113 *Notre-Dame 1914* 114 *Une vue de Notre-Dame 1914*

the austerity was the drawing of a vase by his son Pierre, shown pinned to the wall behind, a drawing that he used more than once to supply an analogy to the oval shapes of life in front. Matisse's subjects were now taking an unexpected turn; often they had an elusive illustrative content that was quite new in his work. Earlier there was an impression of harmonious domesticity in the background of his work. But now he seemed to be reflecting on actual situations, led to them perhaps by the specific likenesses of portraiture. When he came to paint the masterpiece with which the experimental phase culminated in 1916, *Le leçon de piano* in the New York Museum of Modern Art, his subject must have been a memory of family life half a dozen years before when his son Jean as a boy of ten had been constrained to practise. His task and the design of the great broad canvas both imprison him; only his sulky head is visible. *Femme au tabouret*, hanging on the living-room wall at Issy, was turned into a human presence. Instead of victim she is now a forbidding invigilator who turns her head to watch the boy at practice. He is under duress yet the predicament is not seen as wholly painful. It is assimilated to a poetic moment – the moment of twilight on a summer evening. The *porte-fenêtre* is open to the darkening garden; a lighted candle has already been placed on the corner of the piano, perhaps on the way to a bedroom, and there it burns palely in its short brass candlestick. The major light in the room is from a lamp out of sight to the right. It passes transversely across the scene, striking the boy's forehead and leaving triangles of shadow under the shelves of brow and chin, catching the curtain and the open casement with a bright silver-grey, in sparkling contrast to the dull dove-grey of evening outside, and outlining with casual clarity the porcelain window-knob. The picture is often read as a step towards abstraction. In fact the beauty is quite concrete and specific; the structure itself is a function of visual effect. The colours of the room and the green of the garden outside are brought serenely and lucidly together as if to dissolve the strains of life in the consistency of light.

Yet, Matisse kept the other option open. At the same time as *Le leçon de piano*, or soon after, he painted another version of the subject, as relaxed as the other version was tense, known as *Leçon de musique* and now in the Barnes Foundation. The style developed out of his work in Morocco. The fluent description and the spontaneous, fluid paint imply that he is at ease with his surroundings. The whole family foregathers with its occupations in the living-room and garden at Issy. Matisse's own painting and sculpture fall back into their usual roles as passive attendants. It may be that the spectre of the domestic tension had been exorcized by *Le leçon de piano*. But the need for strenuous experiment had passed. From this moment on the world that Matisse painted was again a kind of paradise.

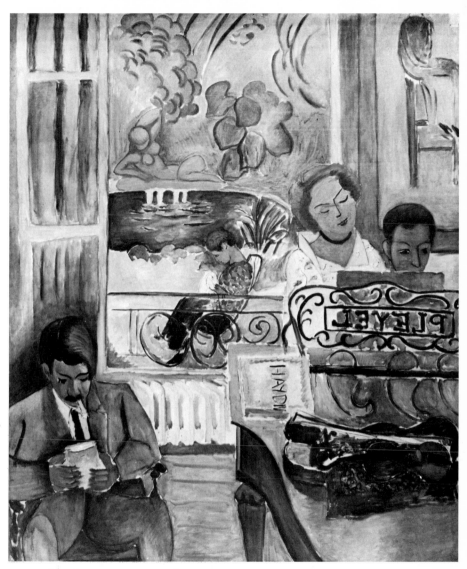

115 *Le leçon de musique* 1917

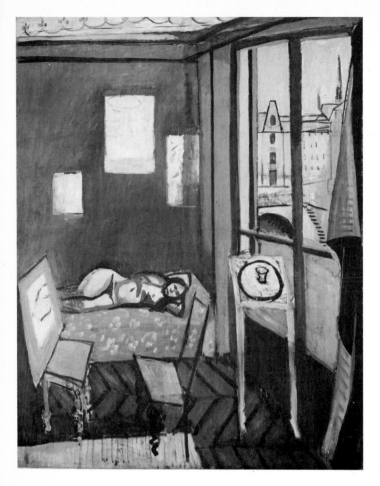

The outcome of the experimental phase was a series of pictures devoted to his painting-room in the Quai St Michel and, more profoundly, to his reflections on the character of his art. The long, worried preoccupation with the plan and the stylistic programme of a picture seems to have led him to the rediscovery that for him painting was ultimately life-painting, recording an instinctive reaction to a living model posing in the studio. Painting his studio he reflected on the character of the equation between model and picture. In one of these canvases, *L'atelier, Quai St Michel* in the Phillips Collection, Washington, D.C., the correspondence is one of geometry and drawing. The

116

132

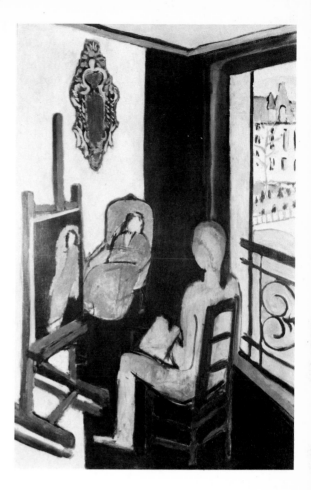

117 *Le peintre et son modèle*
1916–17

roundness of a nude model (outlined in elliptical black contours), who is
posing on a rectangular couch, is equated with a variety of elliptical images
on square panels dispersed round the room until it finds its counterpart in a
round yellow tray on a square table with a glass in the centre, and the primal
circle is recovered – as round as the arch of the bridge outside. A lateral
movement of the eye is built into the picture, recording two if not three
superimposed perspectives, the movement which the absent painter makes as
he compares the shapes of art with life. In the next version, *Le peintre et son* 117
modèle in the Musée Nationale d'Art Moderne, the painter himself appears,

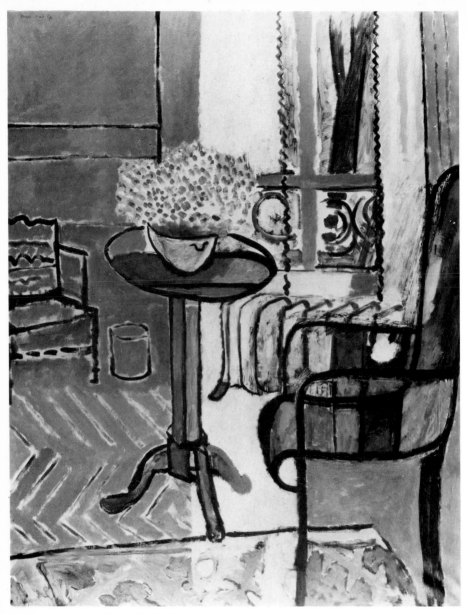

118 *La fenêtre; Intérieur* 1916

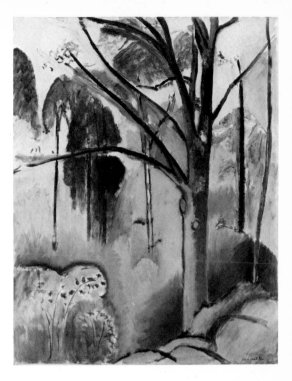

119 *Arbre près de l'étang de Trivaux*
1916

as impersonal as a lay figure, recalling the tubular formulation of the figure in the lithograph, *Nu*, of ten years earlier. The design epitomizes the threefold dialectic of painting. The artist, the model and the picture are arranged side by side. The impersonal painter is observing a close and vivid equivalence, achieved through an echoing chord of emerald and lilac. Again the lateral progress of the equation is reflected in successive perspectives, but now the purpose is to situate the activity of painting comfortably within the rectangle of the picture. The top of the easel is squared off to make it agree not with the canvas represented or with the receding illusion but with the real one, the actual canvas we are looking at. The analogies out of which the design is built are almost more elementary than we can credit. The arch of the bridge is compared with the dome-shaped cloud and the arch of the chairback in the room and in the painting represented; the painter carries them all in his dome-shaped head. He sees himself as an elemental figment of a man; he announces a view of the painter's business which is, by the sophisticated standards of the time, indeed by his own standards in the restless experimental phase, which had lately ended, quite extraordinarily simplistic. The vision grew increasingly direct and simple. In *La fenêtre*, now 118

48

135

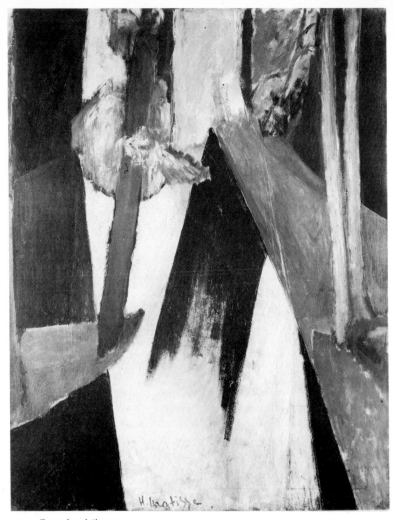

120 *Coup de soleil* 1917

at Detroit, the vertical structure is turned into the geometry of light; the
picture tells more about the natural fall of daylight than anything else that
Matisse had painted for ten years. Some of the landscapes of this time were as
natural and lyrical as anything he ever painted. The tide of colour, which had
flowed and ebbed, now began to flow in his work again and *Arbre près de
l'étang de Trivaux* has a sense of spring. Experience had taught Matisse exactly

119

136

the delicate order of shape in which the colour and forms of nature best agreed. It was a pattern of buoyantly inflated spheres – a design apparently easily come by, almost facile, yet fairly containing the green and blue of earth and sky and holding them gently together.

Yet the duality still remained. In the same woods at about the same time on a canvas of the same size Matisse painted the alternative kind of picture, dynamic, inventive and tense. The parallel lines of a path between the trees, rendered in slanting bands of light and dark, are flooded by a burst of whiteness, which eliminates everything but the geometry of the *Coup de soleil*. In the same mood, the subject of bathers by a river, originally designed as the third decoration to accompany *La danse* and *La musique* on his patron's staircase at Moscow, was at last formulated in parallel vertical zones, with an enormous yet gracious grandeur, as the *Baigneuses* now at Chicago.

Then the anxieties of the experimental phase were laid to rest and they never disturbed him again. He made a great feathered hat for his model, in which he drew her repeatedly and painted her twice, in pictures called *Les plumes blanches* now at Gothenburg and Minneapolis. The white plumes held the same curls and globules of light as the trees at Montalban. The strenuous phase was over. For a time in his suburb of Paris he painted as if in Morocco;

120

41

121

122, 124

121 *Baigneuses* 1916–17

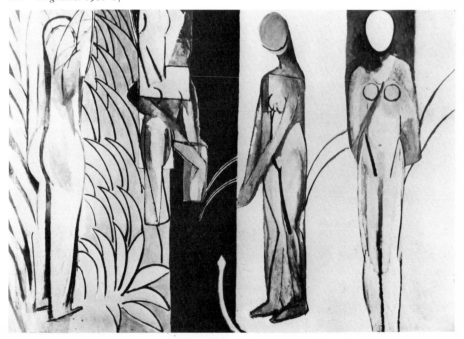

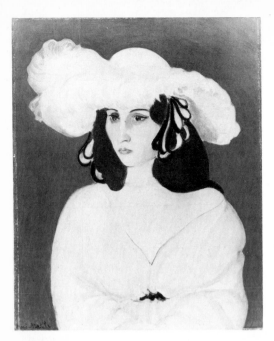

122 *Les plumes blanches* 1919

123 *Les coloquintes* 1916

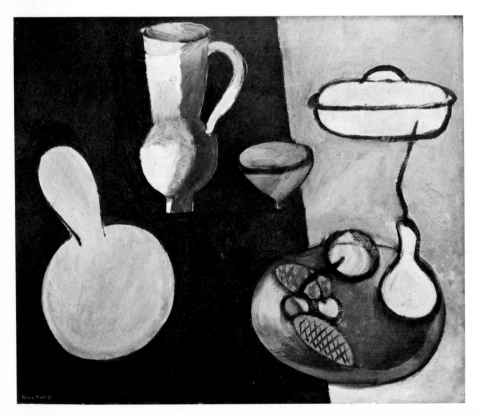

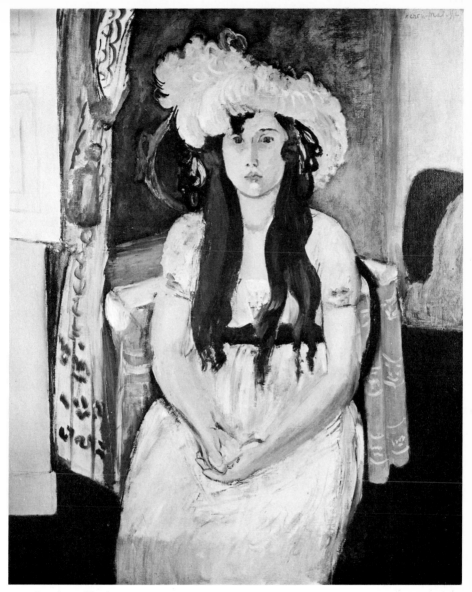

124 *Les plumes blanches* 1919

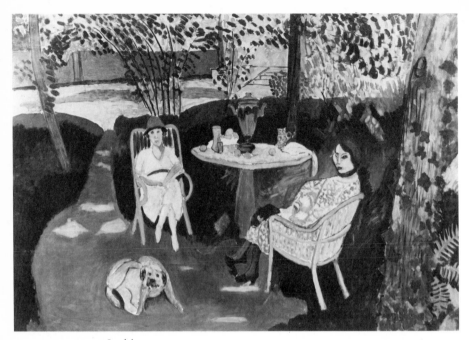

125 *Le thé* 1919

a beautiful fluency resulted. His garden at Issy was found to be a place of
infinite delight. *Le thé*, in the dappled light among the ferns under ivy-
covered trees, where emerald mingled with violet, represented a moment of
ideal contentment; it had even a delicate quality of comedy. The painter's
daughter Marguerite, her head acutely characterized in a combination of
aspects that is a relic of the Cubist experiments, slips wearily out of her shoe;
the dog looks up, arrested in mid-scratch; it is all preserved perfectly for us in
the deep pools of shadow. In this mood of relaxation Matisse made his least
obtrusive yet most intimately satisfactory discovery. The untroubled
comfort of his own household was recognized as the very condition that he
had always sought in painting. He identified his private theme with the
actual domestic subject. It lay all about him, obedient and lovely, and he
painted it with few interruptions for twenty-five years, until at the end of his
life it led him to the transcendent essence of his art.

125

140

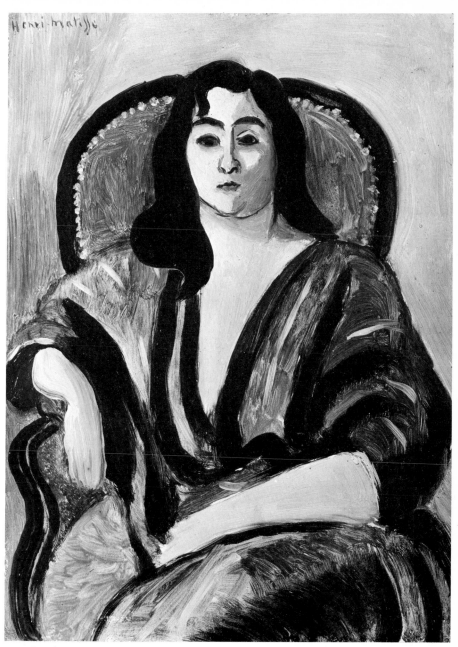

126 *La robe verte* 1916

1919–1930 Wish fulfilment

When he moved to Nice in 1919, the place in itself was enough to confirm his sense of well-being. Painting had merely to reflect it, as directly as possible. Spontaneity, a studied candour, even the repetitiveness with which the same ideally radiant interior was presented, were all essential to the demonstration. When he returned to the subject of *Le peintre et son modèle* his approach was quite innocent of the earlier deliberation. The canvas, now much smaller and more lightly worked, looked like an impromptu impression of how the Nice studio, full of flowers, happened to charm him on a certain day. If the subject, a seductive woman with a palm tree, made an allegory of fertility, it was only another of the happy accidents that he now enjoyed in every picture. They proved that painting shared naturally the sprawling coloured abundance of the world. Matisse was assuring himself of the real existence of the conditions on which his dream depended – flooding colour, pattern that was everywhere and the freedom of every sensuous delight.

Harmonies that he had extemporized before he now studied over again at infinite leisure from nature. The settings and satisfactions of figure-painting, which he had fantasized at intervals all his life, he now reconstructed in actuality. He sat himself down among the florid apparatus of self-indulgence to examine it all with an industry and a frankness that were deeply complacent and quite unashamed. His style was sometimes more naturalistic than it had been since his time as an academic student. Unlike Picasso's *ingrisme* in the same years, Matisse's traditionalism in the twenties was not in the least ironic. He took his leave of art-politics; if his progressive-seeming experiments had retained the interest of *les avancés*, he sacrificed it now, and never fully won it back again until after 1945, when a new generation, which had been taught to regard him as a lost leader, one of those who had retreated to familiar ground in later life, rediscovered him with incredulous delight as the hero of a new *avant garde*. He was seen as the pioneer in a whole new territory, where alone the intrinsic beauties of painting were to be found, a region of which the self-appointed progressives of the twenties and thirties had remained miserably unaware. The solidity of some of his pictures in the twenties reminds one that Matisse owned, as well as works by Cézanne,

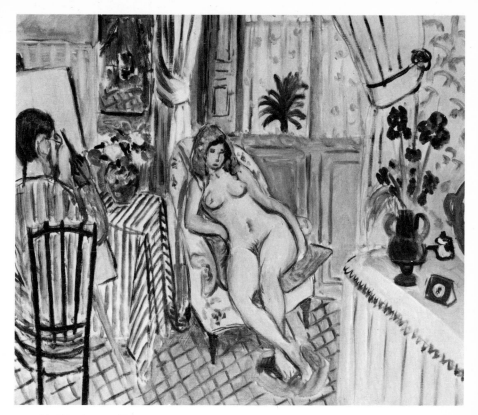

127 *L'artiste et son modèle* 1919

Gauguin and Van Gogh, the most beautiful of Courbet's smaller paintings of
the nude, *La blonde endormie*. A few pictures early in the decade like
Méditation, which is also called *Après le bain*, took on a reflective gravity that 128
is rare in the figurative painting of the twentieth century; the models seem
indeed to be meditating, with a seriousness quite foreign to the time, on
some essence distilled from the tradition of Delacroix and Renoir. The
prolonged pantomime of harems and odalisques which the unimpeachable
painter and his models performed together in the twenties served a purpose –
one that was quite invisible to his progressive critics. Making a fantasy
almost incongruously real, Matisse was systematically reinforcing his faith in
painting as a source of undisturbed pleasure. Methodically he proved to
himself that art was capable of satisfying the exorbitant requirements that he
never renounced.

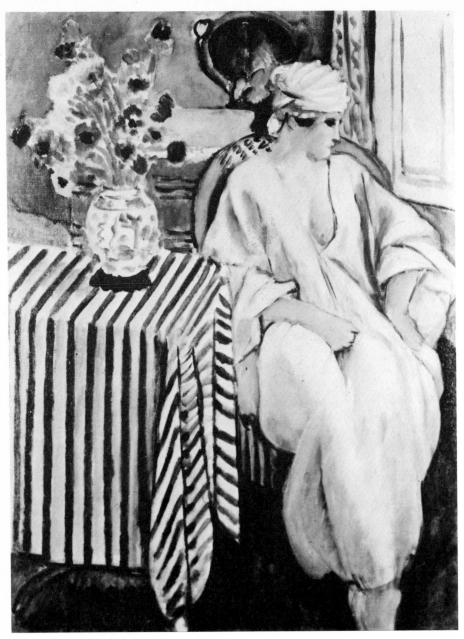

128 *Après le bain* 1920

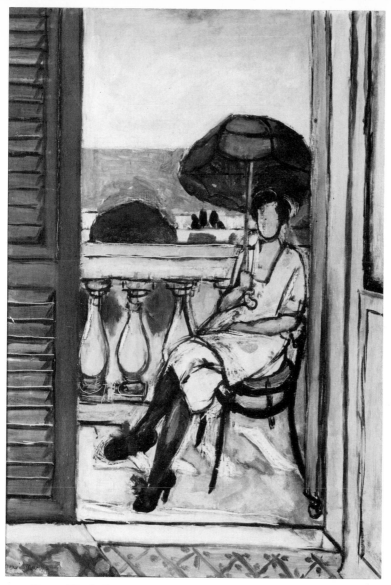

129 *Femme à l'ombrelle* 1921

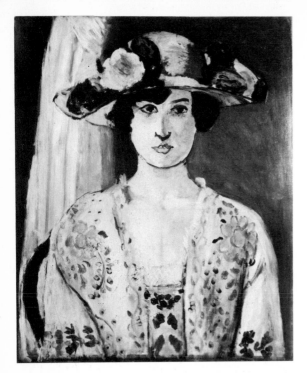

130 *Femme au chapeau* 1920

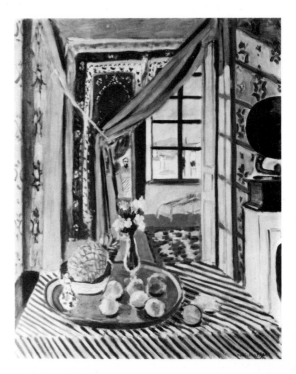

131 *Nature morte dans l'atelier* 1924

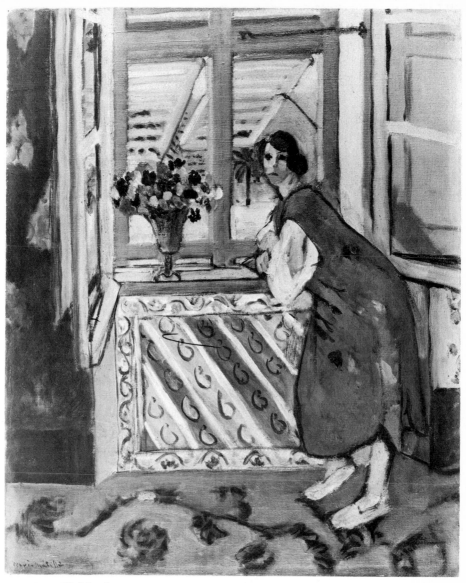

132 *Jeune fille à la robe verte* 1921

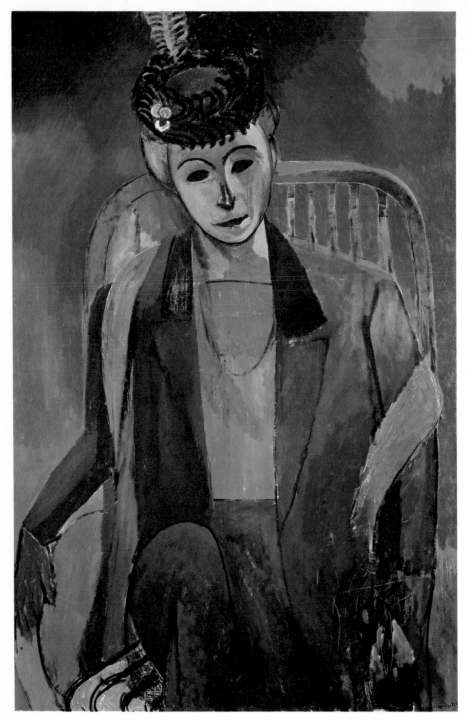

133 *Madame Matisse* 1913

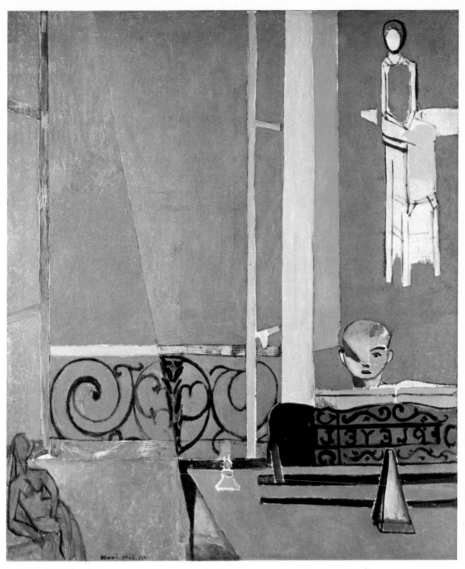

134　*La leçon de piano* 1916

He needed to recover for painting a natural reference that was missing in the deliberately processed images of modern art. The natural effects that concerned him were reviewed a good deal more systematically than the inconsequent style of the pictures suggested. First the common radiance of colour was identified as a quality of reflected light, filtering into calm shuttered rooms by the sea. Then he returned to his old theme of interiors filled not only with light but with the gentle, continuous pulse of southern patterns. He proceeded to relate the robust rhythms of his model more boldly to a Moorish ogee motive. Then the purpose changed again and he traced the figure against a regular lattice.

From the start his style was very literal, but quite mild and *dégagé*, not at all laborious, portentous or ingenious. The paint was thin and the colour initially quite limited, restricted to begin with to a repeated and seemingly trivial scheme of pink and honey-colour. The apparently effortless lightness of touch, which, as Matisse said, in fact cost him a lifetime of labour from morning to dusk, was the sign of confidence and contentment with an actual situation. On this basis Matisse embarked on a systematic and purposeful train of thought. Almost all the significant pictures are of models posed in interiors looking out on the sea at Nice, but this subject-matter and the satisfactions for which it stood evolved continuously through the decade. To begin with the terms of reference were domestic or social; often the model was *mondain* and chic; repeatedly Matisse outlined with incisive delight her high-heeled shoes. As she sat on the balcony the seaside light poured round her into the room, linking the pink and fawn interior with reflections from the red-tiled floor. *Grand intérieur, Nice*, for example, embraced an extraordinarily wide vertical angle of vision, from the cornice to the floor at the painter's feet, which allowed a poetic rhyme: the lobed half-circle of the fanlight was echoed by a padded, round armchair in the room below; we are reminded that, looking down at furniture, we see it as if up-ended. Yet *Grand intérieur, Nice*, the kind of picture that is still underrated except by collectors, is as peaceful and as fresh as anything that Matisse painted. He was never nearer to Vermeer.

Matisse's work in the twenties passed, with unobtrusive purposefulness, through successive phases. He dealt in order with the domestic, the sensuous, the exotic, the sensual and lastly (most unexpectedly) the monumental aspects of his subject. By the middle of the decade family life had largely disappeared. Games of checkers, desultory music at the piano and the familiar living-room possessions reappeared among more and more vivid Moroccan decorations, and were then swallowed up in the studio performance. Henceforward, one has the impression that the studio and the ways of thought that went with it absorbed the whole of Matisse's life. It was

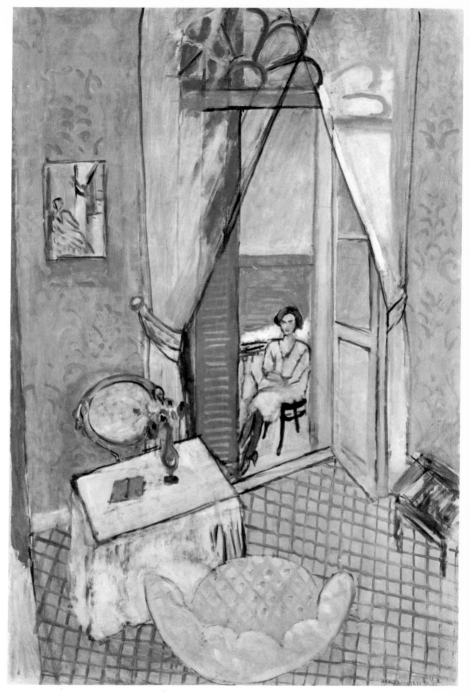

135 *Grand intérieur, Nice* 1920

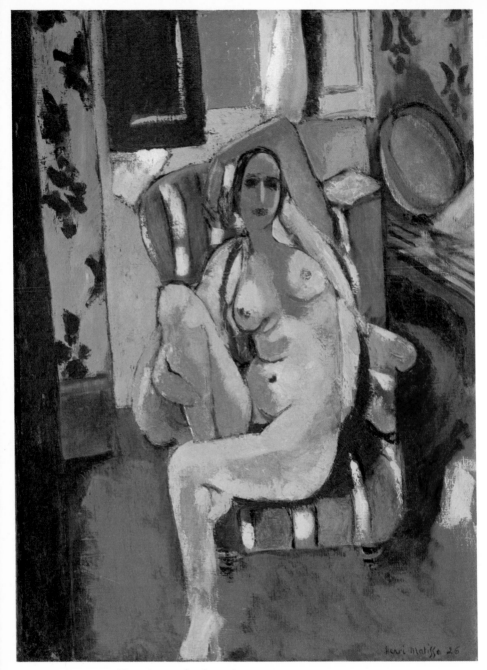

136 *Nu assis au tambourin* 1926

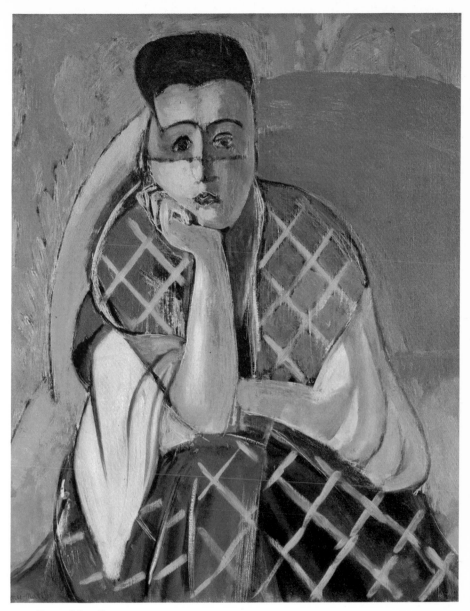

137 *Femme à la voilette* 1927

the setting for his increasing engrossment in the flesh. For a time flesh was the continual subject. Individuality and character, however far his own utterances were from admitting it, were strictly, indeed callously, subordinated. Painting from nature, he was trying to relive an impossibly voluptuous dream. Yet the issue was crucial for an art such as his, and he had never faced it so directly. As always, he was quite clear about his preoccupation: 'My models . . . are the principal theme in my work. I depend entirely on my model whom I observe at liberty, and then I become the slave of that pose. I often keep these girls for years, until the interest is exhausted.' He was evolving the form of dream that could be depended on to last. Ultimately the fleshly preoccupation proved transitory, indeed incongruous, but the fantasy of delight spread to embrace everything. '. . . The emotional interest aroused in me by them does not necessarily appear in the representation of their bodies. Often it is rather in the lines, through qualities distributed over the whole canvas or paper, forming the orchestration or architecture. But not everyone sees this. Perhaps it is sublimated voluptuousness, and that may not yet be visible to everyone.' His first draft of the passage ended, 'I do not insist on it.' (The charm of the man often evaporated before his writings saw the light.) As usual, he knew himself well. His last burst of unblushing self-indulgence contributed something indispensable. The wholeness of his pictures came more and more to possess a distributed, sublimated voluptuousness. The pervasive quality of sensual fulfilment, which marked his achievement in the last decade of his life, was rooted in his work of the twenties.

Yet it may be that there was something in Matisse's habitual pattern of sensual behaviour and in the assumptions that came naturally to him, that was in the last analysis a limitation on the human gravity of his work. The idea of a model as a retainer utterly subject to his caprice and, after however long and charitable a delay, ultimately disposable, to which he confessed with disarming frankness, is not quite the conception of the greatest figure-painters. In the last years of his life, when a writer tried to persuade him to pronounce against the non-figurative tendencies of young painters, he answered: 'For me nature is always present. As in love all depends on what the artist unconsciously projects on everything he sees. It is the quality of that projection rather than the presence of a living person, that gives an artist's vision its life.' Involuntarily he was admitting to a far from amiable conception of love. The fact that the object of love was never wholly real to Matisse, or meaningful to him in her human role for her own sake, placed a limit on the emotional depth of which he was capable. It was a limitation that he shared with his time. When art-politics restored him to an eminence like an imperial throne, a species of sexual politics that seems to make chauvinism

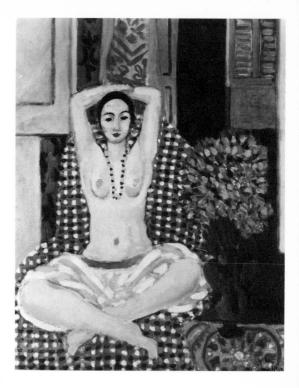

138 *La pose hindoue* 1923

139 *Femme et poissons rouges* 1921

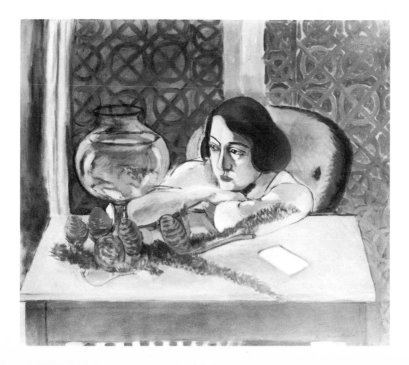

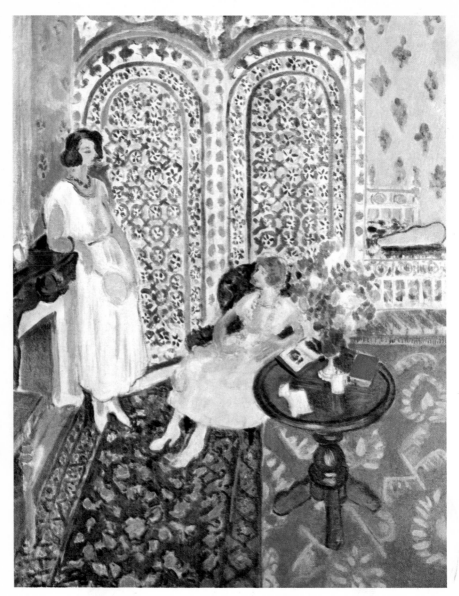

140 *Le paravent mauresque* 1921

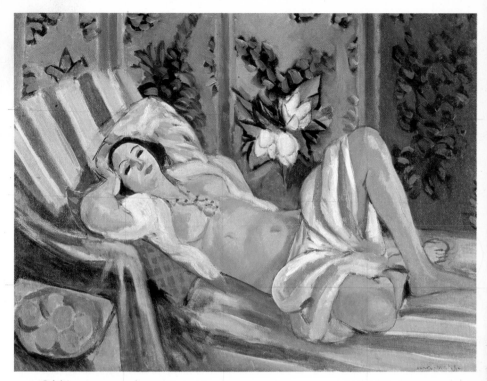

141 *Odalisque avec magnolias* 1924

innocent and beautiful perhaps played some part in the growth of sympathy
for Matisse's achievement. He has proved to us that some of the greatest
achievements of art, in particular the achievements of the mid-twentieth
century, are at root triumphs of the self. This is no more than to say that the
emotional vocabulary available to him and to us does not equip us to respond
to sexuality as the greatest humane painting of tradition has done. The
shameless victory of sensuality is a liberating victory nonetheless; it will
show its ultimate value when it leads to a liberation that is visibly shared.

During most of the 1920s the consistency remained soft and luxurious.
The rediscovery of the structural order and the sharpness that he required
proceeded by stages. In search of monumentality he turned back to his

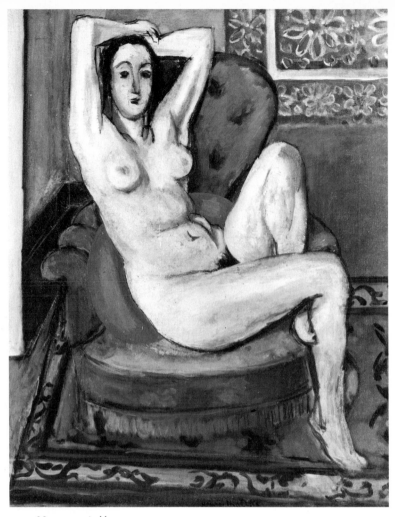

142 *Nu au coussin bleu* 1924

sculptures. He had to eliminate anything arbitrary or evanescent, at the risk
of seeming academic. When he was painting *Nu gris* he said – the imperious
tone returning – 'I want today a certain formal perfection and I work by
concentrating my ability on giving my painting that truth which is perhaps
exterior but which at a given moment is necessary if an object is to be well
carried out and well realized.'

145

158

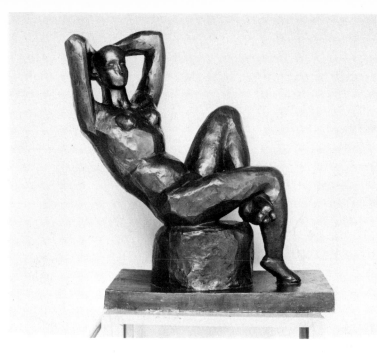

143 *Nu assis* 1925

144 *Jeune fille en jaune* 1929–31

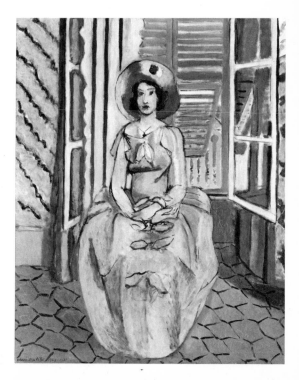

145 *Grand nu gris* 1929

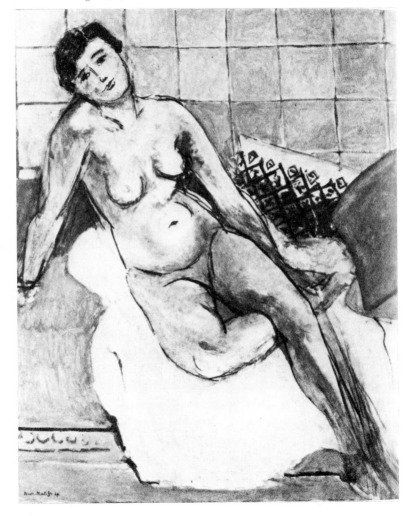

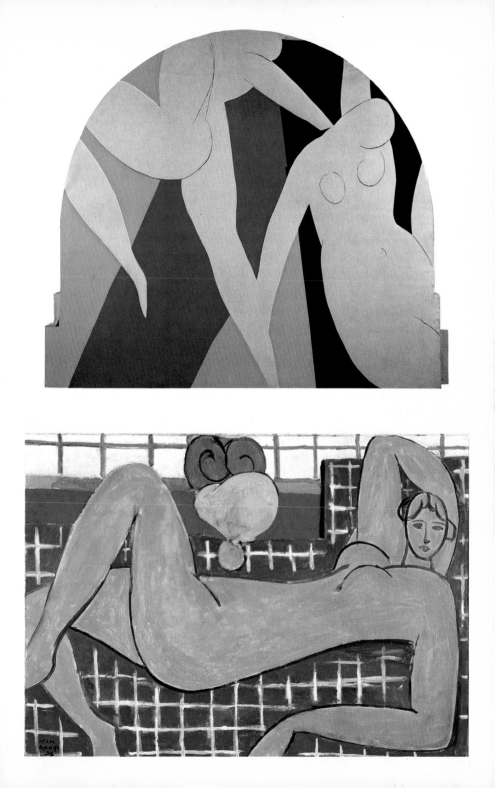

148 *Odalisque au fauteuil* 1928

In 1927 he enlarged the odalisque which he had painted in so many
149 variations, into a gauntly schematic *Figure décorative sur fond ornamentale*. At
about the same time he was doodling a reminiscence of the starting-point of
his relief of *Le dos*. It was a curious throwback, as if embodying a revulsion
from the sensuous masquerade that had been occupying him. He must have
20 thought again of the block-like back of one of *Les trois baigneuses* by Cézanne
which had been hanging on his wall for thirty years. Fifteen years before, the
long hanging skein of hair in Cézanne's picture had begun to suggest a
chiselled scheme like nothing in nineteenth-century art. Now he proceeded
to convert the suggestion into a vertical formulation of his own of
extraordinary boldness and simplicity. The crease down the spine was
converted into a straight median crevasse dividing the relief from top to
bottom; round the central line rotund cylinders of form gave the body a
simplicity more like Maillol than any sculpture since. The shape grew
naturally out of the rectangle; roundness and flatness at last agreed. In its
69 fourth and last version the great relief of *Le dos* was as grand as its size, and it
supplied something essential to the pictures that followed.

162

149 *Figure décorative sur fond ornemental* 1927

150 *Jazz: Icarus* 1943

151 *Jazz: Le toboggan* 1943

1931–1939 Figure and field

152, 153 The next step was due to Dr Barnes, who commissioned a mural for his Foundation outside Philadelphia. It was by far the largest work that Matisse had painted – he rented a film studio for the purpose – and it was a direct invitation to take up again a thread that he had laid down twenty years earlier. The traditionalism of the twenties vanished, and he hardly returned to it. The subject of *La danse* was rendered again in flat areas of colour within simplified, accented contours. He evolved a design of six figures, springing and tumbling across the space in counterpoint with the three arches. As he worked they grew progressively larger until the picture no longer contained them; the edges cut them and joined with them in a single pattern. The subject was no longer the figure, so much as figure and ground together. Matisse had not only contrived a new order of pictorial unity. In effect, the double meaning of the design provided a new formulation, as original as it was sharp and clear, of something enigmatic and unexplored in the flatness of painting. When the first version was finished, a mistake in measurements emerged, which required the artist to paint the whole decoration over again. It was one of those mistakes that turn out to serve an unconscious purpose. Re-creating the whole decoration and changing it far more drastically than the minor alteration in measurements required, Matisse gained a firmer grasp than ever on his discovery and on a new technique that accompanied it.

152 *La danse I*, 1931–32

He had invented a method of manipulating areas of flat colour on the surface of the huge canvas with shapes cut out of paper, painted blue and pink in gouache for the purpose. For the first time he was able literally to take hold of the basic elements of his picture, just as a sculptor handles the material of sculpture, and Matisse was very aware of the analogy when he turned to working with cut paper in its own right.

In a sense his subject in *La danse* was as much the cut paper as the human body. The paper patches cast a narrow band of shadow round their edges which was represented in the actual decoration by a continuous strip of deeper colour. This not only emphasized the arabesque, as had the deep coloured haloes around the figures in *Bonheur de vivre* more than twenty-five years before; it demonstrated a separate, intrinsic reality which was evidently a property of the patch of colour in itself. It appears almost as if these colour patches are about to free themselves from the surface which is otherwise so coordinated and complete; the effect was not unwelcome to Matisse. In later years he used to keep the curling patches of coloured paper out of which his *gouaches découpées* were composed fastened loosely against the wall, flapping a little or looping out across the floor, for a prolonged period, sometimes for years. Their separable material reality was precious to him and stimulating in itself. With the aid of the new technique, Matisse contrived in the second version of *La danse* not only a new and stable consistency of colour, but a huge mobility, an elephantine rhythm rising and falling across the three panels like a rolling and recoiling wave. Again, the massive misadventures of these dancers, bouncing sometimes on their enormous buttocks, diminishes the human meaning. But the figuration, the equivalent significance that attaches to the bodies and the spaces between them is so meaningful in itself that the total effect is far from being impoverished. On the contrary, the subject of figure art has changed; the theme is now a balance which has an athletic, almost acrobatic perfection, in view of the vast weight that is carried

40

152

153 *La danse* 1932–33

154 *L'escargot* 1953

155 *Souvenir de l'Océanie* 1953

156 *Le rêve* 1935

−a balance between figure and field, between the positive, physical presences and the negative areas between them. The innovation was to offer more to the art of the future than any other discovery of Matisse's whole life.

The balance of figure and field remained a recurrent theme of everything that Matisse did afterwards. The arabesque of pink against blue in *Le rêve* of 156
1935 had still a naturalistic, romantic reference. In *Nu rose* a process of subtle 147
purification and metamorphosis refined it away. Then Matisse seems to have realized that the intensity which he still required from painting was lacking. He found the direction once again in his typical self-regarding, retrospective way. He looked back in particular to Fauvism: 'When the means of expression have become so refined and attenuated that the expressive power wears thin, it is time to return to the essential principles. . . . Pictures which have become refinements, subtle gradations, transitions without force, call for beautiful blues, reds, yellows, matter to stir the sensual depths in men.

157 *La musique* 1939

That is the starting-point of Fauvism: the courage to return to purity of means.' Some of the pictures that followed were as freely painted as those of 157 thirty years earlier. But the apparent spontaneity of *La musique* (1939) involved as long a process of adjustment as ever. The design was painted out time after time with white and summarily restated in bright colour.

The oppositions of colour were now bolder and flatter than they had ever been in Matisse's work. Sometimes the result was like a poetic kind of heraldry, full of subtle and sophisticated meanings. In *Grande robe bleue, fond* 158 *noir* a lady takes up a reflective pose descended from Pompeii and Ingres (like some of Picasso's sitters of the same time). Dressed in blue, she is thinking, and behind her hangs a huge blue image of head-in-hand thoughtfulness.

158 *Grande robe bleue, fond noir* 1937

159 *Les yeux bleus* 1935

160 *Odalisque robe rayée, mauve et blanche* 1937

There is an effect of rectitude and even of piety; a necklace wound round her hand is like a rosary and an emblem of repentance. Yet the mimosa-yellow nimbus that radiates from her head suggests that her natural affinity is with another image, a yellow odalisque cradling her head in her arm with sly abandon. So the picture is about attitudes and poses, and about the oppositions between a sensual yellow and a self-contained blue. But it is also about an all-embracing heart-shape, which centres on the heart of the picture, containing yellow, red and blue successively within one another and enclosing them all in a goblet of black – a symmetrical repeating pattern which enshrines the modish thoughtful pose and distributes its implicit voluptuousness through the picture.

Colour had never been so flat and bright before either in Matisse's painting or anyone else's. The metaphoric richness of *Grande robe bleue* became characteristic of his later work. The central shape of the picture, like a heart or a vase or a flower, had a long history, stretching back through *Mlle Yvonne Landsberg* to the heart-shaped portrait of his daughter with a black cat 110, 72 painted twenty-seven years before. Even earlier, his teaching was full of such analogies. He would point out the likeness of the calf of a leg to a beautiful vase form; the way the pelvis joined the thighs suggested an amphora. In the last works they served him better than ever, so that the lobed shapes his scissors outlined were not merely philodendra or algae but the basic common shapes of everything, natural vessels for colour and light.

In the later 1930s, when he was approaching the age of seventy, Matisse was adding new territories to his art. This was rather against some expectations; the luxuries of a studio like a hot-house were not intellectually respectable, and Matisse was omitted from the list of artists commissioned by the State to contribute to the International Exhibition in 1936. His response was to give his Cézanne, intended for the Louvre, to the City of Paris instead. Matisse was adding to his equipment, firstly, an unforeseen purity and precision of means. The clarity of line in the drawings of models in his studio, which were published by *Cahiers d'Art* in 1936, was poured out in 161, 162 unparalleled abundance. It was the medium of a reverie on female beauty in relation to its milieu, its reflection, its image and in relation to the artist himself; it had the consistency only of a curling, endless dream, sprawled out onto paper. This sense of a studio-bred and studio-bound intensification of the most familiar, most self-indulgent of a painter's forms and themes was like nothing else in the art of the time. Dwelt on at length, the subject and the cut-paper medium of *La danse* led Matisse not only to the design of a ballet, *Le rouge et le noir*, but to a series of cut-paper images of two dancers (one of them given to Massine), which opened the door to a whole world of springing shape, accessible to the scissors in the years to come.

161 Drawing from *Cahiers d'Art* 1935

162 Pencil drawing from *Cahiers d'Art* 1935

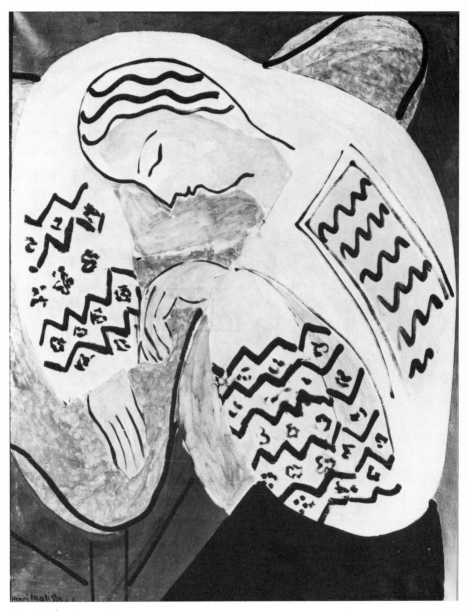

163 *Le rêve* 1940

1940–1954 Triumphant conclusions

Illness and repeated surgery in 1941, which gave the media that could be employed from his chair or his bed a special usefulness, did not interrupt Matisse's work as a painter. His painterly achievement moved on towards its culmination almost without a break. With the war, the chic, summary look of the years before disappeared. There was an increasingly delicate and subtly coloured unity; a series of still-lifes reminds us that the picture was Matisse's oyster. From 1940 onwards the interiors have an element of mystery. They represent states of interpenetration and diffusion that defy analysis. By 1942, he had reached his conclusion; the interior was seen as a cubicle of colour, a habitable volume infused with the qualities of pictorial presence – full of pattern, stripes and concentrated hue. The original, impetuous reaction to colours that 'contain within them . . . the power to affect the feelings' had taken over once again. The force of it was cumulative and astonishing. When he painted his last great series of interiors he was ready not only to sum up all his work, but to add to it a dazzling originality.

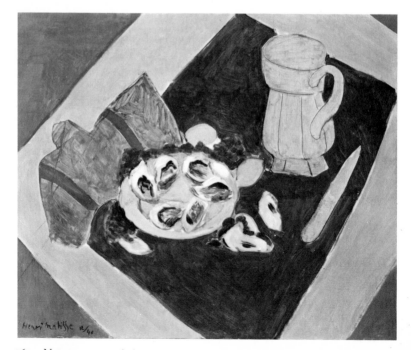

164 *Nature morte aux huîtres* 1940

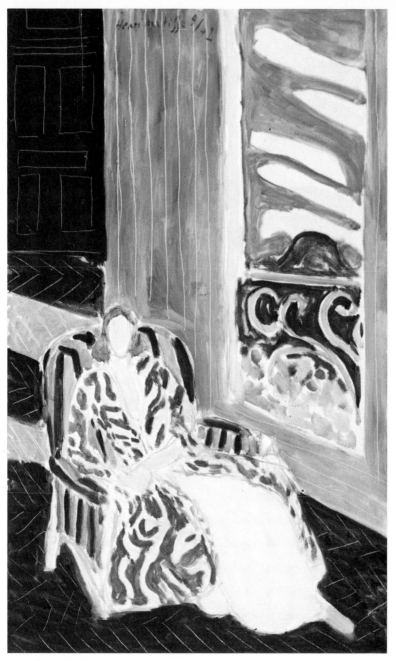

165 *La porte noire* 1942

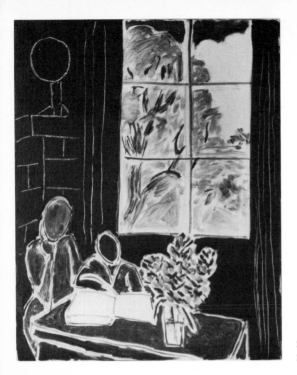

166 *Le silence habité des maisons*
1947

167 *Nu debout et fougère noire* 1948

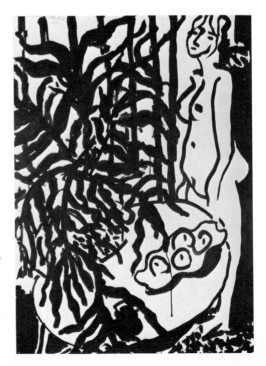

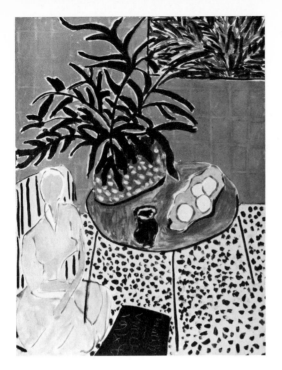

168 *Intérieur à la fougère noire* 1948

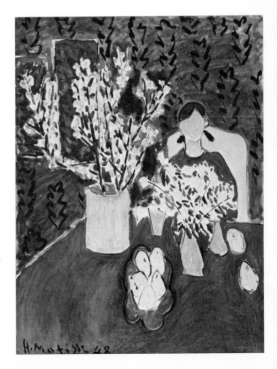

169 *La branche de prunier, fond vert* 1948

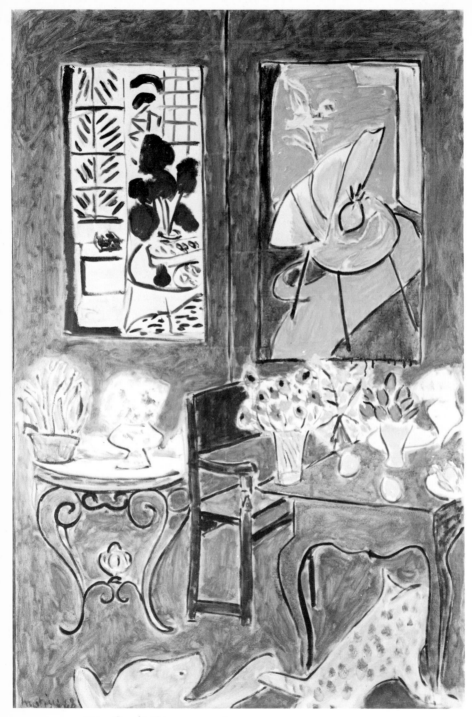

170 *Grand intérieur rouge* 1948

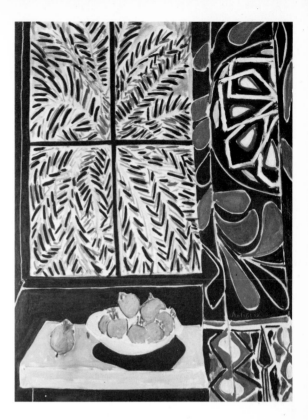

171 *Intérieur au rideau égyptien*
1948

The colour flooded *L'intérieur rouge* as it had *Atelier rouge* nearly forty years 170, 97
earlier. But the meaning is different. The things in the room, not only the
pictures on the wall but the flowers that bloom in an iridescent haze on the
table, retain their own real quality. They remain whole, as if preserved in
redness, with a new and permanent existence. Even the diagonal march of
space across the floor and up into the pictures is linked with a pattern of
coinciding edges, connecting tables to chair and flowers to picture, so that
both are seen as natural properties of the picture's flatness and redness. We
become aware that we are in the presence of the reconciliation which is only
within the reach of great painters in old age. The canvas radiates it. The
redness overflows and people standing in front of the picture to look are seen
to have it reflected on them. They are included in it; they share in a natural
condition of things and of painting.

Matisse's other mood is seen in *Intérieur au rideau égyptien*. The light it 171
radiates is the vibration generated by oppositions of colour. The energy

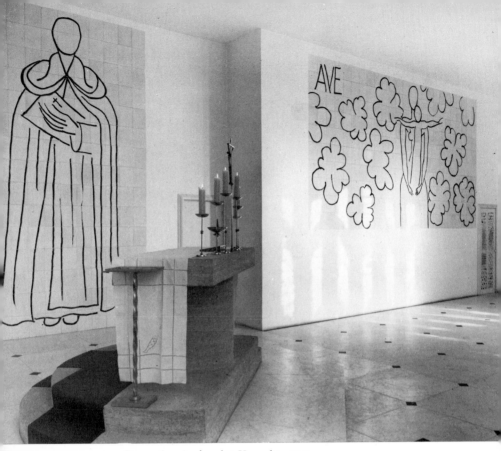

172 Decorations in chapel at Vence late 1940s

which the conjunction of hues releases is more fully realized than ever. The virility is extraordinary; at last Matisse is wholly at ease with the fierce impulse. Red, green and black together in bold shapes make the close, rich colour of shadow. Outside the window, yellow, green and black in fiery jabs make sunlight on a palm tree against the sky, completing Matisse's demonstration of the fertility of painting.

These last paintings show types of pictorial equivalence to the visible world. After meditating for more than fifty years on the pure colour that history had placed in his hands, he had given the two basic equations of Fauvism their final form. *L'intérieur rouge* offered intimations of elemental unity. In *Le rideau égyptien* the interaction of colour epitomized the energetic

182

force of light. Yet the equations are so simple and self-evident that they confront one irresistibly with the element in painting which is not equated with anything. The realities are the ideal states of energy and of rest which colour creates on the picture surface.

Light, after all, could be handled directly in its own right. For a time Matisse turned from painting to deal with it in actuality in a building, the Chapel of the Rosary at Vence. The separable attributes of painting had 172, 173 finally found their appropriate forms. The reality of the surface remained and when he returned to pictorial colour, it was as if to a natural substance. The *papier découpé* medium, in which the windows and vestments for the

173 Apse window for
chapel at Vence

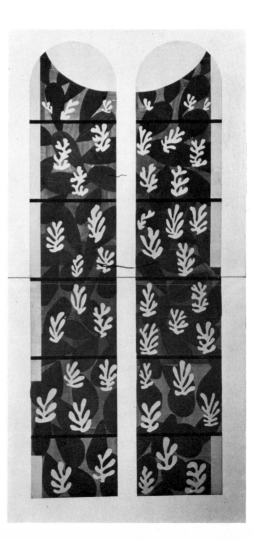

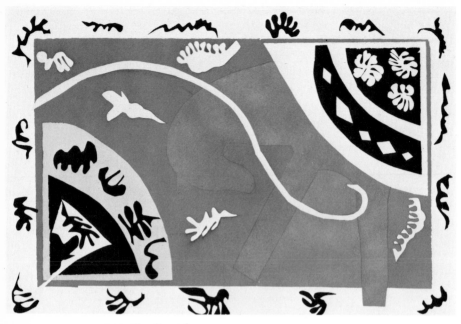

174 *Jazz: Cavalier et clowne* 1947

150, 151, 174

chapel were designed, had evolved steadily in Matisse's work since the early thirties. In 1943 an *Icarus* figure surrounded by the bursts of anti-aircraft shells was the prototype for the book called *Jazz*, a series of images recording exhilaration with the medium as much as with his miscellaneous subjects, to which Matisse later added a text summarizing the rationale of the new technique. It was the apotheosis of the figure-ground relationship; the sharp edge that he cut with his scissors, often extempore, defined both at once. The balance of positive and negative took on a flamboyant, punning content which was new to his art. In *Jazz*, for example, the sword-swallower upside-down suggested the ring-master, Monsieur Loyal, and he, by a natural association, turned into a portrait of General de Gaulle. A few years later a prancing dancer carried in her contour the outline of her spectator's wondering face. Lobed algae grew into exotic heads, Indian or Aztec, with head-dresses to match; vegetable life had gained the power visibly to dream. Nearly every profile did duty twice at least. In *Jazz* the effervescent ambiguity fizzes spontaneously from plate to plate. The interplay of figure

184

and field, in fact, freed itself from anything that had seemed solemn or ponderous in its beginnings in the early thirties. It was now quite visibly and simply play.

In *Jazz* the cut and gummed paper was reproduced by the stencil process. Often in the ten years that followed the medium provided designs for works carried out in a whole range of more or less permanent materials – stained glass, ceramic tiling, appliqué needlework, screened textiles and in printing for permanent or ephemeral uses. It remained just as serious and also just as carefree as in the great compositions in which it was valued for its own sake, the first entirely new autographic medium in twentieth-century art.

Following the clue of *Jazz*, Matisse had expanses of paper brilliantly coloured with gouache to his requirements; to his delight his doctor insisted that he wear dark glasses to go into the room where they hung. Even the streaks of the gouache were like the grain of a natural material. It was the basic material of painting, the flat radiance of colour itself. It was this that Matisse set about with his scissors, always doing the cutting for himself and doing it with a decisiveness that developed into an unparalleled virtuosity with the new instruments. When he began working in cut paper he wrote of 'drawing with scissors'. But he had also in mind a solider and more substantial quality of the new technique. In the revealing text that he provided in 1947 for *Jazz*, he wrote: 'Cutting into living colour reminds me of the sculptor's direct carving.' The association was significant; he was cutting into a primal substance, the basic chromatic substance that he had extracted from Impressionism and preserved intact, as if alive. With each stroke the cutting revealed the character both of the material, the pristine substance, and also of an image. Whether there was an evident motif or none, there was a sense of subject that transcended it, the radiance and movement of an ideal milieu. Often the theme was more mobile and flowing than anything he had painted for years; the movement was like a dance.

Quite soon the *papier découpé* medium accumulated a momentum of its own; the cut-outs had their own floral unfolding within the massive development of Matisse's art. Soon after *Jazz* was finished the characteristic forms began to evolve, proliferating additively like the algae and the corals that they stood for. The motifs floated, soared and drifted out across airy or watery expanses – the fields of sky and sea in *Océanie* and *Polynésie*, which 175–78 were realized as screen-printed hangings. They took on the all-over distribution of mural textiles, yet settled themselves in their fields quite differently from anything in decorative art before; they left space for each other to play in with an instinctive delicacy, like children in a picture by Bruegel, yet the whole field was as living and consistent an environment as a verdure tapestry. In the next year, 1947, the principle was reversed. Similar

175 *Océanie – Le ciel* 1946–48

176 *Océanie – La mer* 1946

177 *Polynésie – La mer* 1946

178 *Polynésie – Le ciel* 1946

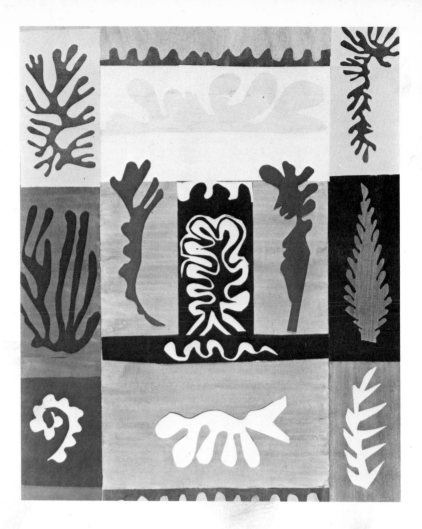

marine motifs were reassembled into heraldic symmetries that had a narrative meaning; one of them, with a fanciful majesty of its own, which must evoke the love of Poseidon, was called *Amphitrite*. The marine metaphor soon extends to the ebb and flow of colour as a liquid medium in itself; the algae that naturally inhabit it have an appropriateness that is never repetitive, never inactive. In 1948, however, one of the designs for stained glass in the chapel at Vence added geometrical figures, rectangles, to the

179

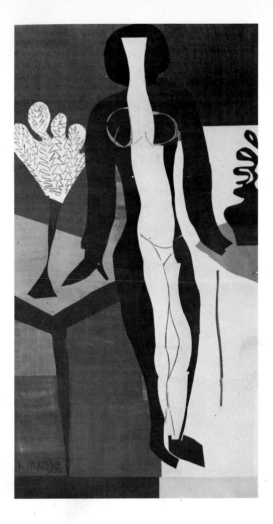

179 *Amphitrite* 1947

180 *Zulma* 1950

repertoire; it was typical of the new breadth of reference that they were modelled on the head-dresses of Dominican nuns yet deliberately evoked the sight and sound of a swarm of bees. When the double and triple meanings might have become merely capricious, in 1950, Matisse abruptly turned *papier découpé* into a self-sufficient pictorial medium, and one that could deal immediately, in *Zulma*, with a theme, the standing Moroccan odalisque, that 180 had been precious to him for forty years. The resources were now

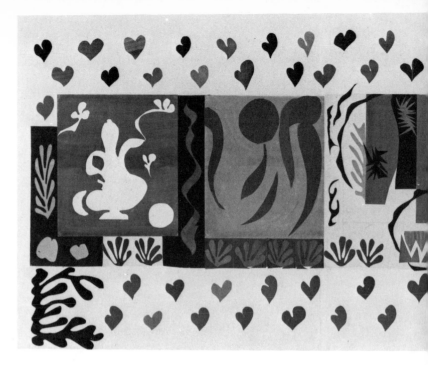

181 extraordinarily wide and brilliant. *Les mille et une nuits*, a long anthology of
182 Levantine motifs with a narrative thread, reads like a fugue. *Poissons Chinois*,
 conceived for stained glass, re-created, whether Matisse knew it or not, the
 convention of the Chinese playing-card. Most beautiful and characteristic of
 all, because so rooted in Matisse's life and imagery, a huge and finely realized
183 picture called *La tristesse du roi* seemed to imagine the artist as an old king in
 Scripture unable to be consoled by music and attended by a dancing houri –
 taken straight, again no doubt involuntarily, from the right-hand figure in
184 Delacroix's *Femmes d'Alger*.

It was right that Matisse's conclusion should be moving, and moving in
a personal sense, without being in any degree grave or oppressive. The
papiers découpés, rather than anything before, were the fulfilment of
the authoritarian demands for painting that he had drawn up in 1908.
'Expression for me does not reside in passions glowing in a human face or
manifested by violent movement. The entire arrangement of my picture is
expressive; the place occupied by my figures, the empty space around them,
the proportions, everything has its share. . . .' It was a triumphant ending.

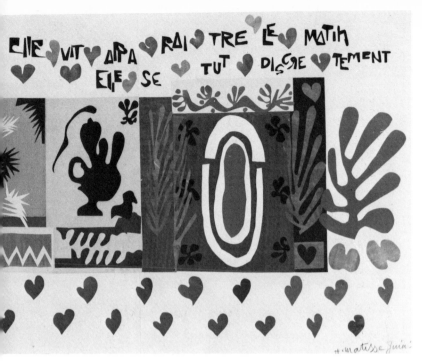

181 *Les mille et une nuits* 1950

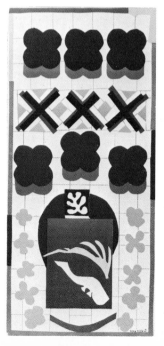

182 *Poissons Chinoises* 1951

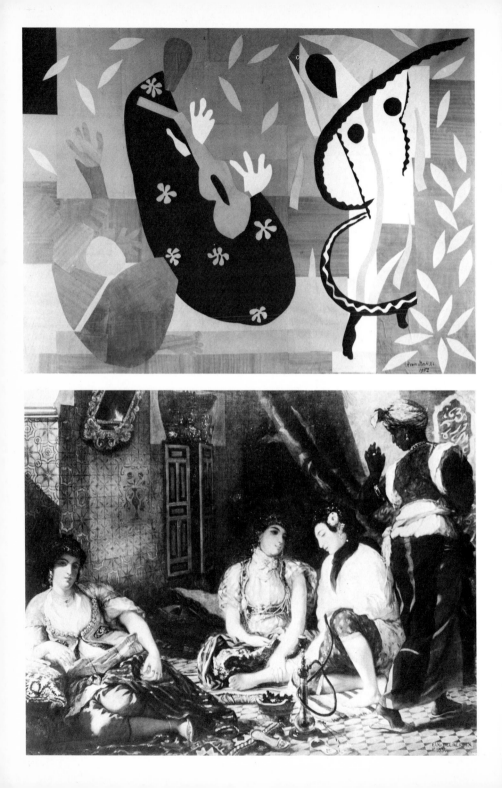

183 *La tristesse du roi* 1952

184 EUGÈNE DELACROIX: *Les femmes d'Alger* 1834

185 *Les acanthes* 1953

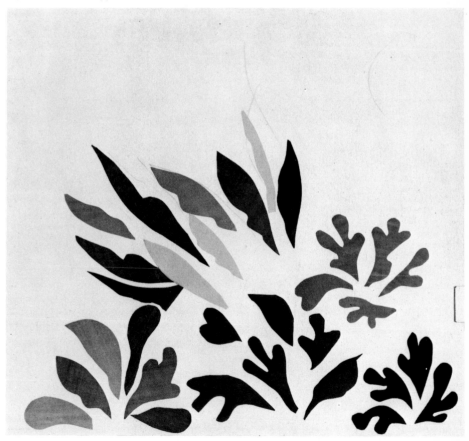

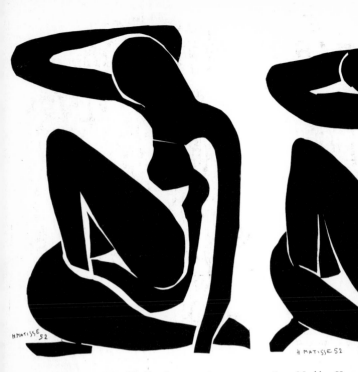

186 *Nu bleu I* 1952 187 *Nu bleu II* 1952

186–89 The year 1952 was the year of the blue nudes, which epitomized the sense of bodily unity and completeness on the model of sculpture, which was at the root of form for Matisse. It was the year of the *Piscine*, in which the play of figure and field, bursting out of the rectangle and plunging along the wall, took on the most dynamic and original form in all his work. In the greatest of the *gouaches découpées*, like the soaring *Souvenir d'Océanie* and the radiating spiral of *L'escargot*, the rhythm resides simply in the action and interaction of colours. The movement springs out of a progression which centres characteristically on emerald-green. It expands in every direction, moving in great lazy leaps out to the extremes of violet and orange-red. An ideal world was completely realized and the achievement, more than any other, discovered a new reality for painting. Late in life, Matisse told an interviewer: 'It is always when I am in direct accord with my sensations of nature that I feel I have the right to depart from them the better to render what I feel. Experience has always proved me right. . . . For me nature is always present.'

191

155
154

194

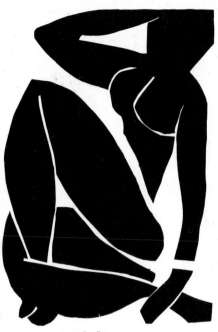

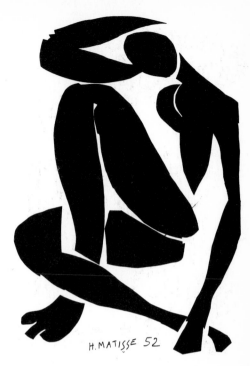

188 *Nu bleu III* 1952

189 *Nu bleu IV* 1952

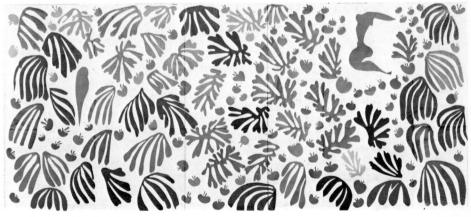

190 *La perruche et la sirène* 1952

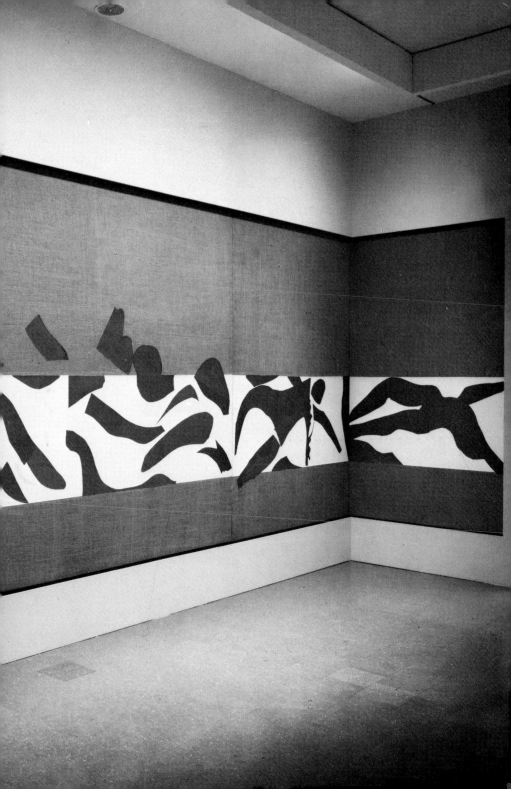

Matisse's life

1869 31 December. Henri Emile Benoît Matisse born at Le Cateau-Cambrésis (Nord) in the home of his grandparents. After the war the family returned to their own home at Bohain-en-Vermandois (Aisne).

1880 Pupil at the *lycée* in St Quentin.

1887 Studied law in Paris.

1889 Passed first law examinations and returned to St Quentin to become a clerk in a law office.

1890 Began painting while convalescing from appendicitis. First picture, a still-life, painted in June. Attended early morning classes in drawing from casts at the art school at St Quentin.

1892 Abandoned law and became a student under Bouguereau at the Académie Julian in Paris. Evening classes at the École des Arts Décoratifs where he met Albert Marquet.

1893 Disgusted with Bouguereau's teaching, left Académie Julian. Impressed by Goya's *La jeunesse* at Lille.

1894 Drew from the antique in the Cours Yvon at the École des Beaux-Arts.

1895 March. Attracted attention of Gustave Moreau who arranged admission to his class at the École des Beaux-Arts. Rouault, Marquet, Manguin, Piot, Guerin and Bussy were among his fellow students. Took an apartment at 19 Quai St Michel. Encouraged by Moreau to copy in the Louvre. Began to paint outdoors in Paris. Painted in Brittany during the summer.

1896 Four of his paintings (two of which were sold) accepted for exhibition at the Salon du Champ-de-Mars. Elected an Associate Member of the Société Nationale. Painted in Brittany.

1897 Exhibited *La desserte* which was adversely received and badly hung. Saw the Impressionist paintings from the Caillebotte Bequest hung in the Luxembourg. Met Camille Pissarro. Worked in Brittany with John Russell who gave him two drawings by Van Gogh.

1898 Married Amélie Parayre of Toulouse. Visited London, where he studied Turner on Pissarro's advice, then spent twelve months in Corsica and Toulouse.

198

1899 Returned to Paris. Worked under Fernand Cormon who succeeded Moreau at the École des Beaux-Arts; was asked to leave the class. Attended classes with Eugène Carrière where he met André Derain. Exhibited for the last time at the Société Nationale. Purchased with his wife's dowry Cézanne's *Trois baigneuses* and a plaster bust by Rodin. Also acquired a head of a boy by Gauguin.

1900 Financial hardship; for a living painted exhibition decorations at Grand Palais. Studied sculpture in the evenings. Madame Matisse opened milliner's shop.

1901 Exhibited at the Salon des Indépendants, an open exhibition under the presidency of Paul Signac. Allowance from his father ended. Met Maurice Vlaminck who was working with Derain.

1902 Forced by need to return with his wife and three children to Bohain during the winter and also the following winter.

1903 Poverty and depression. Foundation of the Salon d'Automne, where Matisse and his associates exhibited. Interested by exhibition of Islamic art in the Pavillon de Marsan.

1904 First one-man exhibition at the gallery of Ambroise Vollard, Paris. Spent the summer at St Tropez where Signac had a villa.

1905 *Luxe, calme et volupté* exhibited at the Indépendants and bought by Signac. Spent the summer at Collioure with Derain. Helped Maillol with the casting of *La méditerranée*. Matisse and his associates caused a sensation at the Salon d'Automne with the group of pictures that earned them the nickname of *Les Fauves*. The Stein family began to buy his work. Took a studio in the Couvent des Oiseaux, rue de Sèvres.

1906 *Bonheur de vivre* (Barnes Foundation) exhibited at the Indépendants and bought by Leo Stein. One-man exhibition at the Galerie Druet. Visit to Biskra in Algeria. Summer at Collioure. Exhibited at the Salon d'Automne. Claribel and Etta Cone of Baltimore, Maryland, began to collect his pictures.

1907 Went to Italy, visiting Padua, Florence, Arezzo and Siena. Exchanged paintings with Picasso, who was working on *Les demoiselles d'Avignon*. Guillaume Apollinaire published an article on Matisse, recording many of his remarks. Admirers organized a school at which he taught in the rue de Sèvres.

1908 Moved to rooms in the Hôtel Biron, 33 Boulevard des Invalides, where his studio and school were also established. Visited Germany. Sergei I. Shchukin, a Moscow merchant, began to collect his pictures and probably commissioned *La danse*. *Notes of a Painter* published in *La Grande Revue*.

1909 Moved to a house at Issy-les-Moulineaux, south-west of Paris, where he built a studio. Full-sized sketch of *La danse* completed; Shchukin commissioned second large decoration, *La musique*. First version of the relief *Le dos*. Summer at Cavalière, near St Tropez. First contract with the dealer Bernheim-Jeune. Visited Berlin, where an abortive exhibition was arranged.

1910 Large exhibition at Bernheim-Jeune. Travelled to Munich to see the exhibition of Islamic art. *La danse* and *La musique* exhibited at the Salon d'Automne, causing a sensation which led Shchukin to refuse them. Visit to Spain in autumn.

1911 Painted in Seville, Issy and Collioure. Visited Moscow to see where his decorations were to hang and studied Russian icons. Visited Tangier in Morocco to paint.

1912 Returned to Issy in spring. C. T. Lund and Johannes Rump in Denmark and Ivan A. Morosov in Moscow began to collect his pictures. Shchukin agreed to accept both decorations.

1913 Returned from Morocco in spring. Exhibition at Bernheim-Jeune. Represented in the Armory Show in New York. Painted at Issy; again took a studio in Paris at 19 Quai St Michel. Exhibition of Moroccan paintings and sculptures at Bernheim-Jeune.

1914 Worked at Issy. Rejected for military service. At Collioure in the autumn.

1915 Painted at Quai St Michel and Issy. The Italian model Laurette began to pose for him. Visited Arachon near Bordeaux.

1916 Painted interiors and monumental compositions at Quai St Michel and Issy. First winter at Nice, staying at the Hôtel Beau-Rivage.

1917 Summer at Issy; autumn in Paris. At Nice from December, visiting Renoir at Cagnes.

1918 Moved to an apartment on the Promenade des Anglais at Nice, then leased the Villa des Alliés. In Paris and Cherbourg during the summer. Autumn at Nice, taking rooms in the Hôtel de la Méditerranée and visiting Bonnard at Antibes.

1919 Exhibition at Bernheim-Jeune. Summer at Issy.

1920 Production of the ballet *Le chant du rossignol* by Diaghilev. Visited London with the ballet. Stayed at Etretat in Normandy. Exhibition at Bernheim-Jeune of works of 1919–20.

1921 At Etretat in the summer, returning to Nice in the autumn. Moved to an apartment on the Place Charles-Félix. The Luxembourg acquired a painting.

1922 Henceforward divided the year between Nice and Paris. The Detroit Institute of Arts bought *La fenêtre*.

1923 Shchukin and Morosov Collections with nearly fifty of his works combined in Museum of Modern Western Art, Moscow.

1924 Exhibition at Brummer Galleries, New York. Completed *Grand nu assis*, his first sculpture in ten years.

1925 Visit to Italy. Made a Chevalier of the Legion of Honour.

1927 Awarded first prize at the Carnegie International Exhibition at Pittsburgh.

1929 Gave more time to sculpture and prints. Worked on final version of *Le dos*.

1930 Visited Tahiti. Visited the Barnes Foundation at Merion, Pennsylvania, and Miss Etta Cone at Baltimore. Commissioned by Albert Skira to illustrate Mallarmé's poems.

1931 Accepted Dr Barnes's commission to paint murals for the hall of the Foundation. Large retrospective exhibition at the Galerie Georges Petit, Paris.

1932 First version of the Barnes mural completed. The measurements of the wall having been wrongly noted, began an entirely new version in the correct size. Mme Lydia Delectorskaya, later his secretary and housekeeper, acted as assistant and model. Publication of *Poésies de Stéphane Mallarmé*.

1933 Visited Merion to install the second version of the mural in the Barnes Foundation. Afterwards took a holiday near Venice and visited Padua.

1935 Made a design for Beauvais tapestry. Painted many compositions of the nude. Contract with the dealer Paul Rosenberg. Etchings of subjects from the *Odyssey* for Joyce's *Ulysses*.

1936 Exhibition of recent paintings at the Paris gallery of Paul Rosenberg. Gave Cézanne's *Trois baigneuses* to the Musée d'Art Moderne de la Ville de Paris.

1937 Commissioned by Ballets Russes de Monte Carlo to design scenery and costumes for *Le rouge et le noir*.

1938 First independent *gouache découpée*, a medium which he had used in the preliminary work for his decorations. Moved to the former Hôtel Regina in Cimiez, a suburb behind Nice.

1939 First performance of *Le rouge et le noir*. Worked in the Hôtel Lutetia in Paris during the summer. Left Paris after the declaration of war, visiting Geneva to see the paintings from the Prado and returning to Nice in October.

1940 Spring in Paris at 132 Boulevard Montparnasse. In May left for Bordeaux, later staying at Ciboure near St-Jean-de-Luz. Decided to remain in France. Returned to Nice by Carcassonne and Marseille. Legal separation from Madame Matisse.

1941 Serious illness, requiring two operations in hospital at Lyon. Returned to Nice in May. Thenceforward often painted and drew in bed. Began to plan the book *Florilège des Amours de Ronsard* with Skira.

1942 Exchanged paintings with Picasso. Gave two interviews over the radio of occupied France.

1943 Air raid at Cimiez. Moved inland to Vence, taking the villa Le Rêve.

1944 Commissioned to paint decorations for Señor Enchorrena. Picasso arranged for Matisse to be represented in Salon d'Automne in celebration of the Liberation.

1945 Visited Paris. Retrospective exhibition at the Salon d'Automne in his honour.

1946 Exhibition at Nice. Appeared in a documentary film, recording him at work and speaking of his pictures.

1947 Publication of *Jazz*, with his *pochoir* (stencil) plates and text, for which he had made *gouaches découpées* in 1943–44. Elevated to Commander of the Legion of Honour. The new Musée National d'Art Moderne began to assemble a representative group of his works.

1948 Painted series of vividly coloured interiors. Designed a figure of St Dominic for the church at Assy and began work on the design and decoration of the Chapel of the Rosary for the Dominican nuns at Vence. Worked on big *gouaches découpées*.

1949 Returned to the Hôtel Regina at Nice. Foundation-stone of the Vence chapel laid. *Gouaches découpées* and other recent works exhibited at Musée National d'Art Moderne. Cone Collection bequeathed to the Baltimore Museum of Art.

1950 Exhibition at Nice and at the Maison de la Pensée Française in Paris. Publication of *Poèmes de Charles d'Orléans* with his lithographed illustrations and text.

1951 Completion and consecration of the Vence chapel. Exhibition organized by the Museum of Modern Art, New York. First paintings since 1948. Worked on *gouaches découpées* and large brush drawings.

1952 Exhibitions at Knokke-le-Zoute in Belgium and in Stockholm. Inauguration of Musée Matisse at La Cateau-Cambrésis.

1953 Exhibitions of sculpture in London and at Curt Valentin Gallery in New York. Exhibition of the *gouaches découpées* at Berggruen Gallery in Paris.

1954 Loan exhibition of paintings at Paul Rosenberg Gallery, New York. Last *gouache découpée*, design for rose-window, Union Church of Pocantico Hills, New York.

3 November died at Nice.

Bibliographical Note

The indispensable book is *Matisse, his Art and his Public* (New York, Museum of Modern Art, 1951) by Alfred H. Barr, Jr. It is both a compendium of source material and a collection of perceptive studies of specific works up to 1951, five years before the artist's death. There is still no more substantial work on any modern artist. It is not, of course, complete, nor is it, even with its corrigenda, wholly reliable; dates attached to pictures, for example, need to be checked against other evidence. Five other books in the older literature remain of interest: Roger Fry, *Henri Matisse* (Paris, Chronique du jour, 1930; London, Zwemmer, 1935); Alexander Romm, *Henri Matisse* (Leningrad, Ogiz-Izogiz, 1937, republished as *Matisse, a Social Critique*, New York, Lear, 1947); Pierre Courthion, *Le visage de Matisse* (Lausanne, Marguerat, 1942); Gaston Diehl, *Henri Matisse* (Paris, Tisne, 1954); Raymond Escholier, *Matisse ce vivant* (Paris, Fayard, 1956; English adaptation *Matisse from the Life*, London, Faber and Faber, 1960), which reported Matisse's writings and sayings freely, though not always correctly. Matisse's own words are now available in two collections, in French by Dominique Fourcade, *Henri Matisse, Écrits et propos sur l'art* (Paris, Hermann, 1972), which includes an invaluable thematic index; in English by Jack D. Flann, *Matisse on Art* (London, Phaidon, 1973), which also gives some of the more important texts in French (in the cloth edition but not in the paperback; New York, Dutton, 1978). Fourcade has supplemented his collection with 'Autre propos de Matisse' in *Macula I* (Paris, 1976). The valuable issue of *Critique* devoted to Matisse (XXX, No. 324, Paris, Éditions de Minuit, May 1974) includes Masson's account of his conversations with the artist. More recent general books include monographs by Jacques Lassaigne (Geneva, Skira, 1959), Jean Guichard-Meili (Paris, Hazan, and London, Thames and Hudson, 1967) and John Jacobus (New York, Abrams, 1973). The extensive writings on Matisse over a period of nearly thirty years by Louis Aragon, collected as *Henri Matisse, roman* (Paris, Gallimard, 1971, and as *Henri Matisse, a Novel*, London, Collins, 1971), about half of which were previously unpublished, are in every way *sui generis*; they are abundantly illustrated. The closest study of one aspect of Matisse is by Albert Elsen, to whose generosity I am grateful, *The Sculpture of Henri Matisse* (New York, Abrams, 1971). Another part of his work has been studied by John Elderfield in *The Cut-outs of Henri Matisse* (New York, Braziller, 1978; London, Thames and Hudson, 1979).

Two at least of the numerous general books make special contributions. *The World of Matisse* by John Russell (London, Time-Life Books, 1969) includes biographical information; Frederick Brill (*Matisse*, London, Paul• Hamlyn, 1966) offers the appreciation of a painter. Among the pocket paperbacks on the artist three are of interest: Clement Greenberg, *Matisse* (New York, Abrams; London, Collins, 1955),

a partial reproduction of *Matisse, Jazz* (Munich, Piper; New York, Museum of Modern Art, n.d.) and Alan Bowness, *Matisse et le nu* (Paris-Lausanne, Skira-Unesco, 1969). Issues of periodicals devoted to Matisse include, in addition to *Critique, Studio International* (London, July 1968), *Arts Magazine* (New York, May 1975) and *Art in America* (New York, July–August 1975).

The numerous studies in periodicals have sometimes added to knowledge. Among those of note are J.-A. Cartier, 'Gustav Moreau, Professor a L'École des Beaux Arts' (*Gazette des Beaux Arts*, May–June 1963); H. Coulonges, 'Matisse et le paradis' (*Connaissance des Arts*, December 1969); J.D. Flann, 'Matisse's Backs and the Development of his Paintings' (*Art Journal*, XXX, Summer 1971) and 'Some Observations on Matisse's Self-Portraits' (*Arts Magazine*, New York, May 1975); D. Giraudy, 'Correspondence Henri Matisse–Charles Camoin' (*Revue de L'Art*, No. 12, 1971); M. Giry, 'Matisse et le naissance du Fauvisme' (*Gazette des Beaux Arts*, May 1970); C. Greenberg, 'Influences of Matisse' (*Art International*, November 1973); A. Milton, 'Matisse in Moscow' (*Art Journal*, XXIX, Winter 1969–70); J. Jacobus, 'Matisse's Red Studio' (*Art News*, New York, September 1972); Y.A. Rusakov, 'Matisse in Russia in the Autumn of 1911' (*Burlington Magazine*, May 1975); F.A. Trapp, 'Art Nouveau Aspects of Early Matisse' (*Art Journal*, New York, Fall 1966) and 'Form and Symbol in the Art of Matisse' (*Arts Magazine*, New York, May 1975).

Much important academic work remains unpublished. I have had access to two recent theses; Christopher Rawlence, *A Study of the influence of Oriental Art on Matisse's Artistic Development between 1895 and 1912* (London University, M.A. Report, 1969), and Nicholas Watkins, *History and Analysis of the Use of Colour in Matisse* (London University, M. Phil, 1970). Only one of John Golding's brilliant lectures has been published, 'Matisse and Cubism' (*W.A. Cargill Memorial Lectures on the Fine Arts*, Glasgow, Glasgow University Press, 1978).

Substantial and up-to-date information is provided in the catalogues of major exhibitions. The following are of particular value: Los Angeles, University of California, *Matisse Retrospective* (1966); Leningrad, State Hermitage Museum, and Moscow, Pushkin Museum, *Matisse* (1969); Saint-Paul, Fondation Maeght, *À la rencontre de Matisse* (1969); London, Victor Waddington, *Henri Matisse, Sculpture* (1969), introduced by William Tucker's excellent study which is included in *The Language of Sculpture* (London, Thames and Hudson, 1977); Paris, Grand Palais, *Henri Matisse, Exposition du Centenaire* (1970) by Pierre Schneider, listing, not without errors, the largest and most representative exhibition yet brought together; Zurich, Marlborough Gallery, *Henri Matisse; Zwanzig auserlesene Werke* (1971); Paris, Centre National d'Art et de Culture Georges Pompidou, *Henri Matisse dessins et sculpture* (1975), with a splendid text by Dominique Fourcade; New York, Museum of Modern Art (later shown at San Francisco and Fort Worth), *The Wild Beasts; Fauvism and its Affinities* (1976), by John Elderfield; St Louis, St Louis Art Museum (also shown at Washington and Detroit), *Henri Matisse, Paper Cut-Outs* (1977) by J. Cowart, J.D. Flann, D. Fourcade and J.H. Neff; London, Marlborough Fine Art, *An Important Exhibition of Works by Henri Matisse* (1978)

There are catalogues of two of the chief permanent collections, *Paintings, Sculpture and Drawings in the Cone Collection* (Baltimore, Baltimore Museum of Art, 1967) and *Matisse in the Collection of the Museum of Modern Art* (New York, Museum of Modern Art, 1978), by John Elderfield, the most detailed and illuminating of recent studies.

List of Illustrations

Measurements are given in inches and centimetres, height before width.

25 Académie bleue (Study in Blue) c. 1900. Oil on canvas, $28\frac{3}{4} \times 21\frac{3}{8}$ (73 × 54). Tate Gallery, London

26 La guitariste (Guitarist) 1903. Oil on canvas, $21\frac{1}{2} \times 15$ (54·6 × 38·1). Collection of Mr and Mrs Ralph F. Colin, New York

27 Portrait de l'artiste (Self-Portrait) 1906. Oil on canvas, $21\frac{5}{8} \times 18\frac{1}{4}$ (54·9 × 46). Statens Museum for Kunst, Copenhagen

28 Le serf (The Slave) 1900–03. Bronze, height $36\frac{1}{8}$ (92·3), at base 13 × 12 (33 × 30·5). Baltimore Museum of Art, The Cone Collection, formed by Dr Clairbel Cone and Miss Etta Cone of Baltimore, Maryland

29 Carmelina 1903. Oil on canvas, $31\frac{1}{2} \times 25\frac{1}{4}$ (80 × 62). Courtesy Museum of Fine Arts, Boston, Tompkins Collection, Arthur Gordon Tompkins Residuary Fund

30 La coiffure (The Dressing Table) 1901. Oil on canvas, $36\frac{5}{8} \times 27\frac{1}{2}$ (93 × 69·8). Philadelphia Museum of Art, Chester Dale Loan Collection

31 Luxe, calme et volupté (Luxury, Calm and Delight) 1904–05. Oil on canvas, 37 × 46 (94 × 117). Private collection, Paris. Photo Giraudon

32 Femme à l'ombrelle (Woman with a Parasol) 1905. Oil on canvas, 18 × $14\frac{3}{4}$ (45·7 × 37·4). Musée Matisse, Nice-Cimiez

33 La fenêtre ouverte (The Open Window, Collioure) 1905. Oil on canvas, $21\frac{3}{4} \times 18\frac{1}{8}$ (52·7 × 46). Collection Mr and Mrs John Hay Whitney, New York

34 La terrasse (The Terrace, St Tropez) 1904. Oil on canvas, $28\frac{1}{4} \times 22\frac{3}{4}$ (71·7 × 57·7). Isabella Stewart Gardner Museum, Boston

35 Vue de St Tropez (View of St Tropez) 1904. Oil on canvas, $13\frac{3}{4} \times 18\frac{7}{8}$ (35 × 48). Stolen in 1972 from Musée de Bagnols-sur-Ceze, France

36 Les toits de Collioure (Landscape at Collioure) 1906. Oil on canvas, $23\frac{3}{8} \times 28\frac{3}{4}$ (59·3 × 73). Hermitage Museum, Leningrad. Photo © 'Iskusstvo' Publishers, Moscow

37 Portrait de Madame Matisse; La raie verte (Portrait of Madame Matisse with the Green Stripe) 1905. Oil on canvas, $15\frac{3}{4} \times 12\frac{3}{4}$ (40 × 32·5). Statens Museum for Kunst, Copenhagen

38 Port d'Abail, Collioure 1905. Oil on canvas, $23\frac{5}{8} \times 58\frac{1}{4}$ (60 × 147·9). Private collection, Paris

39 André Derain 1906. Oil on canvas, $15\frac{1}{2} \times 11\frac{3}{8}$ (39·3 × 28·8). Tate Gallery, London

40 Bonheur de vivre (The Joy of Living) 1905–06. Oil on canvas, $68\frac{1}{2} \times 93\frac{3}{4}$ (174 × 238). Photo © The Barnes Foundation, Merion, Pennsylvania

41 Le jeune marin I (The Young Sailor I) 1907–08. Oil on canvas, $39\frac{1}{2} \times 31$ (100·3 × 78·7). Private collection

42 Le jeune marin II (The Young Sailor II) 1907–08. Oil on canvas, $39\frac{3}{8} \times 31\frac{7}{8}$ (100 × 80·9). Private collection

43 Le luxe I (Luxury I) 1907. Oil on canvas, $82\frac{3}{4} \times 54\frac{3}{8}$ (210 × 138). Musée National d'Art Moderne, Paris. Photo Musées nationaux, Paris

44 Intérieur à Collioure (Interior at Collioure) 1905. Oil on canvas, $23\frac{1}{2} \times 28\frac{3}{4}$ (59·6 × 73). Kunsthaus, Zurich

45 Nature morte aux géraniums (Still-Life: Geranium Plant on Table) 1906. Oil on canvas, $38\frac{1}{2} \times 31\frac{1}{2}$ (97·7 × 80). Art Institute of Chicago, Joseph Winterbotham Collection

46 Nature morte en rouge de Venise (Still-Life in Venetian Red) 1908. Oil on canvas, 35 × $41\frac{3}{8}$ (88·9 × 105). Pushkin Museum, Moscow

47 Nu, le bois clair (Seated Nude) 1906. Woodcut, $13\frac{1}{2} \times 10\frac{5}{8}$ (34·2 × 26·9). Museum of Modern Art, New York, Abby Aldrich Rockefeller Fund

48 *Nu (Nude)* 1906. Lithograph, printed in black, $11\frac{1}{8} \times 9\frac{7}{8}$ (28·4 × 25·3). Museum of Modern Art, New York, Gift of Abby Aldrich Rockefeller

49 *Nu, le grand bois (Seated Nude Asleep)* 1906. Woodcut, $18\frac{3}{4} \times 15$ (47·5 × 38·1). Museum of Modern Art, New York, Gift of Mr and Mrs R. Kirk Askew, Jr

50 *Écorché de Michelange* sixteenth-century sculpture, Florentine

51 *Nu debout (Standing Nude)* 1906. Bronze, height 19 (48·2). Private collection

52 *Nu couché (Reclining Nude, I)* 1907. Bronze, $13\frac{1}{2} \times 19\frac{3}{4}$ (34·3 × 50·2). Museum of Modern Art, New York. Acquired through the Lillie P. Bliss Bequest

53 *La coiffure (The Dressing Table)* 1907. Oil on canvas, $45\frac{5}{8} \times 35$ (115·8 × 88·9). Private collection

54 *Nu debout (Standing Nude)* 1907. Oil on canvas, 36 × 25 (91·4 × 63·5). Tate Gallery, London

55 *Baignade (Three Bathers)* 1907. Oil on canvas, $23\frac{5}{8} \times 28\frac{3}{4}$ (60 × 73). Private collection

56 *Musique (esquisse)* (sketch for *Music)* 1907. Oil on canvas, 29 × 24 (73·4 × 60·8). Museum of Modern Art, New York, Gift of A. Conger Goodyear in honour of Alfred H. Barr, Jr

57 *Bronze aux œillets (Sculpture and a Persian Vase)* 1908. Oil on canvas, $23\frac{3}{4} \times 28\frac{7}{8}$ (60·5 × 73·5). Nasjonal-galleriet, Oslo

58 *Poissons rouges (Goldfish)* 1912. Oil on canvas, $32\frac{1}{4} \times 36\frac{3}{4}$ (81·9 × 93·3). Statens Museum for Kunst, Copenhagen

59 *Poissons rouges et sculpture (Goldfish and Sculpture)* 1911. Oil on canvas, $46 \times 39\frac{5}{8}$ (116·2 × 100·5). Museum of Modern Art, New York, Gift of Mr and Mrs John Hay Whitney

60 *Poissons rouges (Goldfish)* 1911. Oil on canvas, $57\frac{7}{8} \times 38\frac{5}{8}$ (147 × 98). Pushkin Museum, Moscow

61 *Les deux négresses (The Two Negresses)* 1908. Bronze, height $18\frac{1}{2}$ (46·9). Baltimore Museum of Art, Cone Collection

62 *Bronze et fruit (Bronze and Fruit)* 1910. Oil on canvas, $35\frac{3}{8} \times 45\frac{1}{4}$ (90 × 115). Pushkin Museum, Moscow

63 *Le dos (esquisse)* (Study for *The Back)* 1909–10. Pen and ink, $10\frac{1}{2} \times 8\frac{5}{8}$ (26·6 × 21·9) Museum of Modern Art, New York, Carol Buttenweiser Loeb Memorial Fund

64 *Le Dos II (equisse)* (Study for *The Back II)* c. 1913. Pen and ink, $7\frac{7}{8} \times 6\frac{1}{4}$ (20 × 15·8). Museum of Modern Art, New York, Gift of Pierre Matisse

65 PAUL GAUGUIN: *The Moon and the Earth (Hina Te Fatou)* 1893. Oil on burlap, $45 \times 24\frac{1}{2}$ (114·3 × 62·2). Museum of Modern Art, New York, Lillie P. Bliss Collection

66 *Nu de dos I (The Back I)* c. 1909. Bronze, $74\frac{3}{4} \times 46 \times 7\frac{1}{4}$ (189·8 × 116·8 × 18·4). Tate Gallery, London

67 *Nu de dos II (The Back II)* c. 1913–14? Bronze, $74\frac{1}{2} \times 47\frac{1}{2} \times 7\frac{1}{2}$ (189·2 × 120·6 × 19). Tate Gallery, London

68 *Nu de dos III (The Back III)* c. 1914. Bronze, $74 \times 44\frac{1}{2} \times 6\frac{3}{4}$ (187·9 × 113 × 17·1). Tate Gallery, London

69 *Nu de dos IV (The Back IV)* c. 1929. Bronze, $74\frac{1}{2} \times 44\frac{1}{2} \times 6\frac{1}{4}$ (189·2 × 113 × 15·8). Tate Gallery, London

70 ANTOINE BOURDELLE: *La nudité des fruits* 1906

71 *La serpentine* 1909. Bronze, height $22\frac{1}{4}$ (56·5), at base $11 \times 7\frac{1}{2}$ (28 × 19). Museum of Modern Art, New York, Gift of Abby Aldrich Rockefeller

72 *Jeune fille au chat noir (Girl with Black Cat)* 1910. Oil on canvas, $37 \times 25\frac{1}{4}$ (93·9 × 64·1). Private collection, Paris

73 *Jeannette I* 1910–13. Bronze, height 13 (33). Museum of Modern Art, New York, Acquired through the Lillie P. Bliss Bequest

74 *Jeannette II* 1910–13. Bronze, height 10⅜ (26·3). Museum of Modern Art, New York, Gift of Sidney Janis

75 *Jeannette III* 1910–13. Bronze, height 23¾ (60·3). Museum of Modern Art, New York, Acquired through the Lillie P. Bliss Bequest

76 *Jeannette IV* 1910–13. Bronze, height 24⅛ (61·2). Museum of Modern Art, New York, Acquired through the Lillie P. Bliss Bequest

77 *Jeannette V* 1910–13. Bronze, height 23 (58·4). Art Gallery of Ontario, Toronto, Purchase 1949

78 *La conversation (The Conversation)* 1909–10. Oil on canvas, 69¾ × 85½ (177·1 × 217·1). Pushkin Museum, Moscow

79 *Baigneuses à la tortue (Bathers with a Turtle)* 1908. Oil on canvas, 70½ × 86⅝ (179·1 × 220·3). St Louis Art Museum, Gift of Mr and Mrs Joseph Pulitzer, Jr

80 *La nymphe et le satyre (Nymph and Satyr)* 1909. Oil on canvas, 35 × 46⅛ (88·9 × 117·1). Hermitage Museum, Leningrad

81 *La danse (The Dance,* study after the painting) 1909. Pencil, graphite, 8⅞ × 13⅞ (21·9 × 35·2). Museum of Modern Art, New York, Gift of Pierre Matisse

82 *Les capucines à La danse I (Nasturtiums and The Dance I)* 1912. Oil on canvas, 75⅝ × 44⅞ (199·7 × 113·9). Pushkin Museum, Moscow

83 *La danse (The Dance)* 1909. Oil on canvas, 101⅛ × 153½ (258·1 × 389·8). Hermitage Museum, Leningrad. Photo © 'Iskusstvo' Publishers, Moscow

84 *Nu, paysage ensoleillé (Nude in Sunny Landscape)* 1909. Oil on canvas, 16½ × 12⅞ (42 × 33). Collection Mrs Tevis Jacobs

85 FRANCISCO GOYA: *La jeune (Young Woman with a Letter) c.* 1812–14. Oil on canvas, 71¼ × 48 (181 × 122). Musée des Beaux-Arts, Lille

86 *Le luxe II (Luxury II)* 1907–08. Oil on canvas, 82¾ × 54⅞ (209·5 × 139). Statens Museum for Kunst, Copenhagen

87 *Le nu bleu (The Blue Nude)* 1907. Oil on canvas, 36¼ × 55⅛ (92 × 140). Baltimore Museum of Art, Cone Collection

88 *Nu assis (Seated Nude)* 1909. Oil on canvas, 14⅞ × 18 (38 × 46). Musée de Peinture et de Sculpture, Grenoble Photo IFOT

89 *Pierre Matisse* 1909. Oil on canvas, 16 × 13 (40·6 × 33). Private collection, New York

90 *Baigneuse (Bather)* 1909. Oil on canvas, 36½ × 29⅛ (92·7 × 74). Museum of Modern Art, New York

91 *La musique (Music)* 1910. Oil on canvas, 101⅝ × 153½ (258·1 × 389·8). Hermitage Museum, Leningrad. Photo © 'Iskusstvo' Publishers, Moscow

92 PAUL GAUGUIN: *Soyez amoureuses vous serez heureuses (Be in Love, and You Will Be Happy;* detail) 1901. Painted wood relief, 38⅛ × 28¾ (96·8 × 73). Private collection

93 *Nature morte au camaïeu bleu (Coffee Pot, Carafe and Fruit Dish)* 1909. Oil on canvas, 34⅞ × 46½ (87·9 × 118·1). Pushkin Museum, Moscow

94 *Intérieur aux aubergines (Interior with Aubergines)* 1911. Oil on canvas, 83⅜ × 96¾ (212 × 246). Musée de Peinture et de Sculpture, Grenoble

95 *Nature morte, Séville (Interior with Spanish Shawls)* 1911. Oil on canvas 35⅜ × 46¼ (89·8 × 117·1). Pushkin Museum, Moscow

96 *La chambre rouge; La desserte – Harmonie rouge (Harmony in Red)* 1908. Oil on canvas, 69¾ × 85⅞ (177·1 × 218·1). Hermitage Museum, Leningrad. Photo © 'Iskusstvo' Publishers, Moscow

97 *Le studio rouge (The Red Studio)* 1911. Oil on canvas, 71¼ × 86¼ (180·9 × 219). Museum of Modern Art, New York, Mrs Simon Guggenheim Fund

98 Fleurs et céramique (Flowers and Pottery) 1911. Oil on canvas, 36¾ × 32½ (93·3 × 82·5). Städelsches Kunstinstitut, Frankfurt. Photo Kunst-Dias Blauel

99 La famille du peintre (Family Portrait) 1911. Oil on canvas, 56¼ × 76⅜ (142·8 × 193·9). Hermitage Museum, Leningrad.

100 Nature morte, Séville II (Still-Life with Nasturtiums) 1910–11. Oil, 35⅝ × 46¼ (89·8 × 117·1). Pushkin Museum, Moscow

101 La fenêtre bleue (The Blue Window) 1911. Oil on canvas, 51½ × 35⅝ (130·8 × 90·4). Museum of Modern Art, New York, Abby Aldrich Rockefeller Fund

102 Zorah sur la terrasse (Zorah on the Terrace) 1912. Oil on canvas, 45⅝ × 39⅜ (115·8 × 100). Pushkin Museum, Moscow

103 Paysage vu d'une fenêtre, Tanger (Window at Tangier) 1912. Oil on canvas, 45¼ × 31⅛ (114·9 × 79). Pushkin Museum, Moscow

104 La porte de la Kasbah (Entrance to the Kasbah) 1912. Oil on canvas, 45⅝ × 31½ (115·8 × 80). Pushkin Museum, Moscow

105 Zorah debout (Zorah Standing) 1912. Oil on canvas, 57½ × 24 (146 × 60·9). Pushkin Museum, Moscow

106 Le riffain debout (Standing Riffain) 1912. Oil on canvas, 57½ × 38⅝ (146 × 98·1). Hermitage Museum, Leningrad

107 Jardin marocain (Pervenches) (Moroccan Garden) 1912. Oil on canvas, 46 × 32 (116·8 × 81·2). Private collection

108 Les citrons; Nature morte de citrons dont les formes correspondent à celle d'un vase noir dessiné sur le mur (Still-Life with Lemons) 1914. Oil on canvas, 27¾ × 21¾ (70·4 × 55·2). Museum of Art, Rhode Island School of Design, Gift of Miss Edith Wetmore

109 Le rideau jaune (The Yellow Curtain) 1915. Oil on canvas, 57½ × 38¼ (146 × 97). Collection Marcel Mabille

110 Mademoiselle Yvonne Landsberg 1914. Oil on canvas, 57¼ × 42 (145·4 × 106·6). Philadelphia Museum of Art, Louise and Walter Arensburg Collection

111 Madame Greta Prozor 1916. Oil on canvas, 57½ × 37¾ (146 × 95·8). Private collection

112 Les marocains (The Moroccans) 1916. Oil on canvas, 71⅜ × 110 (181·2 × 279·4). Museum of Modern Art, New York, Gift of Mr and Mrs Samuel A. Marx

113 Notre-Dame 1914. Oil, 57⅞ × 37 (147 × 93·9). Private collection, Switzerland

114 Une vue de Notre-Dame (View of Notre Dame) 1914. Oil on canvas, 58 × 37⅛ (147·3 × 94·2). Museum of Modern Art, New York

115 La leçon de musique (The Music Lesson) 1917. Oil on canvas, 96 × 82½ (243·8 × 209·5). Photo © The Barnes Foundation, Merion, Pennsylvania

116 Studio, Quai St Michel 1916. Oil on canvas, 57½ × 45¾ (146 × 116·2). The Phillips Collection, Washington DC

117 Le peintre et son modèle (The Painter and his Model) 1916–17. Oil on canvas, 57½ × 38¼ (146 × 97·1). Musée National d'Art Moderne, Paris. Photo Giraudon

118 La fenêtre; Intérieur (The Window) 1916. Oil on canvas, 57½ × 46 (146 × 116·8). Detroit Institute of Arts, City appropriation

119 Arbre près de l'étang de Trivaux (Tree by Trivaux Pond) 1916. Oil on canvas, 36½ × 29¼ (92·7 × 74·2). Tate Gallery, London

120 Coup de soleil (Sunlight in the Forest) 1917. Oil on canvas, 36¼ × 28¾ (92 × 73). Private collection, Paris

121 Baigneuses (Bathers by a River) 1916–17. Oil on canvas, 103 × 154 (261·6 × 391·1). Art Institute of Chicago

122 Les plumes blanches (White Plumes) 1919. Oil type on linen, 28¾ × 23¾ (73 × 60·3). Minneapolis Institute of Arts, The William Hood Dunwoody Fund

123 Les coloquintes (Gourds) 1916. Oil on canvas, 25⅝ × 31⅞ (65 × 80·9). Museum of Modern Art, New York, Mrs Simon Guggenheim Fund

124 Les plumes blanches (Girl in White) 1919. Oil on canvas, 29⅛ × 23¾ (74 × 60·5). Stolen in May 1973 from the Konstmuseum, Gothenburg

125 Le thé (Tea) 1919. Oil on canvas, 55⅛ × 83⅛ (140 × 211·1). Los Angeles County Museum of Art, Bequest of David L. Loew in Memory of his Father, Marcus Loew

126 La robe verte (The Green Robe) 1916. Oil on canvas, 28¾ × 21½ (73 × 54·6). Collection Mr and Mrs Ralph F. Colin, New York

127 Le peintre et son modèle (The Artist and his Model) 1919. Oil on canvas, 23⅝ × 28¾ (60 × 73). Private collection

128 Après le bain (Meditation) 1920. Oil on canvas, 28⅜ × 21¼ (72 × 53·9). Private collection

129 Femme à l'ombrelle (Woman with a Parasol) 1921. Oil on canvas, 26 × 18½ (66 × 46·9). S. Kocher & Co. Ltd

130 Femme au chapeau (Woman with the Hat) 1920. Oil on canvas, 23 × 19½ (58·4 × 49·5). Private collection, New York

131 Nature morte dans l'atelier (Interior at Nice) 1924. Oil on canvas, 39½ × 31½ (100·5 × 80). Private collection. Photo courtesy Marlborough Fine Art (London) Ltd

132 Jeune fille à la robe verte (Girl in Green) 1921. Oil on canvas, 25½ × 21½ (64·7 × 54·6). Collection Mr and Mrs Ralph F. Colin, New York

133 Madame Matisse 1913. Oil on canvas, 57⅞ × 38¼ (147 × 97·1) Hermitage Museum, Leningrad. Photo © 'Iskusstvo' Publishers, Moscow

134 La leçon de piano (Piano Lesson) 1916. Oil on canvas, 96½ × 83¾ (245·1 × 212·7). Museum of Modern Art, New York, Mrs Simon Guggenheim Fund

135 Grand intérieur, Nice (Interior at Nice) 1920. Oil on canvas, 52 × 35 (132 × 88·9). Courtesy of the Art Institute of Chicago, Gift of Mrs Gilbert W. Chapman

136 Nu assis au tambourin (Nude with Tambourine) 1926. Oil on canvas, 28 × 21 (71·1 × 53·3). Collection Mr and Mrs William S. Paley

137 Femme à la voilette (Woman with a Veil) 1927. Oil on canvas, 24 × 19¾ (60·9 × 50·1). Collection Mr and Mrs William S. Paley

138 La pose hindoue (The Hindu Pose) 1923. Oil on canvas, 28½ × 23⅜ (72·3 × 59·3). Private collection, New York

139 Femme et poissons rouges (Woman before an Aquarium) 1921. Oil on canvas, 31½ × 39 (80 × 99). Courtesy of the Art Institute of Chicago, Helen Birch Bartlett Memorial Collection

140 Le paravent mauresque (The Moorish Screen) 1921. Oil on canvas, 36¼ × 29¼ (92 × 74·2). Philadelphia Museum of Art, bequest of Lisa Norris Elkins

141 Odalisque avec magnolias (Odalisque with Magnolias) 1924. Oil on canvas, 23⅝ × 31⅞ (60 × 80·9). Private collection, New York

142 Nu au coussin bleu (Nude seated on a Blue Cushion) 1924. Oil on canvas, 28½ × 23 (72·3 × 58·4). Collection Mr and Mrs Sidney F. Brody, Los Angeles

143 Nu assis (Seated Nude) 1925. Bronze, height 31¾ (80·6). Baltimore Museum of Art, Cone Collection

144 Jeune fille en jaune (Girl in Yellow Dress) 1929–31. Oil on canvas, 39⅜ × 32 (100 × 81·2). Baltimore Museum of Art, Cone Collection

145 Grand nu gris (Grey Nude) 1929. Oil on canvas, 40¼ × 32¼ (101·9 × 81·9). Private collection

146 La danse (The Dance) 1932; detail showing one panel of the mural. Entire mural 140½ × 505 (356·8 × 1282·7). Mu-

sée d'Art Moderne de la Ville de Paris. Photo Bulloz

147 *Nu rose (Pink Nude)* 1935. Oil on canvas, 26 × 36½ (66 × 92·7). Baltimore Museum of Art, Cone Collection

148 *Odalisque au fautueil (Odalisque in an Armchair)* 1928. Oil on canvas, 23⅝ × 28¾ (60 × 73). Musée d'Art Moderne de la Ville de Paris. Photo Giraudon

149 *Figure décorative sur fond ornemental (Decorative Figure)* 1927. Oil on canvas, 51⅛ × 38½ (129·8 × 97·7). Musée National d'Art Moderne, Paris. Photo Giraudon

150 *Jazz: Icarus* 1943. Stencil print after paper cut-out, 16⅝ × 10⅝ (42·2 × 26·9). Victoria and Albert Museum, London. Photo Eileen Tweedy

151 *Jazz: Le toboggan (Jazz: The Toboggan)* 1943. Stencil print after paper cut-out, 12¾ × 11¾ (32·3 × 28·8). Victoria and Albert Museum, London. Photo Eileen Tweedy

152 *La danse I (The Dance I)* 1931–32. Oil on canvas, left panel 133⅞ × 152⅞ (340 × 387), centre panel 139¼ × 196⅛ (354·9 × 498·1), right panel 131⅛ × 154 (333 × 391·1). Musée d'Art Moderne de la Ville de Paris. Photo Bulloz

153 *La danse (The Dance)* 1932–33. Oil on canvas, 140½ × 564 (356·8 × 1432·5). Photo © The Barnes Foundation, Merion, Pennsylvania

154 *L'escargot (The Snail)* 1953. Gouache on cut and pasted paper, 112¾ × 113 (286·3 × 287). Tate Gallery, London

155 *Souvenir de l'Océanie (Memory of Oceania)* 1953. Gouache and crayon on cut and pasted paper on canvas, 112 × 112⅞ (284·4 × 286·7). Museum of Modern Art, New York, Mrs Simon Guggenheim Fund

156 *Le rêve (The Dream)* 1935. Oil on canvas, 31⅞ × 25⅝ (80·9 × 65). Private collection

157 *La musique (Music)* 1939. Oil on canvas, 45¼ × 45¼ (114·9 × 114·9). Albright-

Knox Art Gallery, Buffalo, New York, Room of Contemporary Art Fund

158 *Grande robe bleue, fond noir (Lady in Blue)* 1937. Oil on canvas, 36½ × 29 (92·7 × 73·6). Philadelphia Museum of Art

159 *Les yeux bleus (Blue Eyes)* 1935. Oil on canvas, 15 × 18 (38·1 × 45·7). Baltimore Museum of Art, Cone Collection

160 *Odalisque robe rayée, mauve et blanche (Odalisque with Striped Robe)* 1937. Oil on canvas, 15 × 18 (38·1 × 45·7). Norton Simon Collection, Los Angeles

161 *Nu dans l'atelier (Nude in the Studio);* drawing from *Cahiers d'Art*, 1935. Pen and ink, 17¾ × 22⅜ (45 × 56·8). Private collection

162 Drawing from *Cahiers d'Art* 1935

163 *Le rêve (The Dream)* 1940. Oil on canvas, 31⅞ × 25½ (80·9 × 64·7). Private collection, Paris

164 *Nature morte aux huîtres (Still-life with Oysters)* 1940. Oil on canvas, 25¾ × 32 (65·5 × 81·5). Kunstmuseum, Basel

165 *La porte noire (The Black Door)* 1942. Oil on canvas, 24 × 14⅞ (61 × 38). Private collection.

166 *Le silence habité des maisons (The Inhabited Silence of Houses)* 1947. Oil on canvas, 21⅝ × 18⅛ (54·9 × 46). Private collection, Paris

167 *Nu debout et fougère noire (Nude with Black Ferns)* 1948. Brush and India ink, 41¼ × 29½ (105 × 75). Musée National d'Art Moderne, Paris

168 *Intérieur a la fougère noire (Interior with Black Fern)* 1948. Oil on canvas, 45½ × 35 (115·5 × 88·9). Private collection

169 *La branche de prunier, fond vert (Plum Blossoms, Green Background)* 1948. Oil on canvas, 45¾ × 35 (116·2 × 88·9). Private collection

170 *Grand intérieur rouge (Large Red Interior)* 1948. Oil on canvas, 57½ × 38¼ (146 × 97·1). Musée National d'Art Moderne, Paris. Photo Giraudon

171 *Intérieur au rideau égyptien* (*Interior with Egyptian Curtain*) 1948. Oil on canvas, 45½ × 35 (115·5 × 88·9). The Phillips Collection, Washington DC

172 Decorations in chapel at Vence, late 1940s. Painted and glazed tiles. *St Dominic*, height *c.* 186 (472) and *Virgin and Child*, *c.* 120 × 252 (305 × 640). Photo Hélène Adant

173 Design for apse window for chapel at Vence 1949. Paper cut-out, 202¾ × 99⅛ (514·9 × 251·7). Vatican Museum, Collection of Modern Religious Art

174 *Jazz: Cavalier et clowne* (*Rider and Clown*) 1947. Stencil, sheet 16¼ × 25¼ (41·2 × 64·1). Museum of Modern Art, Gift of the artist

175 *Océanie – Le ciel* (*Oceania, The Sky*) 1946–48. Paper cut-out, 64⅞ × 149⅝ (164·7 × 380). Musée d'Art Moderne National, Paris. Photo Bulloz

176 *Océanie – La mer* (*Oceania, The Sea*) 1946. Paper cut-out, 65 × 149⅝ (165·1 × 380). Musée National d'Art Moderne, Paris

177 *Polynésie – La mer* (*Polynesia, The Sea*) 1946. Paper cut-out, 77⅞ × 123⅝ (195·8 × 314). Mobilier National, Paris, on loan to Centre National d'Art et Culture Georges Pompidou, Musée National d'Art Moderne, Paris

178 *Polynésie – Le ciel* (*Polynesia, The Sky*) 1946. Paper cut-out, 78¾ × 123⅝ (200 × 314). Mobilier National, Paris, on loan to Centre National d'Art et Culture Georges Pompidou, Musée National d'Art Moderne, Paris

179 *Amphitrite* 1947. Paper cut-out, 33⅝ × 27⅝ (85·4 × 70·1). Private collection, France

180 *Zulma* 1950. Gouache on paper cut-out, 93¾ × 52⅜ (238·1 × 133). Statens Museum for Kunst, Copenhagen

181 *Les mille et une nuits* (*The Thousand and One Nights*) 1950. Gouache on paper cut-out, 54¾ × 147¼ (139 × 374). Museum of Art, Carnegie Institute, Pittsburgh, Pennsylvania. Acquired through the generosity of the Sarah M. Scaife family

182 *Poissons Chinois* (*Chinese Fish*) 1951. Paper cut-out, 75⅝ × 35⅞ (192 × 91·1). Private collection

183 *La tristesse du roi* (*The Sorrow of the King*) 1952. Gouache on paper cut-out, 115¼ × 152 (292·7 × 386). Musée National d'Art Moderne, Paris. Photo Bulloz

184 EUGÈNE DELACROIX: *Les femmes d' Alger* (*Algerian Women in their Apartment*) 1834. Oil on canvas, 70⅞ × 90⅛ (180 × 220). Louvre, Paris

185 *Les acanthes* (*The Acanthi*) 1953. Paper cut-out, 122¾ × 138 (310·8 × 350·5). Ernst Beyeler, Basel, on long-term loan to Basel Kunstmuseum

186 *Nu bleu I* (*Blue Nude I*) 1952. Paper cut-out, 45⅝ × 30¾ (115·8 × 78·1). Ernst Beyeler, Basel

187 *Nu bleu II* (*Blue Nude II*) 1952. Paper cut-out, 45¾ × 35 (116·2 × 88·9). Private collection

188 *Nu bleu III* (*Blue Nude III*) 1952. Paper cut-out, 41¼ × 33⅜ (105 × 85). Private collection, Paris

189 *Nu bleu IV* (*Blue Nude IV*) 1952. Paper cut-out, 40½ × 30½ (102·8 × 77·4). Private collection, France

190 *La perruche et la sirène* (*The Parrot and the Mermaid*) 1952. Paper cut-out, 132⅝ × 304⅜ (337 × 773). Stedelijk Museum, Amsterdam

191 *La piscine* (*The Swimming Pool*) 1952. Gouache on cut and pasted paper, mounted on burlap. Nine-panel mural in two parts, 90⅝ × 333½ (230·1 × 847), 90⅝ × 313½ (230·1 × 796·2). Museum of Modern Art, New York, Mrs Bernard F. Gimbel Fund

Index